ACRYLIC PAINTING
A Complete Guide

Wendon Blake

DOVER PUBLICATIONS, INC.
Mineola, New York

To Donald Holden, without whom
this book could not have been written.

Published in Canada by General Publishing Company, Ltd., 30 Lesmill Road, Don Mills, Toronto, Ontario.
Published in the United Kingdom by Constable and Company, Ltd., 3 The Lanchesters, 162–164 Fulham Palace Road, London W6 9ER.

Bibliographical Note

This Dover edition, first published in 1997, is a revised edition of the work published by Watson-Guptill Publications, Inc., New York, in 1971 under the title *Complete Guide to Acrylic Painting*.

Library of Congress Cataloging-in-Publication Data

Blake, Wendon.
 [Complete guide to acrylic painting]
 Acrylic painting : a complete course / by Wendon Blake.
 p. cm.
 Originally published: Complete guide to acrylic painting. New York : Watson-Guptill Publications, 1971.
 Includes bibliographical references and index.
 ISBN 0-486-29589-3 (pbk.)
 1. Acrylic painting–Technique. I. Title.
ND1535.B55 1997
751.4'26–dc21 97-23763
 CIP

Manufactured in the United States of America
Dover Publications, Inc., 31 East 2nd Street, Mineola, N.Y. 11501

Contents

1
What is Acrylic?

Artists are adventurous in most things, but they're surprisingly conservative when it comes to their painting materials. Many of the greatest painters of the Renaissance, brought up on egg tempera, turned up their noses at the new, untested oil paints, and flatly refused to try them. And since the development of oil paints half a millenium ago, nothing much has happened.

It's no exaggeration to say that the development of acrylic artists' colors is the biggest technical breakthrough in 500 years. Artists have abandoned their usual caution and turned to acrylics with extraordinary enthusiasm. For centuries, artists have searched for the perfect paint—like Ponce de Léon searching for the fountain of youth—and for many of us, acrylic comes closer than any other painting medium. Acrylics are *not* perfect, of course, but they do offer a new range of technical effects, and a far broader range than any other medium. They're also more convenient to use, and promise to be far more durable than any paint in history.

Acrylics offer a range of technical possibilities so vast that no one book can possibly cover the subject. But this book will try, at least, to survey the *basic* acrylic techniques, which can keep you busy for an awfully long time. Having mastered these, you'll feel free to explore the vast, uncharted territory that's opened by this remarkable new medium.

Natural Versus Synthetic Materials

Without boring you with a lesson in chemistry, let me explain just what these new materials are.

Every form of paint consists of two basic ingredients: some sort of colored powder called pigment, and a liquid binder or adhesive that will stick this colored powder to a painting surface. When you go from one kind of paint to another, you discover that most of the pigments are the same. The familiar earth colors, like burnt umber and yellow ochre, turn up in oil, watercolor, tempera, and even in the new acrylics. It's the binder that makes the difference . . .

In oil paint, the binder is linseed oil, extracted from the flax plant. The binder for watercolor is a water soluble glue called gum arabic. For tempera, the usual binder is egg yolk or the whole egg (the yolk and the white are whipped together). Even pastels are made of the same combination: the pigment and the gum arabic binder are mixed, pressed into bars, and then simply allowed to dry— you're literally working with dry paint!

A third ingredient in most paints is some sort of thinner to make the paint more fluid. The usual thinner for oils is turpentine. Watercolor just thins with water, of course. So does egg tempera.

How the paint handles and how fast it dries will depend upon the liquid ingredients. Linseed oil is thicker than water and dries more slowly, which explains the buttery character of oil paints. Water evaporates much more rapidly and is a lot more fluid than oil, which explains the washy, quick-drying character of watercolor and tempera.

The point is that these binders were never really *intended* to make paint. Man simply found them in the world of nature—the vegetable or animal kingdom—and adapted them to make paint as best he could.

Acrylic, on the other hand, is a manmade material—a plastic or synthetic—created in the chemical laboratory for a specific purpose. What serves as the binder in acrylic artists' colors is a liquid plastic that dries to a tough, flexible film as clear as pure glass. In the bottle, the acrylic vehicle has a milky look and has the consistency of cream. When brushed on a painting surface by itself or in combination with pigment, the vehicle loses its cloudiness completely and becomes water-clear.

Most acrylic paints—and the acrylic binder, itself—can be thinned with water, at least while the paint is wet. Once the paint dries, it becomes insoluble in water. There's also an acrylic paint that you thin with turpentine and which you can even combine with traditional oil paints. However, this book will concentrate primarily on the water soluble acrylics.

Now then, what are the unique characteristics of acrylics—the characteristics that have won the hearts of so many artists in so short a time?

Versatility of Acrylic

The most striking feature of the new acrylic paint is its remarkable versatility—its adaptability to a great variety of painting techniques.

Thinned with a great deal of water, acrylic becomes a new kind of watercolor. You can mix luminous, transparent washes; create bold wet-in-wet effects; and paint with the same fluid spontaneity which is the essence of traditional transparent watercolor.

Diluted with a bit less water and modified with opaque white, acrylic becomes a superb opaque watercolor or gouache. The acrylic white is so powerful, so dense, that one opaque color application will cover another very swiftly. Opaque washes will go on as easily as transparent washes. And the medium lends itself easily to broken color, drybrush, and all sorts of elaborate techniques that require a methodical buildup of color upon color.

Add even less water—or better still, thin your color with acrylic medium—and you have paint as thick as oil. You can pile layer upon layer, or thick stroke upon thick stroke, to produce the most intricate textural effects and the most rugged impasto. Then thin your color with acrylic medium and you can glaze like the old masters. If you want color that has *more* body than oil, you can use additives that will produce paint that's almost as thick as clay!

If you've tried the slow, demanding medium of egg tempera, you'll be astonished to discover that acrylic can produce many of the same effects, but with less anguish. Thinned with water and acrylic medium, acrylic paints will produce the delicate veils of color and the intricate buildup of brush-strokes that the tempera painter loves. On the other hand, acrylic eliminates the need to fuss with eggs and powdered color. And when you want a really thick or opaque passage in the middle of an "acrylic tempera," you can have that too.

Acrylic is a dream come true for the painter who wants to try collage. Plain acrylic medium is an ideal adhesive for paper, cloth, granular materials, (like sand), and other lightweight found objects. Acrylic gel (more about this later) will hold down bigger and more unwieldy found objects like metal scraps, chunks of wood, pebbles, shells, plastic—well, you name it. And the acrylic paint, itself, is such a powerful adhesive that collage elements can be imbedded in the wet painting as you work.

I should hasten to add that acrylic is *not* the "universal medium." An acrylic watercolor, whether transparent or opaque, is never exactly like a painting in traditional transparent or opaque watercolor; each has its special character. In the same way, although you can paint thickly with acrylic—as you would with oils—the handling qualities of the two media are quite different. Nor do you paint in acrylic tempera in exactly the same way as you paint in egg tempera. Acrylic is *not* a replacement for the older painting media, so don't think that I'm asking you to chuck out your tubes of oils and watercolor. Each medium has its own rewards—and its own limitations. Explore them all and don't feel that you have to specialize in any one medium, unless that's where your heart takes you. Later in this chapter, you'll find a point-by-point comparison of the handling qualities of acrylic in relation to the older media.

Permanence

My most vivid memory of my first visit to an art museum, when I was about twelve, is wall after wall of dark, gloomy pictures, riddled with cracks. I don't remember the pictures at all, but I *do* remember the cracks! It was a shock to discover that so many treasures were simply the wreckage of pictures that had been smooth and vivid when they were painted centuries before.

The sad truth is that most paints have held up

badly against the ravages of time and the elements. Many colors fade after prolonged exposure to sunlight; layers of paint expand, contract, and finally cave in because of changing temperature and humidity. Pollutants in the air eventually settle into the texture of the paint, and the accumulated dirt of decades is hard to get out. The dried linseed oil skin (or linoxyn) of an oil painting slowly loses its flexibility over the years so that it becomes brittle and eventually cracks. The oil, itself, is likely to yellow and darken, obscuring even the most intense color. Egg tempera is brittle to start with; a slight shock will leave cracks and a sharp fingernail can often leave a scar. A watercolor remains water soluble forever, which means that moisture can be fatal and restoration difficult, if not impossible.

The manufacturers of acrylic paints claim that theirs is the first really durable painting medium. Of course, acrylics are so new that we don't have any old paintings to test out this claim. But the manufacturers have taken great pains to subject their colors to all sorts of artificial aging tests. The evidence is convincing. Acrylic does seem to be as durable as the manufacturers claim. Here are the facts as we now know them.

(1) Acrylic dries to a tougher film than any other medium in current use. Once the paint is dry, you have a layer of plastic—in which the powdered pigment is encased—which you certainly can't scratch even with the thickest thumbnail. Nor can you scratch it away with a palette knife in the process of applying more paint. In fact, I've found it pretty hard to sandpaper away a layer of dried acrylic; only very tough sandpaper will do the job on a paint layer of normal thickness. So then, acrylic seems to stand up well against direct physical wear and tear.

(2) Whether it's applied to canvas, panel, or paper, acrylic doesn't seem to suffer from changes in temperature or humidity. The plastic film is porous and flexible, so the dried paint seems to roll with the punches when canvas swells or shrinks, and when any other painting surface misbehaves.

(3) Because of its special combination of toughness and flexibility, a layer of dried acrylic paint can also resist a shock better than any other medium. If you drop a tempera panel, it will probably crack and chip; this won't happen with an acrylic painting on a panel. You're not likely to lose any paint when you poke a canvas from behind either—but you may tear it if you're that clumsy!

(4) As you've gathered by now, the adhesion of acrylic to just about any painting surface is phenomenal. As long as the surface isn't oily or waxy, acrylic will stick to practically anything you might want to paint on. It sticks tenaciously. You can't peel it off, scrape it off, or chip it off. Because the paint is insoluble in water when the paint layer dries, it's practically impossible to soak it off or dissolve it, unless you use some very powerful industrial solvent like acetone or lacquer thinner.

(5) Unlike linseed oil, which seems to deteriorate with age, acrylic is chemically stable. It doesn't shrink, become brittle, or change color over the years. This means that your color mixtures are encased in a plastic layer which will never change its character and obscure the color effects you've worked so hard for.

(6) The final point really has nothing to do with the chemical behavior of acrylic, but it's worth noting anyhow. Based on common knowledge of the behavior of pigments, manufacturers of acrylic paints have used only those pigments which are absolutely permanent. They've eliminated pigments which fade on prolonged exposure to sunlight and pigments which are chemically unstable for any reason. They've also eliminated any pigments which produce unstable chemical combinations with other pigments—a common problem in oil painting. This means that you can mix any acrylic color with any other acrylic color without fear of producing a chemical time bomb which will wreck your painting in the years ahead.

I might add that acrylic paint and acrylic medium can add durability to materials which aren't, in themselves, particularly permanent. Thus, fragile collage papers, encased in acrylic paint or medium, become tough as leather.

Drying Time

Because water is the main liquid component of acrylic paints and mediums, paintings in acrylic tend to dry rapidly. An acrylic watercolor painting dries just about as fast as a traditional watercolor. Applied more thickly in the manner of opaque watercolor or even oil, acrylic is dry as soon as the water evaporates. In other words, the drying time is a matter of minutes rather than hours. You can keep an oil painting wet for days, but even a very thick acrylic painting is likely to be dry in a few hours—the same day you paint it.

If you're used to painting in oil and you like the idea that oil paint remains wet for a prolonged period, allowing you to make unlimited changes, you may be annoyed by the rapid drying of acrylic. As I'll explain in Chapter 2, you can buy additives that slow down the drying time of acrylic paint, but you really can't keep the picture wet as long as an oil painting. On the other hand, devotees of acrylic regard rapid drying as a distinct advantage for many reasons.

(1) Rapid drying means that you can place one color over another in very rapid order. As soon as the underlying color is dry, it's insoluble in water and the next color can go on. This next color can be a corrective layer or a broken color effect that reveals the color underneath.

(2) Quick drying is a great advantage if you're using the old master technique of underpainting and glazing. The underpainting dries in a matter of minutes—not days—and the glaze can go right on over it. In fact, the glaze dries just as fast, so a second glaze and even a third one can be applied in rapid order.

(3) A medium that dries rapidly retains the precise shape of your brushstroke. The paint dries just as you put it down and the artist's "handwriting" is prominently displayed.

(4) A rapid drying medium like acrylic encourages bold, decisive brushwork because the paint dries before you can overwork it. The painting retains the spontaneity of your attack.

(5) Because it dries quickly and requires a spontaneous approach to painting, acrylic forces you to plan a picture carefully. You can't just dive in and wallow around in wet paint until it turns to mud. You've got to decide what you want to do—in advance—and come in on target.

The rapid drying of acrylic has two kinds of advantages. On the one hand, there are the technical advantages of rapid overpainting and correcting. On the other hand there are the expressive advantages of decisiveness and spontaneity.

Convenience and Safety

Because acrylic is a water-based medium, it's easy to clean up. Brushes are simply washed in water, with the aid of a touch of soap. After a brief soaking, dry paint peels right off the palette. Spills can be sponged up—as long as they're still wet. Dried paint peels off your hands with just soap and water.

The materials and equipment are simple. For all the different techniques described in this book, all you need are a dozen tubes of paint, some bottles or tubes of medium and varnish, and a very limited number of painting tools. Because you can rinse your brushes as you paint, you don't need nearly as many brushes as you need for oil painting. In this sense, acrylic is like watercolor, in which you can get by with just a few brushes, washing them out as you switch from one color to another.

All acrylic materials are entirely safe to use. There are no poisonous pigments or mediums. There's nothing that will irritate your skin. There are no foul smelling ingredients with noxious fumes—to which oil painters often find themselves allergic.

One real problem with acrylic is a side effect of its extraordinary durability. Although it's easy to sponge up when it's wet, watch out when it dries! If you get a splash of acrylic on your clothing or on the floor and wait too long to rinse it off, the color may be there to stay. It's practically impossible to remove dried acrylic from a shirt, a dress, a pair of trousers, or a rug. Conventional dry-cleaning won't do it and you might as well give up any hope of getting it out with soap and water, even with vigorous scrubbing.

So remember this warning. Wear old, expendable clothes when you paint with acrylic. Work in a part of the house where you don't mind if the paint spatters on the floor or wall—or spread plenty of newspapers around if you must work in your bedroom, as I did for a long time. Wear castoff shoes or ragged sneakers, like mine. And try to keep acrylic paint out of your hair, or you may not get it out until your next haircut.

One simple safety measure is always to keep a wet sponge nearby to wipe up spills. It's also helpful to have a few paper towels on hand for the same reason. Sponges are for wiping; towels are for blotting.

Acrylic Compared with Other Painting Media

At this point, it may be helpful to take some time out to compare acrylic with the other major painting media with which you may be more familiar.

The two most significant differences between acrylic and oil are drying time and brushing qual-

ity. As I said earlier, acrylic dries in minutes—or hours if it's very thick—while oil paint dries in days. This means that you make corrections or alterations on an acrylic painting by applying one layer of paint over another, rather than by scraping out or brushing wet paint into wet paint. As you brush out the paint, you're immediately aware that acrylic is a water based medium; the paint brushes out smoothly and quickly, tending to level a bit unless you stiffen it with one of the additives I'll describe in the next chapter. In contrast, oil paint is stiffer, brushes out more slowly, and tends to stand up from the painting surface unless you smooth the stroke down.

In acrylic painting, soft, blended edges and transitions must be handled much as you do them in watercolor: with graded washes, wet-in-wet effects, drybrush, or with a rough, scrubbing stroke which is sometimes called "scumbling." You don't have the time to brush and rebrush a passage until you get the gradation you want, as you do in oil painting; besides, you don't have the oiliness of oil paint, which makes such prolonged blending possible in the first place.

When it's used to paint watercolors, acrylic can do practically everything that traditional watercolor can do, plus a good deal more. The major difference is that a wash of acrylic color dries insoluble, so an overwash won't pick up or dissolve the color underneath. This is always a problem with traditional watercolor. This feature of acrylic is particularly valuable when you want to build up a dark or deep color in a series of washes—a difficult problem with traditional watercolor. Thinned with water, acrylic is just as fluid and transparent as the older medium. However, various additives make it possible to produce far richer drybrush and other textural effects than you can get in transparent watercolor. Finally, a touch of acrylic medium makes it a lot easier to lay washes in acrylic.

As a gouache or opaque watercolor, acrylic is radically different from casein or designers' colors. The older medium must be applied in thin layers, one over the other, to avoid cracking, while acrylic can be piled on without any danger. The older medium is usually applied in the consistency of thick cream, while acrylic can be applied thick or thin, depending upon how much water or how much medium you add. This obviously gives you far more freedom to develop complicated textural effects. Furthermore, one layer of acrylic won't dissolve another underlying layer, so you can paint much more freely than you would with traditional opaque watercolor.

The reason that egg tempera has so few adherents is that the picture must be built up so slowly and methodically. Egg tempera can't be built up thickly, but must be applied in thin veil upon veil, slender stroke upon stroke. The final painting is as smooth as the painting surface itself. Used in the tempera technique, acrylic can be built up rapidly without any fear of the brittleness that plagues the older medium. Mistakes can be painted out swiftly. Textures can be built up much more directly, rather than in the tedious, stage by stage manner that makes egg tempera so frustrating. And the textures, themselves, can be far more varied and three dimensional. Acrylic paint also has much more body than the traditional combination of dry pigment and egg; thus, you can let yourself go and enjoy bolder brushwork. Finally, acrylic allows much greater depth and richness of tone than egg tempera, in which deep, ringing tones are rare.

Let me emphasize that these are differences, but not necessarily advantages. The traditional watercolorist often *likes* the idea that he can sponge out a dry passage. Illustrators who've worked with opaque watercolors all their lives—and who often rebel against acrylic—like the smooth, textureless quality of designers' colors or gouache. Many tempera painters prefer the slow buildup of the traditional medium and like the limited tonal range, which gives egg tempera the "blond" quality we admire in the Italian masters. And certainly, the suave, buttery character of oil paint makes it a great deal easier to blend the soft shadows and reflected lights in a portrait, for instance.

What may be a disadvantage to one painter is an advantage to another. Whatever medium you choose, you must find out how to exploit the advantages and work your way around the drawbacks—or turn these drawbacks into advantages after all. The key is to approach the new medium of acrylic with an open mind. You must discover how the medium will *work for you*. As you try out the various techniques described in the chapters that follow, you're on a voyage of discovery.

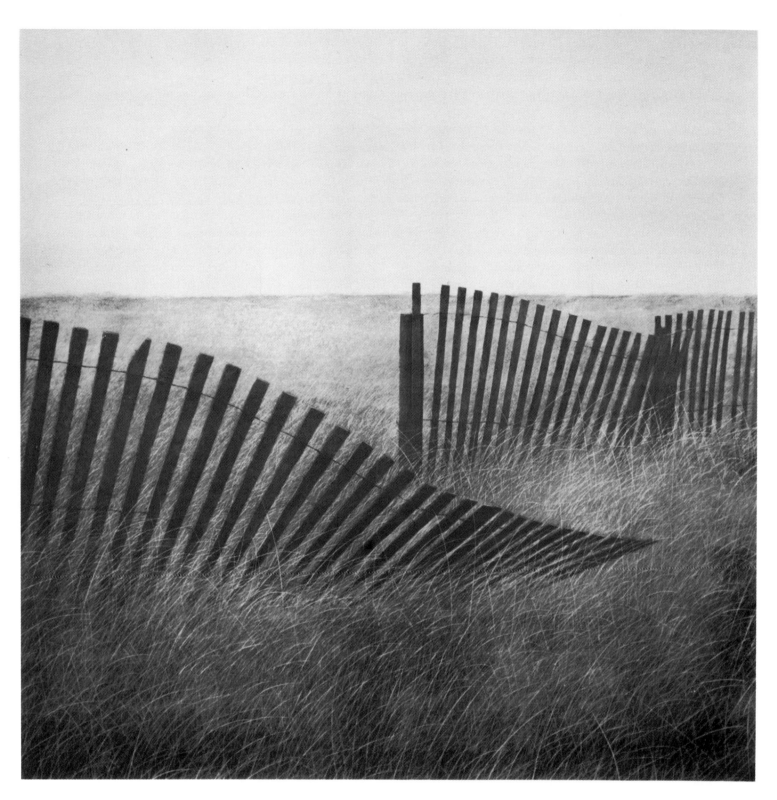

Outer Banks *by Arthur Biehl, acrylic on panel, 23¼" x 23¼", collection Mr. and Mrs. Richard McCarthy, Atlanta, Georgia. Acrylic lends itself not only to broad, free brushwork but to the precise, demanding tempera technique, in which the painting is built up with thousands of tiny, hairline strokes. Study the extraordinary pattern of rhythmic strokes that are used to render the grass in this spare, beautifully designed landscape. Each stroke is carefully placed— and its arc carefully drawn—to suggest the infinite variety of the directions of the individual blades. The strokes constantly change direction in order to keep the eye interested, gradually growing smaller and less distinct as the eye moves toward the horizon. Such a technique requires extraordinary patience and self discipline, but yields special satisfaction to the artist who values accuracy. (Photograph by Geoffrey Clements, courtesy Banfer Gallery, New York)*

2
Colors and Mediums

Entire books have been written about the bewildering variety of mediums which you can buy or cook up for oil painting. As great a painter as Degas once confessed that he found the technology of oil painting so confusing that he hated to pick up a brush—he preferred pastel, which he found so much simpler.

One of the great virtues of acrylic is its technical simplicity. Aside from your tubes of color, all you need are five different additives, plus water, and you're fully equipped for every kind of technique, from the most direct watercolor approach to the most complex underpainting and glazing methods. Here are the basic painting mediums.

Water

At first glance, it may seem silly to devote an entire section to water, but this is really a fundamental component of acrylic paint, and of all the acrylic mediums. The paint is a blend of pigment, acrylic emulsion, and water. The acrylic medium—with which the paint is made—is really an emulsion (to use the correct scientific term) of microscopic plastic particles suspended in water. The emulsion and the paint remain wet until the water evaporates. At that point, the particles of plastic lock together in a continuous film which binds the pigment to the painting surface.

The behavior of water is terribly important to the acrylic painter. You must learn how little or how much water to add to produce the right paint consistency. You must learn to gauge the evaporation time of the water in your paint, since this is the "working time" before a passage dries.

I'm going to begin by giving you some tests which you can conduct to learn more about how water functions in acrylic painting. But first, get yourself two large jars or bowls (at least one-quart size) and fill them both with fresh, clear water from the tap. Always work with two bowls. One will be for diluting your paint, while the other will be for washing your brushes. Never switch bowls. Always use one for diluting and one for washing. In this way, you'll always have one bowl of clear water that you can add to paint. Obviously, the bowl you use for cleaning will get filthy very soon, and you'll want to toss it out and fill it with fresh water periodically.

The other equipment you'll need to conduct these simple tests will be a bristle brush, about ½" wide (the kind you use for oil painting); some odd scraps of white illustration board or sturdy white paper; an old, discarded dish or a plastic margarine container or one of the palettes I'll describe in Chapter 4. Now squeeze out a gob of paint, about the size of a 50¢ piece, and you're ready to go.

(1) Dip your brush into the clear water in the bowl you'll use for diluting your paint. Swish the brush around so it's thoroughly wet. Then shake the brush out so that most of the water is gone, but the bristles remain moist. This is one of the iron-clad rules of acrylic painting: always work with a moist brush. Never dip a dry brush into acrylic paint, and never let paint dry on the brush. Only a moist brush will shed the paint and keep it from hardening on the bristles. Once paint hardens on the bristles, you can kiss your brush goodbye. I won't ask you to test this out by allowing paint to dry on your brush; take my word for it.

(2) Now dip your moist brush into the blob of paint that you've squeezed from the tube. Brush the paint onto your paper or cardboard scrap, applying it evenly, and filling an area about 2" square. Because your brush is only faintly moist, you're really working with pure, undiluted tube color; you haven't added any water. This will give you an idea of the consistency and brushing quality of tube color, which is something like thick sour cream or stiff pancake batter. Let it dry. Observe how long it takes to dry, and test it out with a fingertip. Different brands have different drying times, depending upon the chemical composition chosen by the manufacturer, but this layer of paint will probably dry to the touch in no more than fifteen minutes, perhaps sooner.

(3) Wash out the brush in the jar of water you've reserved for this purpose. Dip the brush into the mixing water; but this time, just shake out a *bit* of the water to keep the brush from dripping, leaving the brush fairly wet. When you pick up some more tube paint, blend the water from your brush into the paint by moving the bristles back and forth on the palette. This time, the paint should come out the consistency of cream or milk. Brush another 2" square on your paper or board and observe the drying time. Also observe how the drying time changes when the paint is moderately diluted. The paint is less stiff, more fluid, more easily brushed out.

(4) Wash the brush again and pick up a real brushload of clear water. Mix this on the palette with just a touch of tube color. In fact, you might even want to add a second brushload of water. The idea is to produce very thin, runny paint, the consistency of watercolor. Paint a 2" square of this greatly diluted color and observe how long it takes to dry. The paint will be very fluid and may be a bit streaky. It will flow on very easily.

(5) Mix up another brushful of paint which will be the consistency of watercolor, but this time make it practically all water, with just the merest hint of color. Your 2" square will be very pale, hardly there at all. Once again, compare drying time and brushing quality with the other squares.

(6) When all four of your squares are bone dry, take a brushload of clear water and scrub each square vigorously, as if you're trying to wash away the .paint. The undiluted and moderately diluted paint will remain immovable; you'll remember that

I said dry acrylic paint is insoluble in water. No matter how much elbow grease you use, the paint stays put. You may be able to take off a bit of the heavier watercolor wash, though I doubt it. You can probably scrub away some of the really thin watercolor wash. The lesson, here, is that the more water you add, the more you dilute the acrylic medium in the paint and cut down the adhesiveness of the mixture. The really thin wash comes off because there's practically no acrylic medium to hold the paint down. So remember, if you want to paint thinly, you've got to reckon with a layer of color that may dissolve when the next layer is applied. Or you can solve the problem by adding a touch of acrylic medium, which I'll deal with in the next section of this chapter.

(7) Paint each of your squares again, just as I've told you to do. But don't let the squares dry. While they're still wet, strike back into them with a moist brush and see how much color you can remove. Then strike back into them with a brushload of water and see how the paint thins out, moves around, dissolves, or comes off. Your point in doing this is to discover that plain water can do surprising things to wet acrylic paint. It can remove the paint, lighten it, spread it, soften it, make it more fluid—well, find out for yourself.

And don't forget: wash your brush out frequently as you work and always keep the bristles moist. Water is both a painting medium and your insurance policy against ruining your brushes.

Gloss Medium

I've said that acrylic paint is compounded of pigment, water, and acrylic medium, which I've also called acrylic emulsion. The manufacturers of acrylic colors sell plain acrylic medium in bottles or jars—and sometimes in plastic squeeze bottles—which you can add to your paint for a variety of effects. In the bottle, this medium looks milky and more or less opaque. But when it dries, it becomes clear as glass; the milky opacity disappears entirely. The medium also dries to a shiny finish, which is why it's sometimes called gloss medium, in contrast to the matt medium which I'm going to describe later in this chapter. Here are some ways to test out the uses of gloss medium.

(1) Pour about half an inch of gloss medium into a paper drinking cup. Dip your moist brush into the plain medium and brush out a 2" square of the milky fluid on your paper or cardboard. The fluid

is creamy, but brushes out smoothly. Note that it dries to a shiny finish, though it's a soft shine, not quite as glary as many oil painting mediums. You'll also observe that the drying time is about the same as that of the tube color.

(2) Wash out your brush and pick up a brushload of clear water. Dribble a couple of drops of medium onto your palette, and blend in the clear water so that the medium becomes a good deal thinner. Now paint another square with this diluted medium. The drying time should be more like that of diluted paint; the medium should be more fluid when you brush it on; and it won't dry as shiny.

(3) Pick up a brushload of pure medium from the paper cup and blend the medium with some tube color on your palette. When you paint the usual square on your test sheet, you'll find that the paint assumes the creamy consistency of the medium. The mixture is still fairly thick, but has a particularly appealing brushing quality, more like oil paint which has been modified by a resinous medium.

(4) Trying diluting some tube color with the combination of medium and water described in step 2. This will make the paint more fluid than the mixture of pure medium and color, but the paint will still have some of the same attractive brushing qualities. Naturally, the dry paint layer will be thinner. It will probably be a bit less shiny than the dry paint in step 3, which dries fairly glossy because of the high proportion of medium.

(5) When the test squares in steps 3 and 4 are thoroughly dry, mix up a pool of fluid color on your palette; the pool will be mostly medium and just a touch of tube color. For this experiment, use some new color which contrasts with the color you've selected for the tests conducted so far. Paint this wash of contrasting color over one third of each dried square. This will be your first glimpse of the luminous transparency of acrylic when strongly diluted with medium. The underlying color shines through the second layer and the two colors combine and produce a third hue. If your underlying color is brown and your glaze is red, you'll produce a red-brown. You can try producing a green by glazing yellow over blue, an orange by glazing yellow over red, a violet by glazing crimson over blue, and so on. If you'd like to apply a thinner glaze, then combine medium, water, and a bit of tube color.

While still moist, this patch of tube color was lightly scrubbed with a wet brush along the top and right hand side. Note how the water blurs and softens these two edges.

A moist bristle brush was used to scrub and lift color from the center and lower edge of this patch of wet tube color. This is easy to do when acrylic paint is wet, but impossible once it's dry.

A solid rectangle of wet tube color was scrubbed, lifted, and pushed around with a wet bristle brush. Note the rich variety of tone and texture.

This also began as a solid rectangle of wet color. Some color was lifted with a moist brush; the wet paint was then manipulated with a brush loaded with acrylic medium, which stiffens the paint and leaves the type of distinct brushstrokes which you can see here.

Two different tube colors were carefully blended with gel on the palette, brushed side by side on the canvas, and then blended like oil paint with a bristle brush. You must work quickly, since the paint dries rapidly.

(6) Paint some squares of pure tube color, tube color diluted with medium, and tube color diluted with water, then work back into them before they dry. Attack them with a brushload of medium or a brushload of medium and water. See how adding medium to a patch of wet paint can lengthen drying time, change the consistency of the paint, blend it, soften it, make it glossier, and develop all kinds of surprising effects.

Matt Medium

Not everyone likes glossy paint, so the manufacturers of acrylic colors have developed a modification of the gloss medium which dries matt. An inert substance is added to the gloss medium by the manufacturers. This substance has no effect on the chemical behavior of handling qualities of the medium—you can't tell the difference until the paint dries—but paint diluted with matt medium dries to a non-glossy finish, like pastel or casein. Whether you choose matt or gloss medium is purely a matter of taste.

(1) Brush out a test square of matt medium and watch it dry. Unlike the dried square of gloss medium, the matt medium will dry almost invisible because it has no shine.

(2) As you did when you tried out the gloss medium, brush out a square of matt medium which has been diluted with water. You'll see that the brushing qualities of the diluted matt medium are exactly the same as those of the diluted gloss medium. So is the drying time. And the dry square will be almost invisible.

(3) Repeating again the tests tried with the gloss medium, dilute some tube paint with straight matt medium and see how the brushing quality changes, becoming creamier and richer, more like diluted oil paint.

(4) Do the same thing with a combination of matt medium and water, producing somewhat thinner tube color, which is still very responsive to the brush, as in step 4 in the section on gloss medium.

(5) When you glaze with a combination of matt medium and tube color—as you did with gloss medium—the color will dry just as transparent. But you'll feel less conscious of the glaze because the effect will be less shiny. Somehow, we *expect* a glaze to be glossy. But the underlying and overlying colors will still produce a third color.

(6) Finally, just as you worked back into several patches of wet color with the gloss medium, try the same experiment with the matt medium. Once again, you'll find that the matt medium can soften, blend, lighten, thin, and extend the working time of the wet color.

Gel Medium

Gloss medium is available not only in liquid form, but in the form of gel, which is packaged in a tube. Like the liquid, the gel is milky and somewhat opaque, but dries completely transparent. The consistency of the tube medium is even thicker than that of the tube paint, since the purpose of the gel is to thicken the paint for impasto painting and textural effects. Now squeeze out a gob of gel on your palette, next to the gobs of paint.

(1) With a clean, moist brush, pick up a thick load of gel and make several quick, decisive strokes on your test sheet. Don't smooth the strokes out; let the gel retain the impression of the bristles. Some of the gel will probably stick up from the surface in a distinct impasto effect. Watch the strokes dry. The gel will harden and become absolutely clear, retaining a shine like the gloss medium. The gel will also preserve the absolute shape and texture of the stroke, like stiff oil paint. The thicker the stroke, the longer it takes to dry.

(2) On your palette, blend some clear gel with some tube color, but don't add any water. Keep the proportions of paint and gel roughly equal. The result will be a thick, pasty color which lends itself to rugged brushwork. Again, make a few quick strokes on your test sheet. The paint retains the impression of the brush and stands up from the surface, rather than leveling slightly as it did when your medium was water, gloss medium, or matt medium. In short, gel is your medium for impasto painting.

(3) Add a bit of water to your blend of gel and tube color. If you don't add *too* much water, the pasty mixture will become just a bit more fluid, easier to brush out, but will be stiff enough to retain that bulky feeling which is the essence of impasto painting. Make several strokes: leave some of them thick and three dimensional; brush some of the others out to a smoother film. You'll see that another property of gel is that it makes your paint more buttery, more pliant, more brushable, more like oil paint. Yet even when you add a bit of

water to produce a smoother paste, the paint film still retains the lively impression of the bristles.

(4) Mix up two batches of color and gel on your palette, say blue and green, Add a touch of water to make each batch a trifle more fluid. Then quickly paint a square of each color side by side and blend them together where they meet. You've got to work quickly, of course, because acrylic dries so much faster than oil paint, but you *can* use gel in this way to produce a soft tonal transition.

(5) Clean your brush thoroughly, shaking it out so that it remains moist, and add just a hint of color to a gob of clear gel. Brush this onto the test sheet and perhaps over a dried patch of color. Apply the paint thickly and you have something which is possible only with acrylics: a transparent impasto or an impasto glaze. In oil painting, a glaze *must* be thin because it's mostly fluid medium—oil and resin—and strongly diluted tube color. When you paint with acrylic, gel makes it possible to produce transparent passages which are richly textured. If you want a really wild textural buildup, you can use gel for a thick, opaque underpainting, followed by an equally thick, transparent overpainting.

Retarder

Several manufacturers of acrylic colors now offer an additive which retards drying. Depending upon how much retarder you add, you can get anywhere from half an hour to a full day's working time before the paint solidifies. One manufacturer guarantees up to twenty-four hours' working time before drying.

Such retarders can be blended with gel and tube color to produce paint which behaves a good deal more like oil paint. But don't add too much water or the effect of the retarder is cut down. Just for an experiment, I tried adding retarder to a really thin wash of acrylic color—the consistency of watercolor—and the retarder was so diluted that it had no effect whatever on the drying time of the fluid paint. So retarder seems most effective in combination with color and medium, whether gel, gloss, or matt.

Frankly, I have somewhat mixed feelings about the use of retarder. If your main purpose is to develop a technique that imitates oil painting, then you're probably better off painting in oils to begin with. Nor should you use retarder as a crutch which allows you to be indecisive simply because

you've got more working time before the paint dries. Even if you do find that it's an advantage to have increased working time, do remember that the charm of acrylic is its spontaneity. Even if you add enough retarder to keep your paint wet all day, work boldly and freely.

Modeling Paste

If gel isn't thick enough for you, the manufacturers of acrylic colors provide something even thicker. Modeling paste is basically a combination of acrylic medium and inert filler—like marble dust—which produces a compound something like clay or putty. The paste is whitish or colorless, so you can add color to it to produce any hue you need. Here are several ways to use modeling paste . . .

(1) If you really must paint pictures thicker than Van Gogh's, try mixing your tube colors with modeling paste. You'll find yourself with mountains of paint on your palette and this sort of paint will need big, thick brushes and painting knives.

(2) Although you may not want to use modeling paste throughout a painting, this can be an effective way of developing a richly textured underpainting, over which you can apply more fluid color. The texture of the underpainting will obviously shine through and enliven the overpainting.

(3) Acrylic modeling paste, lightly toned with color, can be used to create interesting painting surfaces, as I'll describe in Chapter 3. Granular materials like sand can be mixed with the modeling paste, which can then be applied to a panel with a brush or a spatula. Or the modeling paste can be applied to the painting surface and then a textured material, like rough cloth, can be pressed into the moist paste and peeled away to leave an imprint. More about this later.

(4) For richly textured paintings that include collage elements, a rigid painting surface—like Masonite—can be coated with modeling paste and three dimensional objects can be pressed into the wet surface. If the paste is thick enough, it can hold wood scraps, bits of metal, and things as thick as marbles.

(5) A number of painters have tried modeling paste to produce paintings which are more like relief sculpture. Working on a panel, they build up certain forms to a thickness of half an inch or even more, then paint these forms when they're dry.

The one limitation of modeling paste is that you can't apply one really thick layer, but must build it up in a series of thinner layers. If you're really going to build it up to ¼" or ½" thickness, do this in four or five stages, allowing each layer to dry before you apply the next. If you apply the paste too thickly, the surface will dry, but the paste will remain wet inside for quite a while. It may also shrink and crack when it dries eventually. Of course, any cracks can be filled and sealed by more modeling paste, so they're no real problem.

The greatest danger with modeling paste is simply that you may get carried away. It's such fascinating stuff that you may be tempted to let its dramatic textures dominate your pictures. Unfortunately, this can become a case of the tail wagging the dog. Texture, after all, is just one element of the painter's vocabulary, so don't overdo it.

Tubes, Jars, and Squeeze Bottles

Most acrylic paints are packaged in tubes, like oils. Some manufacturers sell them in jars and a few firms package acrylic colors in plastic squeeze bottles.

The tube paint is thickest. The paint that comes in jars and squeeze bottles tends to be more fluid. For general use, tube color is most convenient, since you can squeeze it out on your palette, where it will stay. You can also thin it down to the consistency of the color that comes in a jar or a bottle.

On the other hand, if you like to work with more fluid paint, the jars are worth a try. Just line them up the way you'd line up the colors on your palette and dip your brush into the jars to pick up color for mixing on a nearby surface of metal, enamel, or plastic. Used in this way, the jar colors lend themselves to particularly free, fluid techniques.

The colors that come in squeeze bottles are intended primarily for illustrators and designers, who like the fact that bottled colors are very fluid and dry to a smooth, even surface.

List of Colors

Acrylics come in practically all the widely used colors you may be accustomed to in oil paints or in watercolors. The only colors that have been elimi-

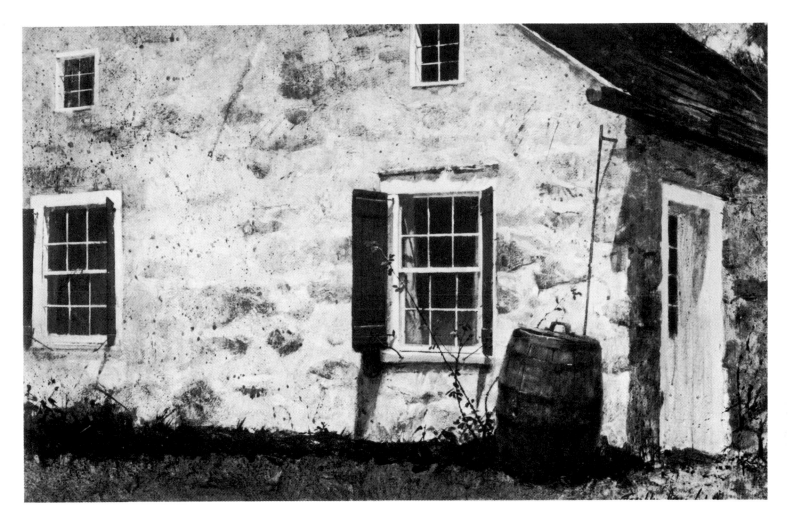

The Stone House *by Franklin Jones, acrylic on Masonite panel, 20" x 30". The entire picture was first underpainted with transparent washes in an essentially watercolor technique. For transparent tones like these, you can thin your tube color with water or with liquid acrylic medium—gloss or matt, whichever finish you prefer. After blocking in the darker stonework in the wall, the artist carefully dragged thick, almost dry, white pigment over the painting surface to build up an irregular texture. (Tube color can be thickened with acrylic gel.) Over this, he applied warm washes of transparent color and again dragged white over the entire area. This was done repeatedly until he achieved the final textural effect. If you look closely, you can see how the thin washes of color settle into the surface irregularities to suggest the character of the stone. As a final textural refinement, liquid color was literally spattered over the last wash. This texture is particularly evident in the upper left and in the immediate foreground.*

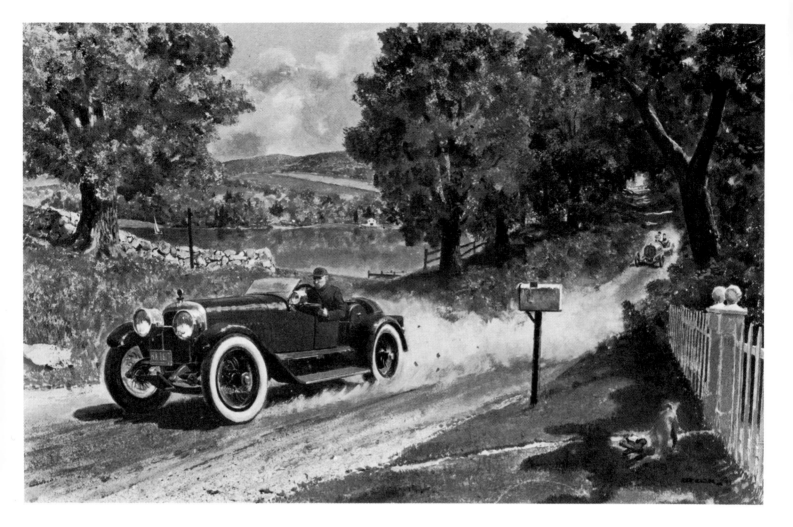

Libaire Raises the Dust *by Peter Helck, N.A., A.W.S., acrylic on watercolor board, 22" x 34", collection John Libaire. The rich texture of this type of acrylic painting is usually the result of using paint straight from the tube, or very slightly diluted paint. Just a touch of water will improve the brushing quality of the paint, keeping it thick enough for passages of solid color, like the car or for rugged drybrush passages like the trees. To maintain this paint consistency, matt or gloss medium can be even more effective diluents than water. Alternatively, gel medium can serve as a thickener. Note how the drybrush textures of the trees, the grass, and the shadows in the lower right hand corner all exploit the rough texture of the handmade English watercolor paper. The cloud of dust is painted more thinly in order to get a softer gradation of tone.*

nated are those of doubtful permanence and a few, like alizarian crimson, which produce adverse chemical reactions when combined with acrylic emulsion. For any really important color that's been eliminated from the list for chemical reasons, the manufacturers have substituted more recently developed colors whose names may be unfamiliar, but which look the same and are absolutely permanent.

The rest of this chapter will be devoted to a list of recommended colors, with descriptions of how they behave. To make these descriptions more meaningful, let me define some terms.

Hiding power simply means the capacity of a color to cover up what's underneath. As I use this term, it's synonymous with *opacity*. This characteristic is important because you must get to know which colors are dense and opaque enough to cover what's underneath, and which colors are *transparent,* revealing what's underneath, just as a sheet of colored glass lets you see through it. Remember that there are degrees of transparency and opacity. Some colors are very transparent, while others are only moderately transparent. In the same way, some colors are very opaque—just a little bit will cover up a lot—while others are semi-opaque, which means that you've got to use more to cover things up.

Tinting strength determines how much of a color you'll need to produce the mixture you want. When a color has a great deal of tinting strength, that means you'll need just a little to go a very long way. Thus, if a blue has great tinting strength, that means you'll need just a touch of blue, but a lot of yellow to produce green. Conversely, if a color is low in tinting strength, you'll probably need a lot of it when you use it in a mixture. Going back to the blend of blue and yellow that I just mentioned, you'll use lots of yellow (but just a little blue) because the yellow is much lower in tinting strength.

As you read through the list that follows, bear in mind that I'm not listing *every* color available. This is simply a list of the colors that seem most useful, based on my own experience. There are lots of exotic hues in the manufacturers' catalogs and all these intriguing colors may have their special uses. But the colors in my list are the ones from which you'll probably select your palette at the beginning.

Let me make it clear that you won't need *all* the colors, even on this selective list. Most painters settle on about a dozen colors for steady use, plus another half dozen or so for special occasions. In the chapters that follow—describing various acrylic techniques—I'll recommend palettes for various purposes. At no time will I recommend the entire list that appears in the present chapter. It's always best to pick a limited number of colors that suit your special needs, so you can get to know each color really well. Having too many colors is like having too many casual friends: you never get to know any one of them well enough.

Blues

Except for Prussian blue, an old standby which some oil painters and many watercolorists consider indispensable, the acrylic color range includes all the standard blues. There are five acrylic blues which are worth mentioning, although only two of them strike me as really essential: ultramarine blue and thalo blue.

Ultramarine blue: This slightly warm, rather transparent blue is on practically every painter's palette. Its tinting strength is reasonable, but not overwhelming; it won't dominate a mixture, but holds its own in combination with a great variety of other colors. It doesn't have great covering power, but this isn't really important because ultramarine blue is used mainly in mixtures. Blended with various browns and white, it produces a marvelous range of warm and cool grays which are vastly more interesting than the grays you can get simply by mixing black and white. Mixed with bright yellows like the cadmiums, it produces greens which are rich, but which don't leap out of a landscape. With earth yellows like yellow ochre, ultramarine blue produces soft, subtle greens which are just as useful as the bright ones. Beware of mixing ultramarine blue with the cadmium reds; you won't get beautiful violets, but a strange, muddy tone, which may have its own kind of fascination, however. Blended with a transparent crimson, ultramarine does produce lovely violets. Because of its transparency, this blue is an excellent glazing color when mixed with other, equally transparent hues.

Phthalocyanine blue: Many painters abbreviate its name to thalo blue and this color is generally regarded as the successor to Prussian blue, though advocates of Prussian blue claim that the colors are far apart. In any case, thalo blue is cool, brilliant,

transparent, and devastatingly powerful in mixtures. A touch of it will dominate a big batch of yellow and produce an electrifying green. When mixed with transparent reds and crimsons, it will produce equally dazzling purples. You *can* blend it with browns and white to produce grays, but thalo blue has so much tinting strength—and the browns have so little—that the grays tend to turn blue. Ultramarine is better for this purpose. Because of its brilliance and transparency, thalo blue is an excellent color for glazes and washes, alone or in combination with other transparent colors.

Cobalt blue: This is a soft, cool blue, with moderate tinting strength and moderate covering power. It has the great virtue of staying in its place and not popping out of a picture like the more electric thalo blue. Cobalt blue can cool down a warm mixture without taking over. This blue is particularly effective in atmospheric landscapes where you want a sense of receding space. It yields delicate greens when mixed with the yellows, pearly grays when mixed with browns and white, but rather innocuous violet tones when combined with reds and crimsons. Portrait and figure painters find cobalt blue particularly useful in the cool shadows within flesh tones.

Cerulean blue: Somewhat more opaque than the other blues, this cool, airy sky blue is splendid for landscapes. Because of its atmospheric tone, cerulean blue can produce delicate greens and grays which melt away into the distance. Because it has more hiding power than most blues, it's not useful for transparent passages. Cerulean is a blue that you tend to use by itself or in occasional mixtures where you *don't* want the blue to dominate. For this reason, its use is somewhat limited.

Manganese blue: This is another sky blue, bright and transparent, useful in atmospheric landscapes, but not a general purpose color like thalo blue or ultramarine blue. It's worth having only if you have a special purpose in mind, like some special effect in the sky or water.

Among these five blues, the two that you find most often on an artist's palette are ultramarine and thalo. This gives you a warm, restrained blue, and a cool, brilliant blue. Together, they should cover most of your needs. Cobalt blue has a special, delicate charm that makes it worth having if you want a third blue. Cerulean and manganese blues are decidedly optional, though you may find them helpful in landscape and seascape painting.

Reds

The range of acrylic reds is exceptionally rich because of the development of several new dyes, which are brilliant and absolutely permanent. The traditional reds have been retained, with the exception of alizarin crimson, which seems to be incompatible with the chemistry of acrylic emulsion.

Cadmium red: There are actually three cadmium reds, labeled light, medium, and dark. Most painters prefer the light, which is terribly intense and stands out like a searchlight if you use it by itself. The dark cadmium red is practically maroon, while the medium hue is somewhere in between. You can easily darken the light hue to get the others, so I'd recommend skipping the medium and dark unless you have some special use for them. Cadmium red is dense, opaque, and is inclined to dominate a mixture because of its great tinting strength. It makes a wonderful accent when used by itself, produces breathtaking shades of orange when mixed with the various yellows, but will demolish most blues and produce mud. Cadmium red can be made even more fiery by adding a touch of crimson and can be thinned with acrylic medium and water for luscious glazes and washes.

Naphthol red: This red and the related naphthol crimson are recently developed colors that more than make up for the disapparence of alizarin crimson. Naphthol crimson is a splendid replacement for the older color and is said to be more permanent. Naphthol crimson is somewhat cooler than naphthol red and therefore the crimson is more useful as a foil for cadmium red light. I don't think it's necessary to have cadmium red light and naphthol red on the same palette, though you may prefer the naphthol red because of its greater transparency. Both the red and the crimson will make luminous oranges when mixed with various yellows. The crimson makes an intense violet when mixed with the more transparent blues, and will make cadmium red even brighter, as I said a moment ago. This crimson will also add fire to brown. By itself or in combination with other transparent colors, naphthol crimson makes a splendid hue for glazes and washes. In mixtures, it's strong, but not overwhelming.

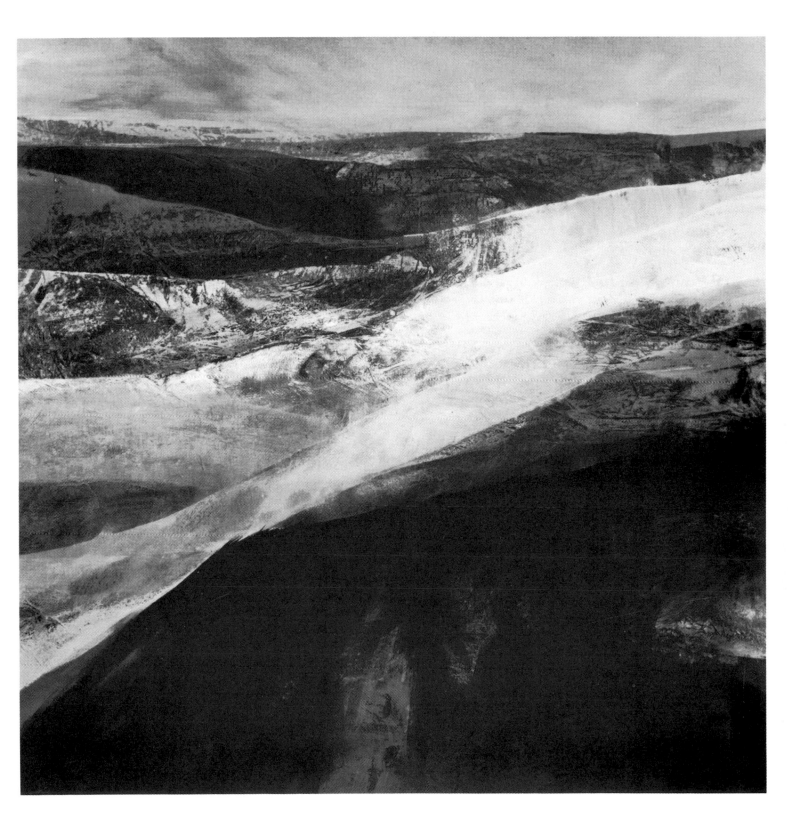

Sirocco by Richard Kozlow, acrylic on panel, 40" x 40". To achieve the mysterious quality of this landscape, the acrylic painting medium was used as an adhesive for crumpled paper, which was glued down to the painting surface and then treated with washes of diluted acrylic tube color. The artist alternated misty light tones with shadowy dark tones, since acrylic lends itself equally well to semi-transparent and semi-opaque painting methods. In fact, matt and gloss mediums work equally well as adhesives and as paint diluents in this intricate technique. Study how some color sinks into the valleys, while other color rides on the peaks of the crumpled paper surfaces in the upper half of the painting. (Photograph by Oliver Baker Associates, courtesy Rehn Gallery, New York)

Phthalocyanine crimson, which is shortened to thalo crimson, replaces alizarin crimson in the catalogs of some manufacturers. What I've said about naphthol crimson applies equally to this bright, transparent hue. Like the other phthalocyanine colors, it's very strong in mixtures, transparent, and intense. Needless to say, you won't need this *and* naphthol crimson; just pick one.

Red oxide: This is deep, earthy red that verges on brown. It's powerful in mixtures, somewhat opaque, and is inclined to dominate when blended with other colors—so use it with care. Its hot tones are splendid for the reflected lights in flesh tones, while it's equally useful for the coppery colors in an autumn landscape. Red oxide can produce a smoldering orange in combination with a strong yellow like cadmium, a very luminous red-brown when blended with an earth tone like burnt umber, and is just restrained enough to hold its place in the picture without popping out. This color will give you a hot accent without destroying your color harmony.

Burnt sienna: Like red oxide, this beautiful color is in some no-man's-land between red and brown. Burnt sienna is a luminous, transparent amber tone which makes wonderful glazes and washes by itself, or in combination with other transparent colors. Combined with blues, it will make splendid warm and cool grays and a wide range of browns. Burnt sienna can subdue and enrich a red at the same time, though that may be hard to visualize until you try it. You'll get handsome, coppery tones by mixing it with the yellows. And you can even use it to tone down an insistent green. Technically, this is an earth color—named for its origin in Italy—but it's more vivid than earthy.

Among these colors, the really important ones are cadmium red light, which gives you the warm red you need; either naphthol crimson or thalo crimson for the cool red on your palette; and either burnt sienna or red oxide for an earthy red-brown. If you're accustomed to Venetian red or light red in oil painting, red oxide is the best equivalent in acrylic. And burnt sienna is so useful—both in flesh tones and in landscape painting—that you may want *both* of the red-browns.

Yellows

Acrylics include a full range of yellows, running the gamut from the intense cadmiums to the subtle earth yellows. The only one that I really miss is Naples yellow, although you can mix a similar hue with a little experimentation.

Cadmium yellow: Like the cadmium reds, this comes in three varieties—light, medium, and deep. The light variety is the most useful and can be easily darkened. All the cadmiums have considerable tinting strength, are fairly opaque, and are very intense. Cadmium yellow will make a vivid green when mixed with thalo blue, a somewhat more subtle green when mixed with ultramarine blue, a vivid orange when mixed with cadmium red, and wonderful golden tones when blended with the various earth colors. Because of its great hiding power, cadmium yellow needs to be thinned with a good deal of medium or water to produce an effective glaze or wash.

Hansa yellow: Like cadmium yellow, this comes in light, medium, and deep. The hue is just a touch cooler than the sunny cadmium yellow, and considerably more transparent, which is an important advantage when you use acrylic in a watercolor or glazing technique. The light Hansa yellow is often called lemon yellow and has a special delicacy all its own. The medium and deep tones tend somewhat toward orange, as do the darker tones of cadmium yellow. Hansa yellow will produce lively, transparent greens when mixed with thalo blue, somewhat more subtle (but still transparent) greens when mixed with ultramarine blue, luminous orange when mixed with one of the naphthol reds, and golden glazes when mixed with transparent earth colors like burnt sienna. The Hansa yellows have reasonable tinting strength, but they won't overpower a mixture, which is always a danger with the more assertive cadmiums.

Azo yellow: Another transparent yellow, which behaves somewhat like Hansa yellow. This is a newly developed dye color and comes in several shades. It is worth trying if you need a transparent yellow. I don't think I'd buy both Hansa yellow and azo yellow, but one of them is worth having if you find cadmium yellow too opaque.

Yellow ochre: Essential for portrait and figure painting, this is the subtle earth yellow which is so valuable for mixing flesh tones. The tone is dusty and slightly tannish; its moderate tinting strength won't dominate a mixture. Yellow ochre is reasonably opaque and needs a fair amount of medium or water to become an effective glaze or wash. Mixed

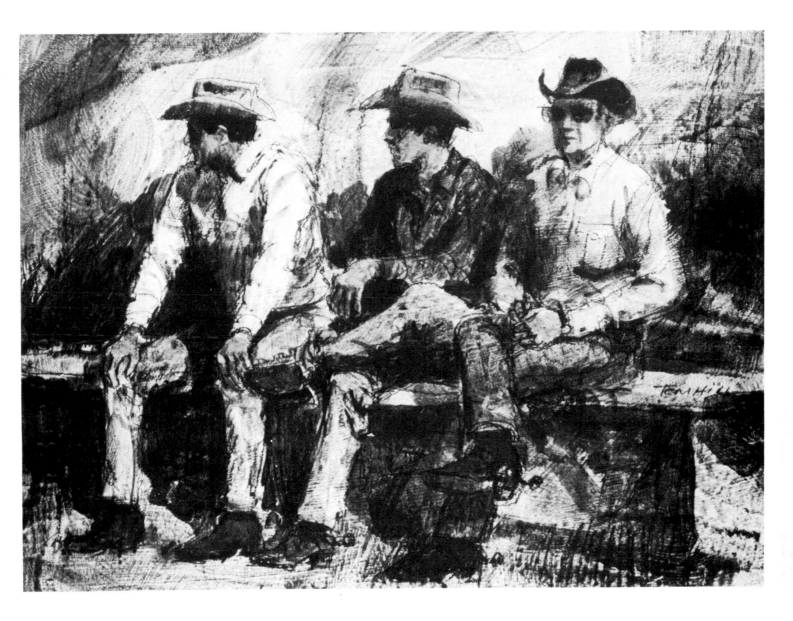

Rodeo Riders *by Tom Hill, A.W.S., acrylic on gesso coated hardboard, 12" x 16", collection Dr. Anthony Don. The board was coated first with irregular, random strokes of acrylic gesso which were thick enough to leave behind the texture of the stiff brush. Thus, when washes of color were strongly diluted and applied over the dried gesso ground, the transparent color sank into the textured gesso. This technique gives the painting its exciting surface vibration. When tube color is radically diluted with water in this way, it's often a good idea to add just a touch of matt or gloss medium—not quite enough to thicken the color—in order to make sure that the wash contains enough adhesive to hold the color firmly in place. The treatment of the figures is an interesting example of the way in which drawn lines can be used to reinforce freely applied washes.*

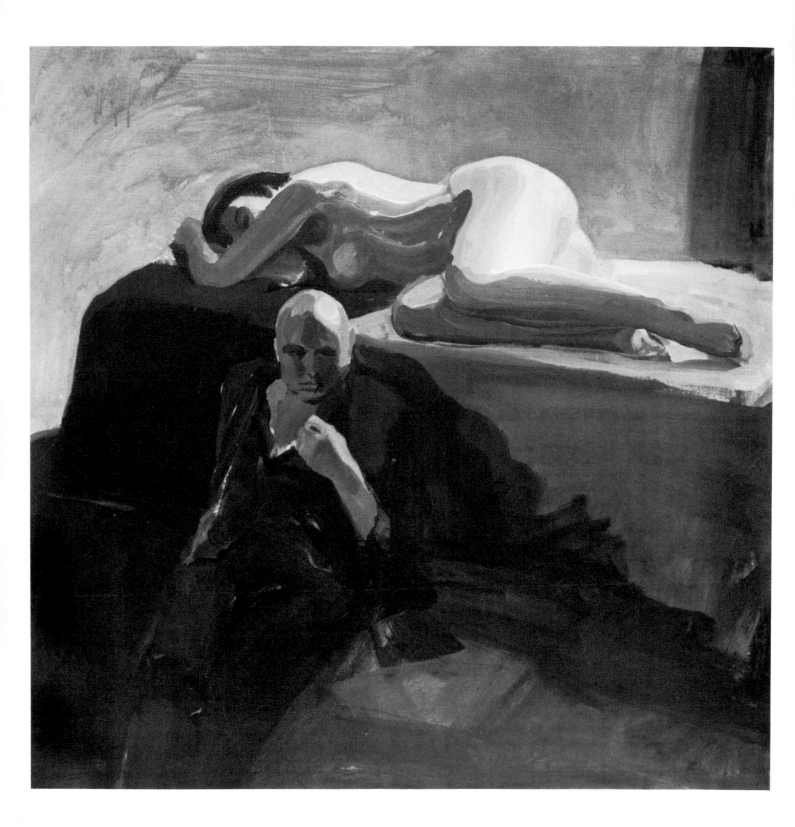

Suzanne and Jack by Seymour Pearlstein, acrylic on canvas, 50" x 50". This boldly painted figure study runs the full gamut from thin, scrubby color in the background to thickly applied strokes in the figures themselves. The surface color constantly shifts from opaque to semi-opaque to semi-transparent passages, keeping the viewer's eye intrigued by the changing character of the paint quality. Although the forms are distinctly three-dimensional, the paint is applied flatly, with a minimum of modeling. Form is rendered by placing one block of tone against another; the egg-shaped male head is painted in three flat gray tones with a large white highlight. The acrylic tube color retains the casual character of each brushstroke. (Photograph by Peter A. Juley & Son)

with other earth colors (like burnt sienna, burnt umber, red oxide, and raw umber) plus white and even a touch of blue, yellow ochre becomes the basis for a tremendous variety of flesh and hair tones, from the palest blond to the darkest brown. A bit of blue or black produces subtle, slightly olive toned greens. Because of its moderate tinting strength, yellow ochre will subdue a red without destroying its richness, make a coppery orange that melts back into an autumn landscape, and warm a gray without turning it to green. Many painters like to blend a bit of yellow ochre into a sky to warm the blue—an unthinkable idea with any other yellow. Yellow ochre is the best yellow for underpainting because it will reinforce, but never overwhelm, the color that goes over it.

Yellow oxide: This is a more recently developed color which several manufacturers have introduced to replace yellow ochre. Although the hues are close enough, the yellow oxide tends to be stronger in mixtures, and is sometimes a trifle more intense. However, you can use the two colors interchangeably.

Most painters would say that you need at least two of these yellows on your palette. Cadmium, Hansa, or azo will provide the vivid yellow you need; pick either the opaque cadmium or one of the two transparent yellows, depending upon your technique. Practically every painter I know uses either yellow ochre or yellow oxide as his soft yellow, providing a necessary alternative to the vivid cadmium, Hansa, or azo. I do know a few who sometimes switch from yellow ochre to raw sienna, which has more of a brown-orange tone, though it behaves like a yellow when mixed with blue, red, or white. More about raw sienna in the section on browns.

Greens

Like many painters, I have a prejudice against green on the palette. I think you can mix much more exciting greens than you can get out of a tube. However, not everyone agrees, so I'll review the more useful greens available in acrylics.

Phthalocyanine green: Often shortened to thalo green, this vivid, transparent hue is related to thalo blue, and behaves in much the same way. Thalo green has extraordinary tinting strength, and must be used with care to avoid demolishing a mixture. The color is so bright that it bounces out of the

picture and often needs modification with a touch of some warm color like brown or red. A touch of transparent yellow will make thalo green even more vivid, if that's what you want. Mixtures with various earth colors will produce an excellent variety of brown-greens for landscape painting.

Chromium oxide green: This dusty, opaque green, with a distinct olive flavor, lends a good deal of atmosphere to a landscape. Some painters like to use it for the shadowy underpainting of a figure. It has more tinting strength than you might expect, producing soft yellow-greens when mixed with an opaque or transparent yellow, and fascinating olive browns when mixed wth earth colors. You can also do odd things with it like adding a touch to tone down a red or soften a vivid blue.

Hooker's green: A favorite hue of watercolorists, this transparent, sappy green can be very useful in landscape painting, for which thalo green is often too electric and chromium oxide green too subdued. Hooker's green combines well with all the earth colors to produce the wide range of greens, browns, and green-browns that you need for painting trees and other growing things at different times of the year. Blended with yellow, Hooker's green will produce softer, more atmospheric yellow-greens than the overpowering thalo. Because of its medium tinting strength, Hooker's green handles well in mixtures. You can easily create thalo green by mixing thalo blue with a transparent yellow, but Hooker's green is a lot harder to mix— which is why so many painters buy it in the tube.

Thalo green is a fascinating color to have if you really want a vivid green ready made. Actually, I think chromium oxide green and Hooker's green, because of their peculiar, slightly offbeat tones, are more helpful to have. However, once you've learned how to mix your colors quickly and instinctively, there's *no* green you can't get simply by mixing blues, yellows, and earth colors.

Oranges

Like the greens, oranges can be mixed readily from other colors, like reds, yellows, and earth tones. I don't think it's essential that you have a ready made orange on your palette, though some of them are so attractive it's hard to resist having them available, if only as time savers.

Cadmium orange: This beautiful, intense orange

has the same powerful tinting strength as the other cadmiums, and the same hiding power. You can easily mix it with cadmium yellow light and cadmium red light. Because of its opacity, it needs a lot of medium or water to produce a glaze or a wash. In combination with various earth colors, cadmium orange produces lovely coppery tones for autumn landscapes.

Hansa orange: In contrast with the opaque cadmium orange, this is a transparent hue, which is more useful in glazes and wash techniques. Hansa orange isn't quite as strong in mixtures, and doesn't have as much impact as cadmium orange when used by itself. This combination of transparency and greater delicacy may be an argument in its favor for those painters who find cadmium orange too hot to handle.

Indo orange red: Although I think it's usually pointless to include tertiary colors like yellow-green, red-violet, or orange-red on the palette, this beautiful color might be an exception to the rule. It's a vivid, transparent vermilion color, which I suppose you can approximate by mixing a transparent yellow and a transparent red; but this is a particularly exciting color for transparent techniques like glazing or washes.

To see the variety of oranges you can mix without having orange on your palette, don't just stick to the usual formula of yellow and red, but try mixing yellows with hot earth tones like burnt sienna, mixing reds with earth yellows like yellow ochre or with yellow-browns like raw sienna. The results may surprise you.

Violets

I'm certain that most painters would consider violet the least useful secondary color to have ready made on the palette, since you can mix so many violets with your various reds and blues. However, there are three violets you might consider if you *must* have one available.

Mars violet: Like all the Mars colors, fairly recent products of the chemical laboratory, this has great tinting strength and must be used with care so that it doesn't dominate a mixture. Use it in small doses.

Dioxazine purple: Another recent development, this vivid purple is quite opaque and looks terribly dark when you squeeze it from the tube. When diluted, it produces a vivid, fairly transparent glaze or wash.

Acra violet: This is a rich, reddish violet, not nearly as blue as dioxazine purple. It's also more transparent and produces a vivid magenta when thinned with medium for glazing.

But before you buy any of these violets, see what you can do with thalo blue or ultramarine blue mixed with thalo or naphthol crimson.

Browns

All the beautiful earth browns are available in acrylics and you'll want to include at least a couple of them on your palette. Although it's true that you can mix browns by combining blue, red, and yellow, as the textbooks tell you, the earth browns have special qualities which are hard to duplicate in mixtures. Besides, they're all so cheap that it's worth buying them in tubes.

Burnt umber: A deep, fairly opaque brown, this widely used color has moderate tinting strength, just enough to hold its own in a mixture, but not enough to dominate. Combined with any blue and white, burnt umber yields a superb range of warm and cool grays, as well as deep, cool browns. With earth reds like burnt sienna and red oxide, burnt umber produces a rich range of coppery tones which are equally useful in landscape and figure painting. This brown will deepen a vivid red and make it more subtle, warm a green or a blue, and produce golden tones in combination with the various yellows. Burnt umber isn't especially interesting as a glaze when used by itself, but all of its mixtures produce splendid glazes and washes when diluted with medium or water.

Raw umber: A very subdued yellowish, faintly grayish brown, raw umber is useful precisely because it's *not* a standout. Totally uninteresting by itself, raw umber can be used to modify a great number of other colors which need to be faintly toned down without losing their own inherent excitement. Adding raw umber is something like adding a touch of warm gray. Try it with various other colors and see what you get. Painters who rely on subtle tonal effects often feel they can't do without this modest, inconspicuous hue. Its low tinting strength is the secret of its value.

Raw sienna: I'm never sure whether to class this as a brown, a yellow, or perhaps an orange. It has

some of the characteristics of each. It's fairly opaque, has moderate tinting strength, has a lovely golden tan hue when used by itself, and produces some surprising mixtures. Some painters prefer it to yellow ochre because raw sienna creates more vivid, but still subtle greens when mixed with blues. Raw sienna, as I've explained, will warm and restrain a hot red at the same time. It holds other surprises when mixed with greens, which it can warm and enrich for landscapes.

The most generally useful of these three is burnt umber, particularly for the wide range of grays you can make with it. But you should really try raw umber and raw sienna at some point, if only to discover what they can do. For a description of burnt sienna, look under the section devoted to reds.

Black

In acrylics, the traditional ivory black of oil painting has been replaced by Mars black. Payne's gray, a favorite with watercolorists, is also available.

Mars black: This dense, powerful black has much greater tinting strength than ivory black—if that's what you're used to—so remember that a little goes a long way. Don't overuse Mars black or it will turn all your mixtures to mud. If you want to tone down another color, black is always the worst color to add. You'll get far more interesting results by adding a complementary color or some other unlikely hue: for example, a touch of red will tone down a green, a touch of orange will tone down a blue, etc. You can even tone down one hot color with another, like modifying red with brown. Black is a bad modifier, but it *is* an interesting color in itself. Try reversing things and modifying black with some vivid warm or cool color, to produce a red-black, a blue-black, or a brown-black. If you look at black as a color with its own unique possibilities, then you'll see why the Chinese masters considered black the most exciting color of all.

Payne's gray: Although this looks like black when you squeeze it from the tube, it's actually a bluish-gray. Many watercolorists consider it indispensable because it's a ready made cool tone which looks good by itself and can be used to modify other colors because of its mild tinting strength. Payne's gray is just quiet enough to cool another hue without destroying it. It's most valuable when well diluted with water or medium.

As you can see, I'd consider Mars black the more valuable of the two, although many painters argue against having black on the palette at all. (Their view is that you can get much more lively dark tones by mixtures of brilliant colors like red and green.) However, if you're a watercolorist who wants to try using acrylic as a watercolor medium, you may be accustomed to having Payne's gray on hand.

White

Theoretically, there's only one white in acrylic painting: titanium white. However, a number of painters have discovered that acrylic gesso—which I'll describe in more detail in the next chapter—also has value as a white paint.

Titanium white: Unless you're a watercolorist, working entirely in transparent color, white is a *must* on your palette. Titanium white is an exceptionally powerful color in mixtures: just a touch of it will go a surprisingly long way toward reducing a vivid color to a tint. Be sure to use it sparingly or you'll discover that all your vivid colors have turned to pastels. However, this is actually a great advantage. As you'll discover when you read further in this book, one of the greatest technical features of acrylic is its capacity to produce a wide range of semi-transparent, semi-opaque, and opaque colors. Much of this flexibility depends upon titanium white. Thus, just a faint touch of titanium white, added to another color, will produce the most magical semi-transparent veil. Just a touch more will yield semi-opaque color which still allows the underlying tone to strike through. It's worthwhile to experiment with titanium white, adding it to various colors in various quantities. You'll learn a lot from seeing how these mixtures vary in transparency or opacity.

Acrylic gesso: Although acrylic gesso is really manufactured for the artist who wants to prepare his own canvas or panels for painting, the gesso may also serve as an excellent white for underpainting. It's not nearly as powerful as titanium white, so you can add it more freely to your colors without overwhelming them and turning them to ghosts. Acrylic gesso also has lots of body, which means that you can add a lot of it to your colors and produce thick, brushable paint; if you added the same quantity of titanium white, you'd have nothing but white! This is important in underpainting, because you want to use a lot

of white to produce delicate tones that have lots of texture. Then, in the final layers—whether semi-transparent or semi-opaque—you can use titanium white, since you now want thinner, more fluid color for glazes and scumbles.

Titanium white, of course, is the indispensable one. Be sure to buy a large tube. If you want to experiment with acrylic gesso, buy a big can of it, since you're going to use it anyhow for the purpose I'm going to describe in chapter 3.

3
Painting Surfaces

Although acrylic has a reputation for sticking to almost anything, the word *almost* is worth remembering. You can use all the usual painting surfaces that you're accustomed to in oil painting, watercolor, tempera, casein, designers' colors, and pastels. This means canvas, panels, paper, illustration board, and various cheaper boards that you may buy at the lumber yard or at the building supplier. However, there are some exceptions . . .

(1) Although acrylic emulsion is a fantastically powerful adhesive, its adhesiveness is threatened by even a slight oil or wax content in any painting surface. The paint may appear to stick at first, but you run the risk of it peeling off at some time in the future. Thus, stay away from commercially prepared canvas—the kind used for oil painting—which is usually coated with white oil paint; the priming contains just enough linseed oil to weaken the bond between acrylic and canvas. For the same reason, stay away from the canvas panels you buy in the art supply store. The same would be true of any wallboard or fiberboard that contains a waxy or oily substance, like tempered Masonite.

(2) Super-smooth surfaces, like polished metal, plastic, or glass, are dangerous too. At first, the acrylic may seem to stick, but it's likely to peel off eventually. Acrylic needs a painting surface with a certain *tooth* or texture to grip the paint. Some artists claim you can paint on a sheet of metal, glass, or plastic, if it's slightly roughened by some sort of abrasive, but I'd stay away from such surfaces altogether.

(3) Because acrylic is a water based medium, I find that it handles best—and sticks best—on a surface that's slightly absorbent. This is another argument against metal, plastic, or glass. Canvas and other fabrics, hardboard and fiberboard, paper and illustration board are all absorbent to some extent. And when they're coated with acrylic gesso or acrylic medium, they're even better. A coat of gesso or medium has microscopic pores that allow moisture to penetrate; this encourages a firm bond between the surface and a fresh coat of wet acrylic paint.

Although mural painting is a specialized, professional trade beyond the scope of this book, I might mention that plaster is one other traditional surface to which acrylic will adhere tenaciously. A coat of clean, dry plaster, free of any oily residue from an old paint film you may have removed, is an ideal painting surface. If you paint directly on the dry plaster, you may find it almost *too* absorbent, although this is worth trying for an effect like fresco. To cut down absorbency somewhat, you can coat the plaster with acrylic medium, which gives you a painting surface more like a panel.

Priming with Acrylic Gesso

If you're accustomed to oil painting, you know that all the authorities warn you against painting directly on raw canvas, on an unprepared panel, or on any other surface that hasn't been sealed with a protective layer of glue size and white paint. There are two reasons for this: first, the oil will ultimately soak into the surface and rot it; second, oil paint tends to become more transparent with the passage of time, and the tone of the raw painting surface will eventually work its way through and darken the painting.

Neither one of these threats is a problem with

acrylic painting. You *can* paint directly on an unprepared surface without fear that the medium will rot the ground; on the contrary, the acrylic emulsion will seal off and preserve the painting surface. Nor is there any evidence that acrylic deteriorates or loses its covering power with age; if anything deteriorates, the ground will go before the paint does.

However, many painters in acrylic still prefer to paint on a surface which has been treated with gesso. The most important reason is that the manufacturers of acrylic paint have developed a gesso which provides an ideal painting surface, on which the medium handles beautifully. The gesso has just enough tooth and absorbency to hold the paint exactly as you put it down, thereby encouraging free, spontaneous brushwork. In contrast, raw canvas is likely to soak up the paint and blur your dynamic brushwork. Almost as important, a luminous white underpainting gives a wonderful glow to the transparent, semi-transparent, and semi-opaque colors which are often the distinctive features of acrylic painting. And even a heavy, opaque passage gains some degree of luminosity from a gesso ground.

Two other important features of acrylic gesso are worth mentioning. First of all, if you apply it thinly, it will conform to the contours of a textured surface like rough canvas or even weathered wood, so you have the dual advantage of a textured painting surface and the luminous gesso. Second, acrylic gesso is surprisingly flexible—in contrast with traditional gesso—and this means that you can use it on a flexible painting surface like canvas or on a rigid sheet of hardboard. The gesso, like the paint, will stick to practically anything that isn't waxy, oily, or glassy smooth.

The gesso of the old masters, if you've ever tried it, is a terrible nuisance to make and apply. It's a brew of animal hide glue (which is inclined to turn rancid) and powdered white pigment, which you must cook up in a double boiler and apply hot. You can use it only on a rigid surface like a wood or Masonite panel, since it's too brittle for a flexible surface like canvas. Even then, it's subject to scratches, chips, and cracks, so you must handle a gesso panel with extreme care and *never* whack it against anything.

So don't confuse traditional glue gesso with the new acrylic gesso, which is vastly more convenient. The new acrylic product is a blend of acrylic medium and white pigments, drying to a tough, flexible film that can take extraordinary punishment. Acrylic gesso comes in a can or a jar, some-times as thick as cream and sometimes more like pancake batter (depending upon the manufacturer), but always ready to use straight from the can, or diluted with water to whatever consistency you like. It won't scratch, chip, or crack, since it's even more flexible than the canvas or paper you prime with it. And acrylic gesso will stand a severe shock if you happen to drop a panel coated with it; the panel will crack or crumble before the gesso does. In a moment, I'll tell you how to apply acrylic gesso to various painting surfaces.

Sizing with Acrylic Medium

There will be times, of course, when you'll want to apply a coat of *something* that makes a painting surface more receptive to acrylic paint, but which doesn't change the color. In this case, it's obviously a mistake to use acrylic gesso, which is designed to turn things white as snow. For example, you may find a sheet of hardboard or fiberboard that's just the right shade of beige or brown to provide the undertone you want. Or you may find a sheet of toned paper that's just the color you need. However, these surfaces may be too rough, too absorbent, or otherwise unresponsive for some reason. The simplest solution will be a coat or two of plain acrylic medium.

You'll find that acrylic medium has many of the same advantages as acrylic gesso. A thin coat will preserve the tooth of the ground without changing the color, since the medium dries absolutely clear. And because acrylic always sticks best to acrylic, you'll find that the treated surface encourages and preserves exciting brushwork. Furthermore, the medium will preserve the ground itself if you're working on some fragile paper or delicate fabric.

You'll have to see whether you like sizing a surface with matt or gloss medium. You may find it annoying to paint on a shiny surface treated with gloss medium, and prefer (as I do) to use matt medium as a size, since this dries practically invisible, with no shine. Or if you like a semi-gloss surface, you can mix the two mediums half-and-half. In a later section, I'll tell you how to size various surfaces with acrylic medium.

Preparing Canvas and Other Fabrics

Canvas is just as good a surface for acrylic painting as it is for oil painting. But as I've explained before, don't buy the prepared canvas used for oil painting,

since the white surface is inclined to be oily and will eventually shed a layer of acrylic paint. Instead, buy raw canvas and prime it with acrylic gesso.

Linen and cotton canvases are equally suitable. There are two big differences. Linen is generally more expensive than cotton and the best linen is often *very* expensive because it comes from abroad. For the painter on a budget, cotton is a blessing. However, the best linen canvas is hand made and has a lively, slightly irregular surface which is more fun to paint on than cotton, which is usually machine made and much more regular looking. The regularity of cotton canvas can be monotonous. However, if your brushwork is lively enough, the regular grain of the cotton canvas will soon disappear beneath the texture of your paint.

Applying acrylic gesso to canvas is very simple—a lot simpler than doing the same job with traditional gesso on a panel, or with the white lead that's normally used to prepare a canvas for oil painting. Just stretch the raw canvas on the usual wooden stretcher bars, using carpet tacks or a staple gun. Make sure the stretched canvas is fairly smooth and taut, though it doesn't have to be absolutely as tight as a drum because the cloth will shrink as the gesso dries.

With the raw canvas stretched, you're ready to apply the gesso. I find that the quickest and cleanest way to do the job is with a putty knife 3" or 4" wide. Just scoop a tablespoonful of thick gesso out of the can—yes, I use an old tablespoon—and puddle it onto the center of the stretched canvas. Working from the center outward, I spread the gesso with the straight edge of the putty knife, pressing the batter-like fluid into the fibers and scraping off any ridges of gesso that might stick up to disturb the pattern of the woven surface. I keep adding more tablespoons of gesso, and spread them outward toward the edges of the stretched canvas until the job is done. Hold the knife with the handle pointing toward you so that the blade is at a 45° angle; it's best to pull the knife toward you with a gentle pressing and scraping motion. If you *push* the blade away from you, you risk nicking the canvas.

When you get out toward the edge of the stretched canvas, slip a cardboard behind it, between the cloth and the wooden stretcher bar. This stiffens the canvas when you work over it with the putty knife. Without the cardboard, you might press the canvas against the inner edge of the stretcher bar and make a ridge in the cloth, which may be there to stay.

When you apply acrylic gesso to canvas with a putty knife, hold the knife at a 45° angle and pull it toward you with slow, steady strokes.

These nylon utility brushes, that I bought in a paint store, are ideal for applying acrylic gesso to canvas or to a panel. You can also use them for painting.

If you're priming a particularly rough sheet of canvas, you may need a couple of coats of gesso. Although rough canvas will absorb more gesso than smooth canvas, don't make the mistake of piling on the gesso thickly. It's still best to press the gesso into the fibers and scrape away any excess that sticks up. Two coats, applied in this way, will preserve the distinctive texture of the canvas, and make it more responsive to paint at the same time. On the contrary, one thickly applied coat will destroy character of the canvas.

If you prefer to apply gesso with a brush, get a big nylon utility brush, 3" or 4" wide, at the paint or hardware store. This stiff but resilient brush will do the job a lot better than a softer brush. If you use the thick gesso straight from a can or jar, scrub the heavy white fluid into the fibers of the canvas and don't leave any gesso sticking up. Working with a brush, you may find it better to dilute the gesso with a bit of water; the diluted primer goes on more easily and settles into the fibers without leaving any ridges of paint protruding from the surface. To dilute acrylic gesso, pour some into an empty ice cream container (I always save them) and then add water gradually, stirring with something like an old ice cream stick (I save these too) until you get the consistency you want. When you apply gesso with a brush, you'll almost certainly need two coats, even with fairly thin, smooth canvas; the brush also takes longer than the putty knife.

Before you apply a second coat, be sure the first coat is thoroughly dry to the touch. The second coat will lock together with the first, forming a continuous film.

Painters often ask if they can use acrylic on raw canvas, because they like the soft tan of the unprimed fabric. Because acrylic paint contains no oils that will rot raw canvas over the years, it *is* possible to work directly on the fabric without any preparation. However, most painters find the raw canvas annoying because its absorbency soaks up the paint and its fuzziness resists fluid brushwork, thus blurring and devitalizing your brushwork. If soft, fuzzy brushwork is what you like, raw canvas may be just what you want. A good compromise is to size raw canvas with one or two coats of acrylic medium diluted with water. The matt medium is better than the gloss if you want to retain the soft look of the raw canvas. Just stretch the canvas on the usual wooden bars, and brush on the diluted medium with that big nylon utility brush. If the stretched canvas is a trifle slack, don't worry; it will shrink tight when the sizing dries. In this way, you'll have what *looks* like raw canvas, with an invisible coating of acrylic medium that makes painting a lot easier.

Oil painters have experimented with other fabrics than canvas—things like burlap, jute, raw silk—but usually return to the traditional fabric because the more exotic materials turn out to be too inconvenient. Burlap and jute are almost always too rough and their texture is impossible to tame. Silk, on the other hand, usually turns out to be too smooth. However, acrylic gesso and medium can adapt almost any fabric for painting purposes. Textiles as rough as burlap or jute can be coated with as many layers of acrylic gesso as you need to smooth them down for painting, yet retain their distinctive texture. You'd probably hesitate to apply three or four coats of white lead, but there's practically no limit to the number of coats of acrylic gesso you can knife on to a surface in order to get what you want. Needless to say, you've got to stop before the texture of the cloth disappears altogether!

When you're dealing with a smooth fabric like silk, the problem is just the opposite. The surface can be obliterated easily by even one coat of primer, ineptly applied. You can, of course, work directly on the silk with acrylic colors, with no preparatory priming or sizing. If you do prefer a treated surface, one or two very thin coats of diluted acrylic medium will remain invisible and preserve the illusion that you're working directly on the silk. If you want to preserve the texture of the silk but not the color, it's usually best to leave the acrylic gesso on the shelf and try a diluted blend of acrylic medium and titanium white tube color. In the preceding chapter, I talked about the extraordinary tinting power of this white. This means that you can get a lot of coverage without building up any thickness. With white tube color, medium, and water, you can mix a thin but opaque primer that will seal off and whiten the silk in one or two slender coats. The color will change, but the surface will remain almost intact.

Thick fabrics like burlap or jute should be stretched like canvas. Thinner fabrics like silk can also be stretched, but should be handled with extreme care to avoid tearing or puncturing. Actually, thin fabrics always remain fragile and I think it's best to mount them on some rigid material like Masonite, following the procedure I'll describe later in this chapter, when I talk about mounting paper. The sequence is to glue the fabric onto the Masonite first with pure acrylic medium, then apply your sizing or priming when the fabric has been stuck down.

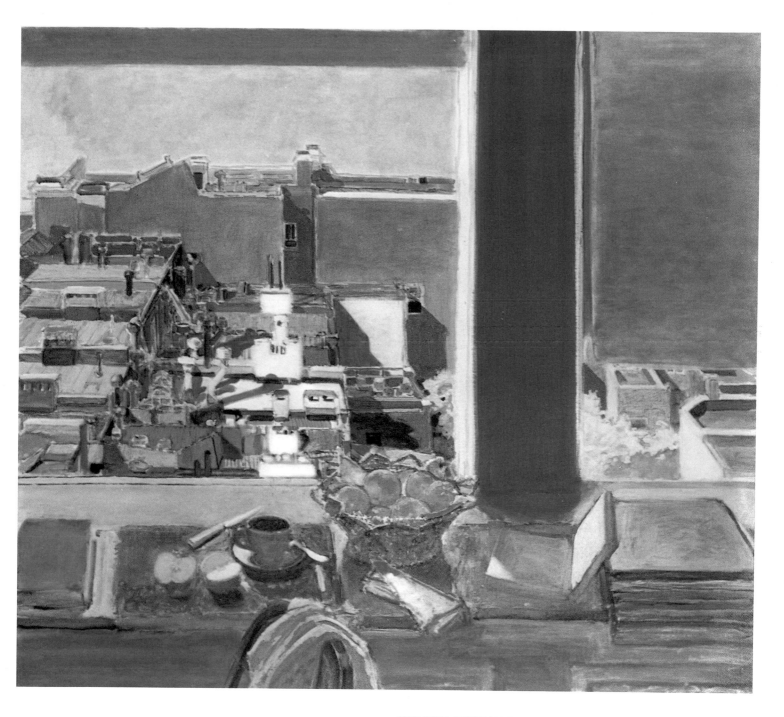

SEMITRANSPARENT COLOR

View from the Studio *by Morton Kaish, acrylic on canvas, 45" x 50", Flagg Family Collection, Monterey, California. The rich color and inner glow of acrylic are exemplified in this lush combination of still life and architecture. Many painters feel that acrylic is a transparent medium, because, unless it's applied with a distinct impasto, the color always seems to transmit a certain amount of light from within. Working with brilliant primaries, Kaish scrubs on his color in thin veils, leaving behind a vibrating, semitransparent surface. The paint is never smoothed out—never blended, as it might be in oil painting—but allowed to retain the casual, seemingly accidental character of the brushwork. (Courtesy Staempfli Gallery, New York)*

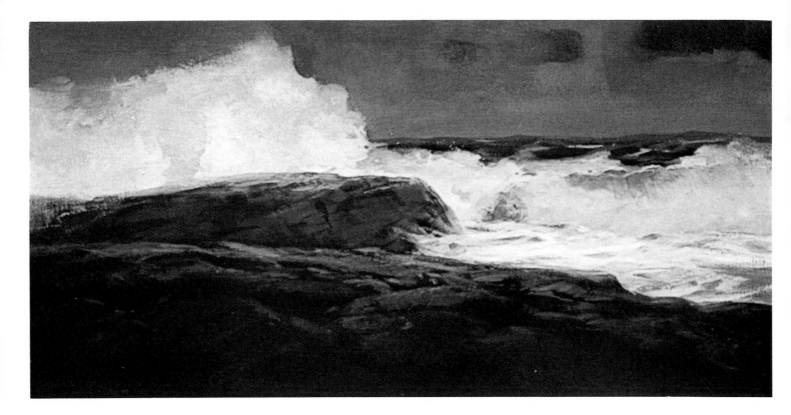

OPAQUE AND TRANSPARENT COLOR

Rising Storm *by Paul Strisik, A.W.S., acrylic on Masonite, 16" x 30", collection Francis A. Cook. Acrylic lends itself equally well to saturated color and to muted color, as we see here. At first glance, this moody seascape might be an oil painting, but notice the scumbled—rather than blended—brushwork in the mass of foam to the left; this type of brushwork is characteristic of acrylic. So are the drybrush effects that render the texture of the rocks so powerfully. The artist has also taken advantage of his control over the opacity and transparency of his medium. The brilliant transparency of the green water and the breaking wave contrasts with the thick, crusty, opaque paint quality of the foam.*

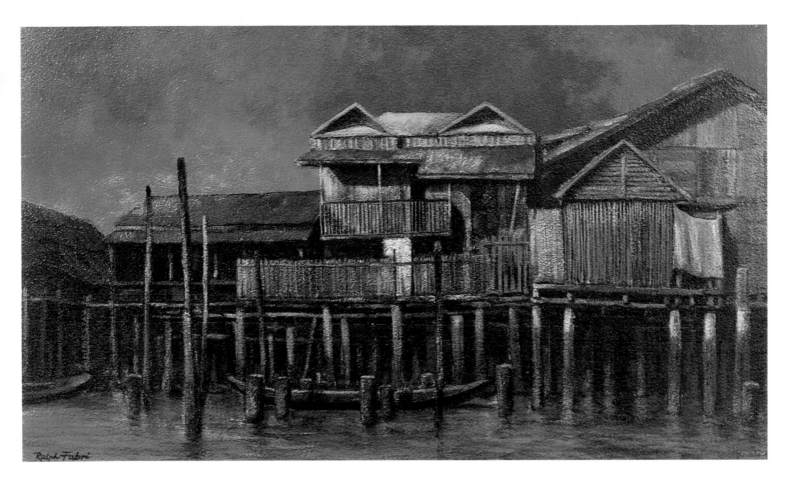

OPAQUE COLOR

Houses of Bangkok *by Ralph Fabri, N.A., A.W.S., acrylic on panel, 19" x 32", collection Donald Holden, Irvington-on-Hudson, New York. The artist has used the granular texture of the surface of a multi-media board to blend his brushstrokes—much as the texture of a canvas can be used to soften brushwork—and to help him interpret the texture of the weathered houses along the shore. The walls, railings, and pilings are rendered with a rich tapestry of drybrush strokes. The handling of the sky demonstrates that acrylic can be blended, particularly if the tube color is diluted with gloss or matt medium, which makes it handle more like oil paint. An even thicker consistency for blending would be a mixture of tube color and gel medium. (Photograph by Geoffrey Clements)*

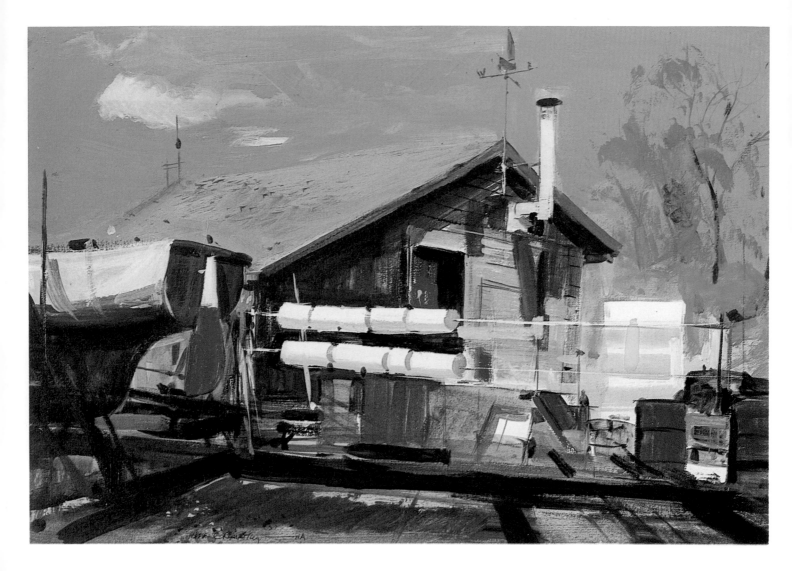

THICK AND THIN COLOR

Little Shipyard *by Hardie Gramatky, N.A., A.W.S., acrylic on gesso board, 14½" x 21". Contrast the fluid, heavily diluted color in the immediate foreground with the thicker color—perhaps used straight from the tube—on the lighted side of the boat to the left. The clouds in the blue sky, freely scrubbed in, range from a thick white passage (where the clouds are lightest) to a pale, washy scumble of highly diluted, semitransparent tone. Much of the fascination of this lively picture stems from the constant shifting from transparent, diluted color to more opaque color.*

FLUID COLOR

Tide Passage *by Edward Betts, N.A., A.W.S., acrylic on Masonite, 60" x 40". The brushing consistency of acrylic can be carefully controlled by the way in which the paint is diluted. For a splash of liquid color like the blast of foam at the center of this dynamic picture, the best diluent would be pure water or a combination of water and medium. For the rocks in the foreground, a slightly thicker paint consistency could be developed by diluting the tube color with pure matt or gloss medium, perhaps slightly diluted. Acrylic medium also served for the hint of collage in the rocks. (Courtesy Midtown Galleries, New York)*

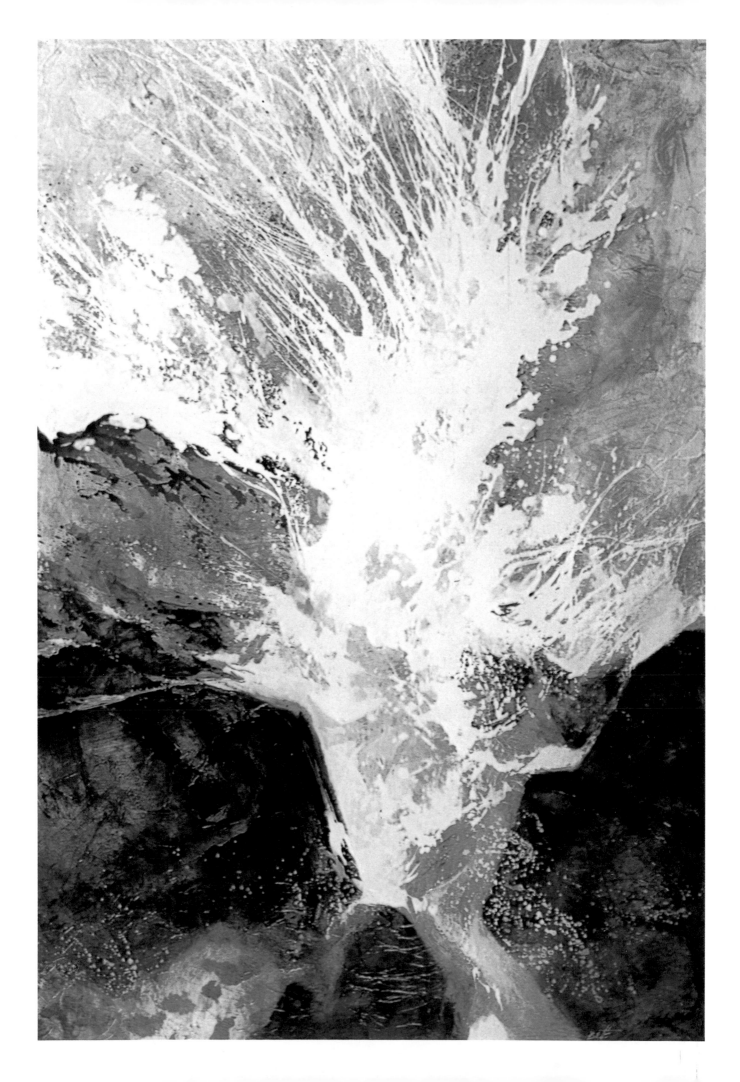

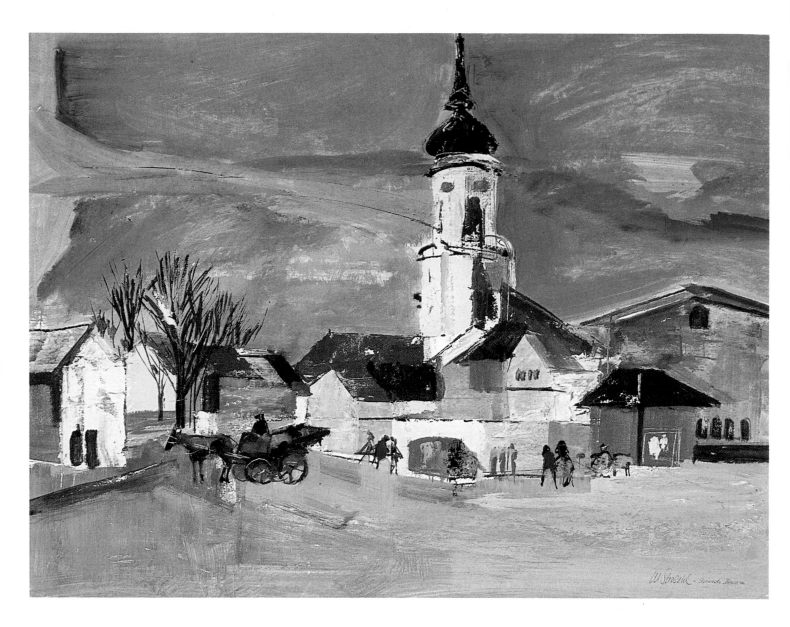

RETAINING THE BRUSHSTROKE

Garmisch by William Strosahl, A.W.S., acrylic on gesso coated watercolor board, 22" x 28". The artist has purposely avoided fluid color, exploiting the rough, broken strokes of a brush that carries color that's not diluted to the consistency of a transparent watercolor wash. Actually, the color is brushed out rather thinly, rarely piling up to a distinct impasto, but the quick-drying acrylic retains the exact texture of the stroke.

ROUGH BRUSHWORK

Two Old Women by Sergei Bongart, A.W.S., acrylic on Masonite, 36" x 48". The colors are scrubbed into one another freely, with a minimum of blending, sometimes wet-into-wet, sometimes after the undertone is dry. Note how long, spontaneous strokes are brushed into and over one another in the arms of the seated woman, suggesting tonal gradations which are blended by the eye of the viewer. A similar effect occurs in the very rough brushwork of her hair.

TEMPERA TECHNIQUE

The Cupboard by Donald M. Hedin, A.W.S., acrylic on Masonite, 18" x 16¼", collection Mr. and Mrs. Bruce Payne. This magical trompe l'oeil still life is executed in the very demanding acrylic tempera technique. Look closely at the wooden masher in the upper right and you'll see the network of tiny strokes which form the basis of this technique. Traditionally, an acrylic tempera—like an egg tempera—is executed in very thin color, diluted either with water or with a very fluid combination of water and medium. The finished picture has no texture of its own—that is, the paint has no texture—but, paradoxically, this technique is ideal for rendering the illusion of a great variety of textures.

DRYBRUSH AND BROKEN COLOR

Granite Mountains by Charles Coiner, acrylic on Masonite, 25" x 34". Primed with acrylic gesso, Masonite is an ideal surface for acrylic painting. When applied a bit thickly—as it is here—the gesso retains a slight texture which lends itself beautifully to the drybrush technique used in the water and in the mountains. Notice how flatly the paint is applied; gradations are suggested by drybrushing one color over another, as in the foreground, to develop an effect of broken color that suggests recession into space. (Courtesy Midtown Galleries, New York)

TEXTURED PAINTING SURFACE

Bleak Coast *by Paul Strisik, A.W.S., acrylic on Masonite, 24" x 36", collection David W. Conklin. Applied thickly enough so that the brushstrokes remain visible when dry, acrylic gesso can provide a preplanned texture that enlivens the painter's brushwork. Look closely at the sunlit area where the sea seemes to merge with the sky. Here, the texture of the gesso is apparent; it aids Strisik in blending one tone into another. The textured gesso functions in the same way for the rock formation in the foreground, where the artist needs a slightly irregular surface to grip the brush and roughen the stroke. However, these effects can only be achieved when the paint is fairly thick; because the sky is painted more fluidly, and the texture of the painting surface disappears.*

TRANSPARENT WATERCOLOR TECHNIQUE

Amish Farm *by John Rogers, A.W.S., acrylic on watercolor paper, 22" x 28". For the transparent (or acrylic watercolor) technique, a rough or cold pressed, handmade watercolor paper provides a surface that responds beautifully to the sable and oxhair brushes of the watercolorist. Painting in the transparent technique requires precise control over flat washes like those on the shadow side of the building, graded washes like those on the tree trunks, as well as wet-in-wet and drybrush effects like those on the foreground foliage and the distant trees in the upper left. Because the color is highly diluted and applied in transparent veils, the bright white paper shines through, even in the darkest tones.*

SPONTANEOUS BRUSHWORK

The House on the Marsh *by John C. Pellew, N.A., A.W.S., acrylic on gesso panel, 9" x 12". The short, broken strokes of this spontaneous color sketch—reminiscent of the flavor of Constable's oil sketches—are the result of bristle brushes or perhaps short, flat sables like those used in oil painting. The texture of the painting has enormous vitality because one color has been quickly scrubbed over and into another. This requires stiff brushes and it's often best to use bristles which are a bit worn, rather than the neat, rectangular bristles of new brushes. The canvas-like texture of the board also lends charm to the surface; this is particularly apparent where the color of the board breaks through along the lower edge of the painting.*

SPONTANEOUS BLENDING

Distance *by Lawrence C. Goldsmith, A.W.S., acrylic on canvas, 30" x 40". In this semiabstract interpretation of sea and shore, the brushwork is softened by the weave of the canvas, which aids the artist in blending one stroke into another. The strokes are never blended thoroughly, but the soft "give" of the canvas encourages a spontaneous, partial blend when one color is laid over another, either wet or dry. Observe how one free stroke seems to melt into another, particularly in the warm passage to the right.*

SCUMBLING TECHNIQUE

Nassau Front Street *by William Strosahl, A.W.S., acrylic on watercolor board, 22" x 28". The dark blue sky behind the boat is a good example of a light-into-dark scumble; the colors aren't quite blended together which lends a lively, spontaneous feeling to the brushwork. The sails are executed by long, curving, slashing strokes of semi-opaque color; the white allows a darker, underlying tone to peek through. The colorful pattern of the boxes and their contents (in the foreground) is painted quite flatly, one color dabbed over another to create an intricate tapestry of strokes. Observe the vignette effect: the painting appears to fade out in the lower right hand and left hand corners.*

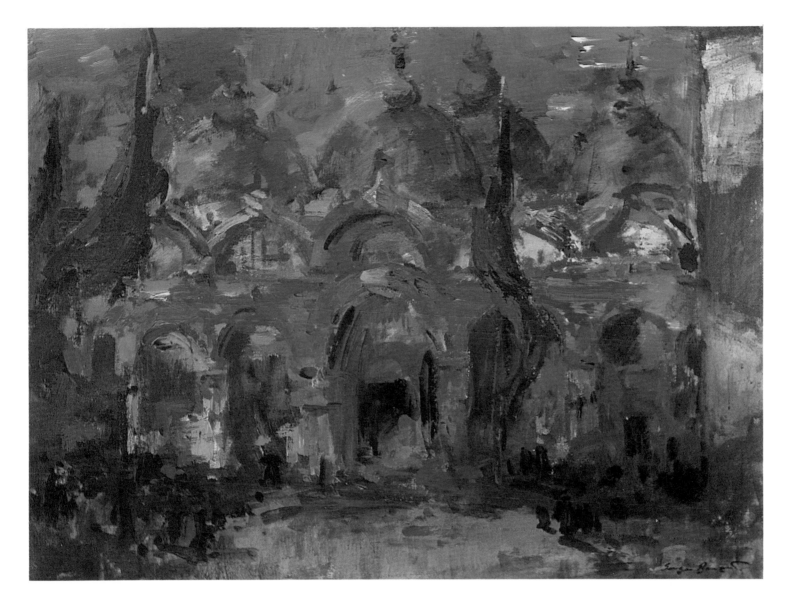

WET-IN-WET BRUSHWORK

Cathedral San Marco *by Sergei Bongart, A.W.S., acrylic on gesso coated Masonite, 36" x 48". The cathedral emerges from a storm of short, thick, rapid strokes. The entire painting has a marvelous flickering quality, like a shattered mosaic in which all the tiles are slightly askew, but which succeed in adding up to a distinct and recognizable subject. Bongart's painting is a fascinating example of a technique in which each stroke retains its identity, never completely blending into the other colors, even when applied wet-into-wet. The brush makes a mark, and it is never quite obliterated by the next mark that may go over it or beside it.*

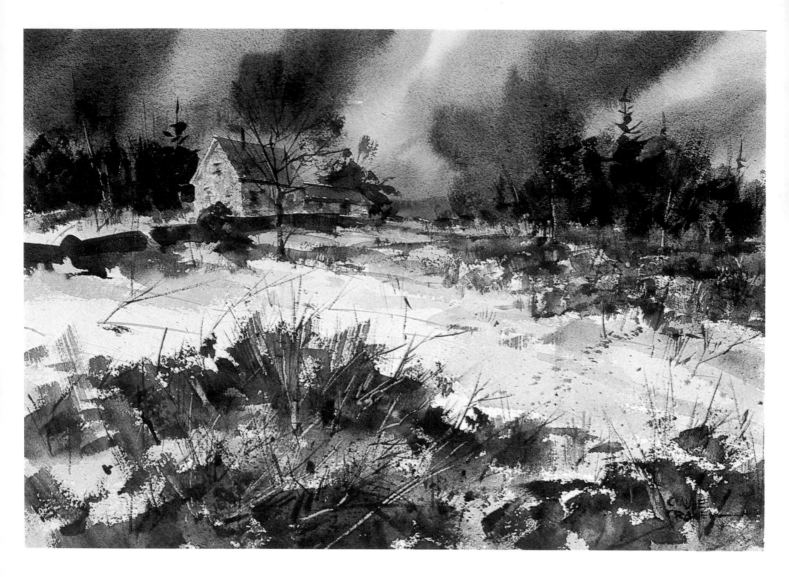

SCRATCHING INTO WET AND DRY COLOR

December Snow *by Claude Croney, A.W.S., acrylic on water-color paper, 14" x 20". The soft strokes of sable watercolor brushes are evident here, particularly in the foreground, where the squarish strokes suggest flat sables. But these are not the only tools used. White lines, like those scratched out in the foreground, can be scored into a wet wash with a pointed (but not sharp) instrument like a brush handle, a clay modeling tool, or even a chopstick! Or, once the color is dry, these white lines can be scratched away by a sharp instrument like a razor blade or a knife.*

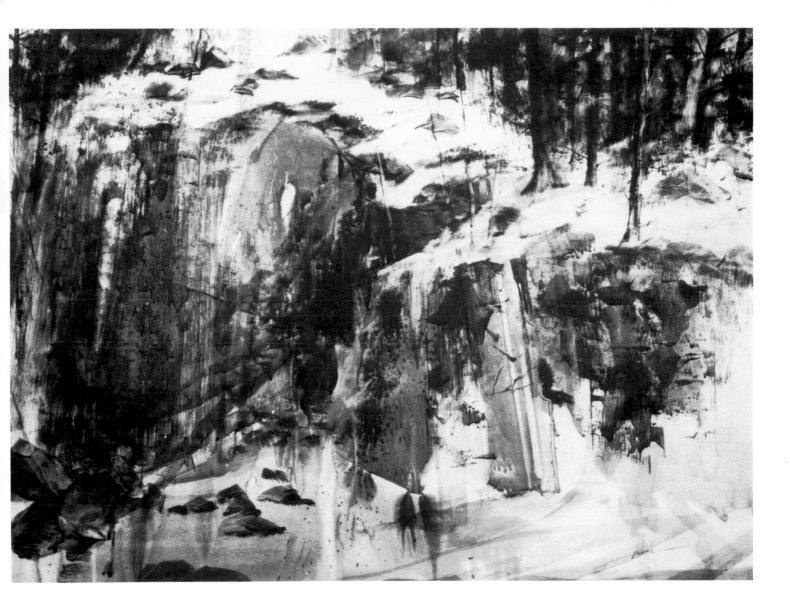

Snow Ledge *by Larry Webster, A.W.S., acrylic on hot pressed paper, 30" x 40" This National Academy prize-winning painting was created with thin washes of acrylic watercolor on the smooth, almost polished surface of Strathmore hot pressed board. The liquid color doesn't sink into the valleys of the paper, as it would if the artist were painting on rough or cold pressed watercolor paper. As the brush rides along the surface, it leaves behind clearly defined strokes. The pattern of these strokes varies from the jagged trails on the left to the smooth, delicate streaks on the lower right. Hot pressed paper or board is not a desirable working surface for the beginning painter, as this is a particularly demanding technique. However, the experienced hands of this artist achieved vivid results.*

Preparing Paper and Illustration Board

You can paint with acrylics on any good, sturdy paper or illustration board that you might use for watercolor, casein, or any other water based medium. If you're experienced in watercolor, you know that thin papers are inclined to swell and buckle when they get wet. This is equally true when you apply fluid acrylic paint to thin paper; so the heavier and stiffer the paper, the better. Illustration board, of course, has its stiffness built in, since a sheet of sturdy white paper comes to you mounted on cardboard.

Watercolor papers come in a variety of weights. The thinnest you're likely to use is 72 lb., and the weights move upward from there to 140 lb., 200 lb., 300 lb., and 400 lb. The last two are heavy enough to hold their shape and lie flat with the aid of thumbtacks or tape. But the two lighter weights curl when water soaks into them. For this reason, the lighter weights need stretching or mounting. Here are some ways to do the job.

(1) Get yourself a wooden stretcher frame (the kind used for oil painting) a couple of inches smaller all the way around than the sheet of watercolor paper you want to stretch. Then soak your sheet in the tub until the paper is really soft and sopping wet. Place the sheet on a smooth, clean surface and carefully locate the stretcher frame on top of the sheet, allowing an inch of paper to protrude all around. Fold the paper border up against the edge of the frame on all four sides; then fix the paper to the four edges with staples or carpet tacks. You can use thumbtacks too, though I find that carpet tacks hammer in more easily. Turn the stretched paper—which looks like a stretched canvas—face up and allow it to dry. It should shrink smooth and tight as a drum. It may soften and buckle a bit when you paint, but it will go right back to its flat shape when it dries.

(2) You can also stretch paper on a sheet of wallboard or fiberboard, like Homasote, Celotex, or Upson board. In this case, the board should be a couple of inches *bigger* on all sides than the paper. Soak the sheet in the tub once again and then place the wet sheet flat on the board, allowing at least a 1" boarder (preferably more) on all sides. Now tape down all four edges of the sheet with brown wrapping tape, the kind you use for packages. The tape should be a couple of inches wide so an inch overlaps the paper, and the other inch overlaps the board. Be sure that the glue on the tape is water soluble, not the pressure sensitive kind used on Scotch tape, which won't stick to wet paper. The watercolor paper will shrink smooth when it dries, and will return to its shape even if it curls slightly when you paint. When you work on stretched paper, bear in mind that you're going to lose an inch on all sides when you remove the paper from the frame or the board with a razor blade.

(3) You can also *mount* a sheet of thin paper, which means gluing it down to a board. The best cheap mounting board is the stiff, gray chipboard which you can buy in huge sheets at the art supply store. Cut the board about ½" larger all around than the sheet of watercolor paper you want to mount. In addition to the board, get yourself an inexpensive sheet of drawing paper that's about the same weight as the watercolor paper. Soak both sheets of paper and glue them down to the two faces of the board. The best adhesive is acrylic medium, which you apply to the wet paper with a big nylon utility brush, being careful not to get any medium on the unglued side of the sheet. Normally, the medium dries fast, but the wetness of the paper will retard drying long enough for you to cover the sheet and paste it down. When you've got the sheet down on the board, rub gently from the center out toward the edges to get rid of ripples and bubbles. The two sheets, drying and shrinking on either side of the board, will counteract each other's "pull" and will eliminate any danger of the board curling.

So much for watercolor papers, which are made for such treatment. But what about those beautiful, colored pastel papers? These are almost certain to be too thin for painting, and *must* be mounted on boards as I've described above. You may also find their surfaces unresponsive to the brush, since they're made for chalks rather than for liquid paint. This is even more likely to be true of all sorts of exotic drawing papers that have lovely textures, but which tend to be too absorbent or too hairy for painting. A simple solution is to size these papers with matt acrylic medium after mounting. In this way, almost every attractive looking surface—no matter how unresponsive to the brush—can be conditioned to receive acrylic paint. Thin the medium half-and-half with water so the size sinks into the fibers, rather than forming a coating. Brush the size on with a soft hair brush if you think the nylon utility brush is too rough for the delicate surface.

Many painters claim that a coat of acrylic medium will turn even an impermanent paper into a durable

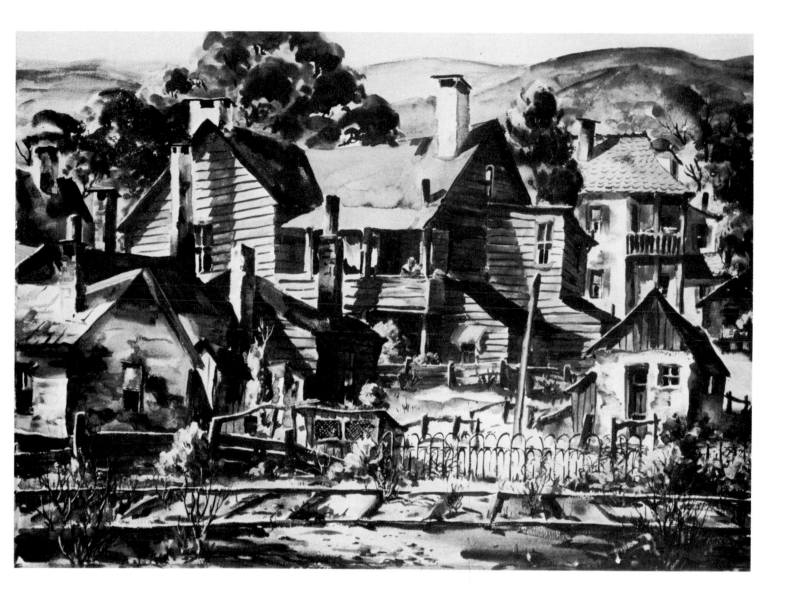

Down by the Tracks *by Henry Gasser, N.A., A.W.S., acrylic on mounted watercolor paper, 22" x 30". When acrylic is used in a traditional watercolor technique on the textured surface of rough or cold pressed paper, it retains the spontaneity of traditional, transparent watercolor. However, a major difference between the new medium and the old is that a wash of acrylic dries insoluble; wash after wash of acrylic watercolor can be applied in rapid sequence without any danger of the underlying color dissolving and turning the fresh color to mud. This property of acrylic paint is important in a complicated composition like this architectural study which requires an elaborate buildup of washes, strokes, and textures.*

painting surface. Theoretically, you shouldn't paint on those beautiful papers designed for commercial printing—with their marvelous variety of colors and textures—since these are made from perishable wood pulp, rather than from rag fibers. But properly mounted and coated with acrylic medium (so they're sealed and protected from both sides) these papers are said to survive the years. If you want to try this, go ahead. However, I make no guarantees. One thing to bear in mind is that even if a coat of acrylic medium does protect the fibers from *crumbling,* the medium can't protect the color of the paper from *fading.* If the dye used by the manufacturer isn't lightproof—and it often isn't—the paper will eventually bleach out.

So if you discover some commercial printing paper that you can't resist, try a simple test to determine the sheet's resistance to light. Cut a strip of paper about the size of a bookmark and slide half the strip into some book you won't be reading for a while. Put a rubber band around the book so that it stays tightly shut and then put the book on a windowsill that gets lots of direct sunshine. Half the test strip will protrude from the book, and will begin to lose its color in a few weeks if it can't take the sun. When you flip open the book and compare the two halves of the test strip, you'll know. Obviously, it's pointless to paint on a colored paper if the dye is doomed to fade and destroy your color effect.

Illustration board needs no preparation, since any good brand of board is stiff enough to resist warping. However, many painters prefer to give illustration board a coat of acrylic gesso to make the surface even more responsive to painting. If you'd like to try gesso on illustration board, thin the creamy white fluid with some water so it's more like the consistency of milk. Then apply two thin coats to *each side* of the board. This so-called counter priming will eliminate any possibility that the board might warp slightly as the gesso dries. The two coats on each side should be applied at right angles to one another; that is, the first coat should go from side to side and the second coat should go from top to bottom. This will minimize the slight streakiness that you sometimes get in a gesso ground. The faint crisscross of the two coats provides a canvas-like texture to paint on.

Preparing Panels

The old masters often painted on wood panels instead of canvas, but the development of various hardboards, like Masonite, has really made wood obsolete. Wood panels are subject to rot, warping, worm damage, and all sorts of threats from moisture and temperature changes. Masonite and its various competitors eliminate most of these problems. Since such hardboards are available from practically every lumber yard and building supplier, I'm going to assume that this is the material you'll use if you want to paint on panels.

You may recall my mentioning that acrylic won't stick securely to any surface that contains wax or oil. It's important to bear this in mind when you buy Masonite, which comes in tempered and untempered varieties. The tempered kind is tougher, apparently because it contains some waxy or oily substance that hardens the surface and makes it more resistant to wear and weather. However, it's best to avoid tempered Masonite for just this reason. The untempered board, on the other hand, is absolutely free of any wax or oil content that might threaten the adhesion of acrylic paint. So be sure to use the untempered kind.

Masonite normally comes in two weights which are useful to the painter. Sheets that are 1/8" thick are suitable for panels no more than 24" long; this isn't very thick and larger panels are likely to curve. For the larger panels, 24" and more, use Masonite that's 1/4" thick.

If you've ever seen the back of a panel painting in a museum, you've noticed that it's been cradled. That is, the museum conservation department has carefully glued strips of wood to the back of the panel to make it absolutely rigid. When the professional conservator designs a cradle, it's a very elaborate crisscross affair, which you don't really need. But I do recommend a very simple cradle for the modern Masonite panel. A panel less than 24" long won't need a cradle to stiffen it; but once you get to a bigger size, even if you switch to the 1/4" thickness, I think a cradle is advisable.

The simplest, most efficient cradle for a picture up to 3' long—let's say a panel 24" x 36"—would consist of four strips of wood glued to the back of the Masonite, flush with the four edges. A one-by-two is thick enough. Use a mitre box and saw to cut the ends of the boards at 45° angles so the strips fit together neatly at the corners. Elmer's or some other white glue is best for sticking the strips to the panel back. Use clamps to hold the strips tight against the Masonite until the glue dries. One tip that's worth remembering: clamps are likely to dig into the relatively soft surface of the Masonite, so put a scrap

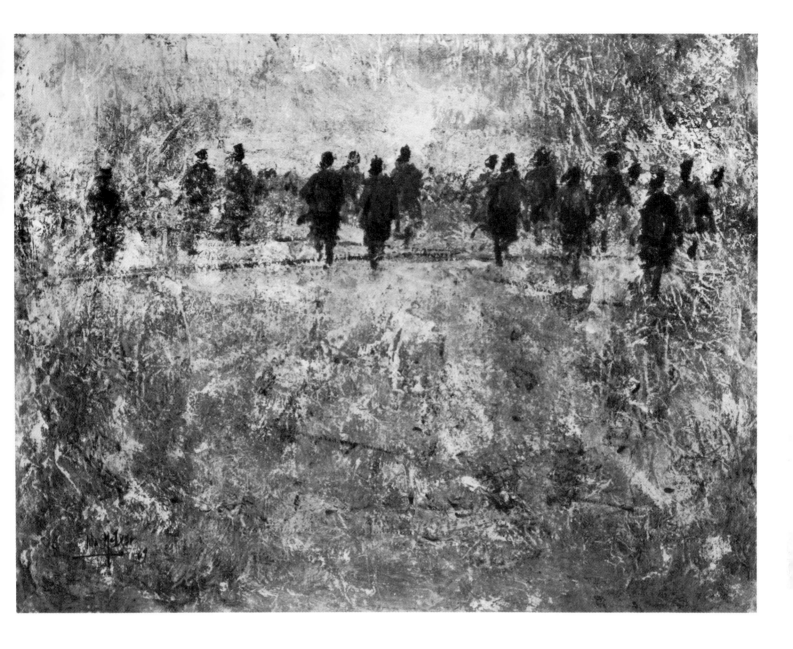

Pedestrians *by John McIver, A.W.S., acrylic on Haruki Japanese paper, 20'' x 36''. The fascinating, random texture of the fibers in this rough Japanese paper contribute an exciting atmospheric effect to this study of figures on a city street. Dark and light drybrush strokes accumulate on the ridges of the paper so that the figures seem to emerge from a haze of paint. Oriental papers like this one come in a remarkable variety of textures and are worth exploring for unexpected effects. Although this painting is handled almost entirely in opaque color, many Oriental papers are equally suitable for transparent effects. However, you must bear in mind that such papers are generally more absorbent than European papers.*

of cardboard between the clamp and the painting surface to prevent the clamp from leaving a dent.

On a really big panel, strips along the edges may not be enough. You may want to add a crossbar midway across the back of the Masonite. Once again, a one-by-two is thick enough. Use white glue. Clamps will probably reach the ends of the crossbar, but not the middle, so use weights of some sort, like a few bricks or heavy books.

Masonite, like plywood and other wallboards, is usually sold in big sheets, 4' x 8'. If the lumber yard or building supplier has smaller leftovers, he's usually happy to sell them to you. However, he may have only the big sheets. On the chance that you may have to buy a big sheet (which isn't all that expensive), go to the lumber yard with a clear idea of how you'd like the sheet cut up—the exact sizes you'd like out of the 4' x 8'—and have the yard cut up the sheet on machinery specially designed for that purpose. Unless you've got a really good woodshop of your own, the yard will give you much cleaner, more precise cuts than you could possibly get with a handsaw.

Now, with the Masonite cut to size—and cradled, if necessary—you're ready to prepare the painting surface. The more familiar kind of Masonite comes with a smooth side and a rough side. Since most painters find the smooth side just a bit *too* smooth for painting, they roughen it slightly with sandpaper. The rough side is not only too rough for most painting purposes, but has a mechanical surface that looks like it was pressed against a wire screen of some sort. Even when heavily treated with gesso, the rough side is monotonous to paint on and monotonous to look at. So most artists work on the smooth side, and it's this side that I recommend. However, you may be lucky enough to find a lumber yard that stocks hardboard that has one very smooth side and one side that has just a faintly irregular, fibrous surface, which is just as suitable for painting as the smooth side. In this case, you can use either side, whichever you like best. Naturally, if you're cradling the panel, glue the cradle to the side of the panel you like least.

Masonite and other hardboards vary in color from deep brown to a lovely honey-tan. You may like one of those colors so well that you don't want to cover it with gesso, but work directly on the brown surface. You *can* work directly on the raw hardboard, but I'd recommend one or two thin coats of size, which means matt or gloss acrylic medium slightly thinned with water. This will preserve the color, not smooth out the surface too much, and make the board more receptive to the brush.

The traditional surface for panel paintings is gesso. It's very easy to apply acrylic gesso to a Masonite panel. Use that big nylon utility brush—not a putty knife—and decide in advance whether you want the strokes of the brush to show in the gesso surface. If you want the strokes to show prominently, use the thick gesso straight from the can. It's best to apply two coats—one from side to side, then a second coat from top to bottom—which leaves an attractive, canvas-like, crisscross texture. This is less monotonous and less obtrusive, somehow, than a single coat with the brush marks running horizontally or vertically. If you want a smoother surface, add water to the gesso until it becomes the consistency of light cream or milk. Working with diluted gesso, you'll need at least two coats—one vertical, one horizontal—and perhaps more, depending upon how much water you add. The thinner the gesso, the more coats you'll need, but the fewer brush marks will show in the surface. Unlike traditional animal glue gesso, acrylic gesso can't be sanded smooth, so don't expect to apply it roughly and then smooth it down later on. Decide from the very beginning what surface you want.

Another way to surface a panel is with a sheet of canvas or some other fabric whose texture you like. I don't think I'd try this on a panel much bigger than 3' long—the job becomes cumbersome—but it's easy enough to do on small or medium size panels. Use 1/4" hardboard for this purpose; the 1/8" variety is too thin and is more likely to curl. Before gluing down the fabric, be sure to cradle any panel that's larger than 16" x 20". Since the fabric will be applied wet—as I'll explain in a moment—it's going to shrink when it dries, and the board must be as stiff as possible to resist curling.

If you're planning to glue fabric to small, uncradled panels, begin by cutting a piece of fabric that's at least 2" larger than the board on all sides. Soak the cloth in the tub until the fibers are so wet that they're positively soggy. Then place the fabric on a smooth, nonabsorbent surface—like a plastic tabletop, a sheet of glass, or just a sheet of plastic—and brush a coat of matt acrylic medium or diluted white glue onto one side of the wet fabric. Place the board, smooth side down, on the glue coated fabric so that the margins of excess fabric are equal all the way around. Press down hard so the board really sticks.

Now you have two choices. My own preference is

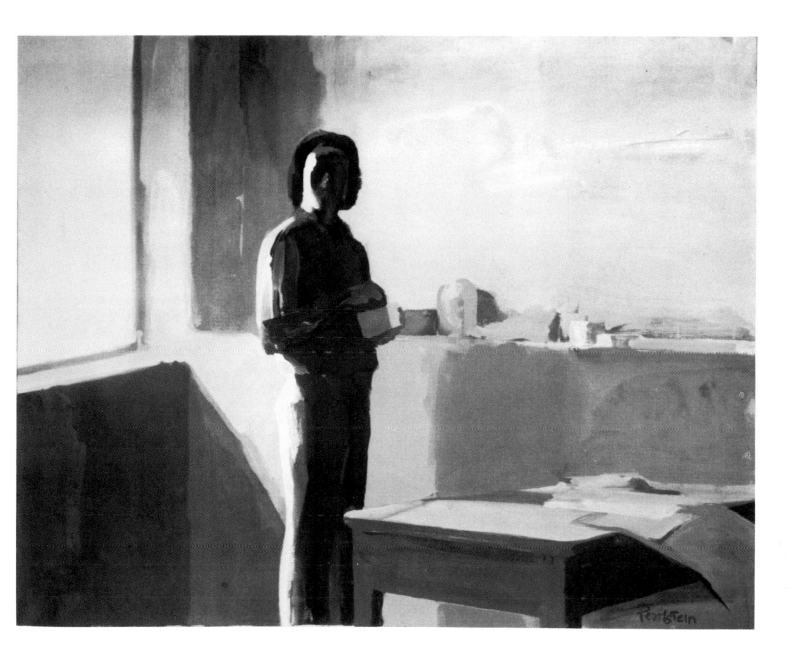

Albert *by Seymour Pearlstein, acrylic on canvas, 40" x 50"*
Canvas, the traditional surface for the oil painter, is equally
suitable for acrylic painting. The flexibility of the stretched
linen or cotton has a delightful "give" and gently softens a
painter's brushstrokes, responding to the brush like a living
thing. This artist paints with broad, flat sweeps of his brush
which might look harsh on the smooth, rigid surface of a
panel, but his strokes gain a certain subtlety by being ap-
plied to fabric. The irregularity of the canvas' texture also
blends well with the calculated casualness of the artist's
brushwork. (Photograph by Peter A. Juley & Son)

to fold the excess fabric down onto the back of the panel, rubbing the glue covered cloth down so it sticks. I then flip the panel over, face up, and leave it to dry. As it dries, the fabric shrinks and the overlapping strips, pasted to the back, seem to equalize the "pull" and prevent the board from curling. The other method is *not* to fold down the excess fabric, but to flip the panel over so that the excess fabric is simply hanging loose off the edges. When the glue dries, you simply trim off the excess fabric. In this case, the extra cloth simply serves as a "shrinkage allowance." If you cut the fabric to the exact size of the board in the very beginning, the dried, shrunken fabric may actually end up *smaller* than the board. Having more fabric than board is insurance against this happening. I think there may be more danger of warping when you use this method, but I've made panels successfully both ways.

When you're mounting fabric on a larger, cradled panel, the system is essentially the same. Cut the fabric to a size that's at least 3" larger than the panel on all sides. Soak the cloth, place it on a nonabsorbent surface, coat the cloth with matt acrylic medium or white glue, and place the panel face down on the wet, glue covered surface. Fold the excess fabric up against the edges of the cradle, rub, and pull the cloth taut from all sides, just as you do when you stretch canvas on its wooden stretcher frame. A certain amount of cloth will still be hanging loose beyond the edges of the cradle, but don't cut this material off until the panel dries. Now flip over the fabric coated panel and leave it face up to dry. The fabric should stick not only to the face of the panel, but to the sides of the cradle, very much the way canvas covers the face and sides of a wooden stretcher frame. When the whole production is dry, trim off the excess fabric.

Here are a few tips about mounting fabric on hardboard. First of all, be sure to rub down every inch of the wet fabric after it's stuck to the board and the cradle; this is important because you want to be sure that there are no bubbles, puckers, or loose spots. It's messy, but I do this with the palm of my hand and my fingers so I can really *feel* any loose spots where the fabric hasn't really stuck. The glue is inclined to penetrate from the back of the cloth to the front, which means that your hand may be covered with glue—but this is easy enough to wash off with water. This rubdown actually *encourages* the glue to penetrate to the face of the fabric; thus, the glue becomes a kind of size, which seals and

toughens the fabric, as well as making it more receptive to paint.

Second, always be sure to pull the cloth taut while it's still face down, with the panel on top. Actually run your hands along the edges of the cloth, pulling it taut inch by inch. This will eliminate most wrinkles. When you flip the panel over with the cloth sticking to the face, the rubdown described above will then eliminate any minor flaws in adhesion.

Third, you may be wondering what to rest the panel on while the glue is drying. After all, there may be excess cloth hanging off the panel and the whole thing may be pretty sticky. My own method is to keep a bunch of old shoeboxes in the studio. When a panel is drying, I put a couple of boxes on the floor and place the panel (fabric side up) on top of them so that any excess fabric hangs free while the panel dries. I suppose old books will do too. Whatever you do, don't lean the drying panel against the wall diagonally, which may lead to curling unless the panel is very solidly cradled.

The fourth and most important tip is really a kind of disclaimer. There's no way of guaranteeing which of these methods will work. Fabrics all behave differently and unpredictably. Some shrink more than others, some swell more than others, some pull harder when they shrink, and *all* of them need to be tested. Before you invest the labor in making a big bunch of fabric coated panels, test out your cloth by making a few small ones, perhaps by different methods. Above all, watch the rate of shrinkage and see how hard the fabric pulls when it dries. Some shrink so tight that they may curl even a small, stiff panel unless it's cradled. You can try making panels with all sorts of fabrics—linen and cotton canvas, burlap, jute, muslin, silk, etc.—but you've got to test them out and see how they behave.

Having glued the fabric to the panel, your final decision is whether or not to apply gesso. If you like the color of the untreated fabric, try painting directly on the color of the cloth. The glue may have penetrated from the back sufficiently to size the cloth and make it receptive to the brush. If not, you can easily add another coat of acrylic medium, slightly thinned with water. If you prefer the white gesso surface, apply the gesso directly from the can with a putty knife—being careful to press the paint into the fibers and scrape away any excess—or use that big nylon utility brush with diluted gesso. You now have an ideal compromise surface, which combines the texture of canvas with the toughness and rigidity of a panel.

Preparing Textured Surfaces

I've said that acrylic gesso makes it possible for you to paint on almost any interesting surface, from hairy burlap to weathered wood. However, you may also want to prepare textured surfaces of your own. Here are some suggestions.

(1) Granular painting surfaces—like sandpaper, let's say—are often intriguing to paint on. A simple way to prepare a sandy surface is to coat the smooth side of a sheet of hardboard with acrylic medium (matt or gloss) and sprinkle sand onto the surface before the medium dries. Here's how you do it. Coat about a square foot of the surface with medium straight from the bottle. Then dump a thick layer of fine grained sand (you can buy it from your building supplier) onto the wet medium. Not all the sand will stick, of course, but only those grains in direct contact with the adhesive. So tip the panel and dump the excess sand into a nearby bucket; then tap the back of the panel, and then the next, until the entire surface is sanded. Don't try coating the entire surface of a big panel with medium, and then race to cover it with sand; the medium dries too fast and you may botch the job. If the sand sticks unevenly to some parts, you can apply another coat of medium and try again. When the sandy surface is dry, it's best to coat it with gesso, since the sand isn't especially receptive paint.

(2) If you don't want to paint on a canvas coated panel, but you'd like to paint on a texture that *looks* like fabric, you can *imprint* various fabric textures on wet gesso or on modeling paste. Coat a panel with a thick layer of gesso directly from the can. While the white paint is still wet, lay your sheet of fabric over the wet surface and rub down the cloth evenly. Then peel it away slowly, leaving the texture of the fibers impressed on the wet gesso. If you want an even more pronounced texture, trowel on a reasonably smooth layer of modeling paste and do the same thing with your fabric, which will sink more deeply into the clay-like surface. Working with modeling paste, you can also try this imprinting technique with a sheet of weathered wood, textured glass or metal, or any irregular surface you'd like to transfer to a panel. In a sense, you're using the modeling paste to make a mold of the textured surface.

(3) You can actually texture wet gesso or modeling paste with a variety of tools. An ordinary hair comb will leave straight or curved striations, which can be crisscrossed any way you please. Stippling with the end of a stiff brush—like that big nylon utility brush—will leave an interesting, irregular texture. You can even try a wire brush. Methodically dabbing a layer of gesso or modeling paste with a sponge will leave a lively, pocket surface. Hunt through the kitchen and the tool box to see what other interesting tools you can find for texturing.

(4) The technique described for applying sand can be used for applying a variety of other materials. A thin layer of crumpled, wrinkled tissue paper can be stuck onto wet acrylic medium and then coated with another layer of medium to form a very subtle, irregular painting ground. The same can be done with thin cloth. I know one painter who's even broken dried autumn leaves into irregular shapes and pasted them down. Carefully covered with a couple of layers of acrylic medium, these fragile materials become hard, permanent, and attractive to paint on—even the leaves, my friend says.

These four suggestions can be only the beginning. Given time and imagination, you can come up with many combinations of your own. Just don't let textures become so insistent that they dominate the paint and make you a slave to your surface.

Preparing Toned Surfaces

Up to this point, I've assumed that you want to paint either on the natural color of the ground or on a layer of white gesso. But you can also mix the exact color you want for a painting surface. Just a touch of tube color, added to the white gesso, will give you any ground color you choose.

The most commonly used toned surfaces are various shades of warm and cool gray. Try mixing these with thalo or ultramarine blue and one of the earth browns, like burnt umber. If the umber predominates, you have a warm gray; if the blue predominates, you have a cooler tone. But be careful how much blue you add, since it easily overpowers the brown. Some yellow ochre, added to this mixture, will lend a slightly golden tone to the gray.

What color you choose for toned ground really depends upon the nature of your painting. Although warm and cool grays are suitable for virtually any subject, you may have more specific color requirements. For a sunset, an autumn landscape, or a nude full of glowing flesh tones, you may want a dusty, golden yellow undertone. This may mean adding a touch of yellow ochre or raw sienna to your gesso. The old masters often chose earthy red toned grounds, for which red oxide would be the modern

equivalent. The thing to avoid, at all costs, is a brassy, hot toned ground. Cadmium yellow is likely to be wrong, but yellow ochre or raw sienna will give you the warmth you need without overpowering the color that goes on top of the ground. For the same reason, red oxide is just subdued enough, while you certainly wouldn't think of cadmium red or naphthol crimson.

The same logic would apply to a cool ground. For a blue tone, thalo blue would be too electric, while ultramarine blue, muted with a touch of burnt umber or burnt sienna and white, would give you the restrained blue you need. For a green ground, an earthy, subdued tone like chrome oxide green would do the job without jumping out at you, while thalo green would drown the picture.

All these colors can be mixed with acrylic gesso to produce the exact tint you need. I think it's unlikely that you'd ever use any of these colors straight from the tube—unmixed with gesso—which would produce an undertone that runs the danger of overwhelming the picture. The purpose of a toned ground is to unify the picture so unobtrusively that you hardly notice it. You should be able to work comfortably over the toned ground without having to fight to overcome the color of the painting surface.

Adding tube color to gesso isn't the only way to produce a colored painting surface. Another way, with its own unique character, is the *imprimatura.* An imprimatura is a glaze or wash of transparent color over the white gesso surface. Simply mix up a saucerful of tube color and lots of matt or gloss medium to the density you want. Then brush this lightly over the dried gesso surface with a big, flat brush. Most artists brush the imprimatura on very freely, without bothering too much about leaving streaks; the streaks actually enliven the color that goes over the imprimatura. The advantage of this technique is that you retain the inner light of the white, shining gesso, which glows through the thin, transparent color of the glaze. Good colors for an imprimatura are the earth browns and reds, like burnt umber, burnt sienna, red oxide, raw sienna, and even that dusty raw umber; earth yellows like yellow ochre or yellow oxide; a muted green like chrome oxide green; or stronger colors like thalo blue or green, muted by earth browns.

Toned gesso or an imprimatura over gesso can be combined with the various texturing techniques I've already described. Putting together several different methods, you could conceivably begin with a panel that's been coated with acrylic modeling paste, textured while wet; then apply a coat of white or even tinted gesso; and then finish off with an imprimatura that sinks into the texture.

And speaking of acrylic modeling paste in connection with toned grounds, it's worthwhile to experiment with *colored* modeling paste to develop painting surfaces. Although the paste is thick, it's possible to stir in tube color to produce paste of any tone or hue. You may even wish to experiment with various combinations of modeling paste, gesso, acrylic medium, and tube color to produce paste of various consistencies and colors. Luckily, all acrylic materials are compatible, so there's no limit to the combinations you'll find possible.

4
Painting Tools and Equipment

If you're painting with acrylics, you can use all the tools and equipment you use for other media. The only tools specially designed for acrylics are the new nylon brushes, but if you've already got brushes and knives for oil painting, watercolor brushes, and other familiar items in the studio, these will do just as well. However, on the chance that you don't have a fully equipped studio—or if you're in the mood to buy some new tools—I'm going to review the items that are useful to have on hand for acrylic painting.

Bristle Brushes

If you've painted in oils, you know that there are four kinds of bristle brushes, called flats, brights, filberts, and rounds. All of these are just as suitable for painting in acrylics. In fact, if you clean your oil brushes very carefully, you can use them for acrylic painting. Just be absolutely sure that there's no trace of oil, turpentine, resin, or any other oil painting medium on the bristles. Give the brushes a thorough lathering in mild soap and water, let them dry, and then give them a final swish in lacquer thinner, which will dissolve those last invisible traces of dried paint or oil. When the lacquer thinner has evaporated and the brushes are bone dry, you're ready to use them for acrylics.

The brushes which are called flats have long, springy bristles, which are assembled in the ferrule (the metal tube that holds the bristles together) so that they curve in slightly and come to a straight, rectangular tip. Because of its squarish shape, the brush makes a square, regular looking stroke. Of course, when the brush becomes old and worn—which lots of painters like—its shape is more irregular, and so is the stroke. These long bristled flats are

For acrylic painting, you can use the same brushes that you use for oil painting. From left to right, you see the short, stiff shape called a "bright"; the longer, more resilient shape known as a "flat"; and the rounded shape called a "filbert."

specially useful in acrylic painting because they carry lots of fluid paint. Because acrylic is a water based medium, it's inherently more fluid than oil paint, and long, springy bristles hold such paint well. Flats are equally useful in opaque painting techniques and in methods where acrylic is used more like watercolor.

The brights have shorter, stiffer bristles than the flats. These short bristle brushes are useful mainly for carrying heavy loads of thick acrylic which has been stiffened by gel medium or used straight and undiluted from the tube. The brights won't make a fluid stroke, but will pile the paint on. For a thick accent, a heavily textured passage, or a painting which is heavily textured throughout, this is an effective painting tool. But for general purposes, the flats are more versatile.

The filbert shape is less familiar than the two I've just described, but I find it particularly attractive for acrylic painting. Perhaps the best way to describe it is as a cross between a flat and a round bristle brush. The bristles are long and springy, but are set in the ferrule so that they curve together and form a rounded point. The effect is something like a worn flat. The filbert will carry lots of fluid acrylic, but makes a stroke more like a watercolor brush, a softer, more irregular stroke than the squarish mark left by the flat. Its rounded shape makes the filbert especially good for the scrubbing, scumbling stroke which many acrylic painters favor.

Round bristle brushes are rarely used, although they were popular centuries ago. Few oil painters use them because the filbert shape will do the same job and retains many of the advantages of a flat bristle brush. The significant thing about a round bristle brush is that it has the shape of a round watercolor brush, but the bristles are a lot stiffer. A long, round bristle brush will give you the sweeping, fluid stroke you like in a watercolor brush, but will leave behind the streaks and furrows of the bristles. This creates a lively, slightly unpredictable texture even when the paint is applied very thinly. Round bristle brushes are definitely optional, but you may enjoy trying them.

Sable and Oxhair Brushes

For fluid painting in acrylics, especially when the tube color is diluted with water or medium, the various soft hair brushes are especially important—far more important than they are in oil painting. You can use the same sable brushes you bought for oil

painting, provided that they're properly cleaned as I've described above. Or you can use your watercolor brushes. Remember that soft hair brushes are especially vulnerable—they're far more delicate than bristles—and must be cleaned carefully after acrylic painting to be absolutely sure that no traces of dried paint are left. Later in this chapter, I'll describe the method that I find effective for cleaning brushes used for acrylic painting.

The sables used for oil painting come in two shapes: round, pointed brushes; and flat, wedged-shaped brushes with square ends. The sables used for oil painting tend to be a bit short for the more fluid medium of acrylic; if you buy this sort of sable, get the longest body of hair available. However, oil painting brushes generally have one important advantage over those used for watercolor—oil brushes have long handles which allow you to stand away from the painting and see the total effect as you work.

The sables made for watercolor painting tend to have longer, fuller bodies of hair than those made for oil painting. So painters in acrylics generally turn to watercolor brushes. Such brushes are essential if you're going to use acrylic in a watercolor or gouache technique, where you want lots of fluid color on the brush. Round, pointed watercolor brushes and flat, square-ended watercolor brushes are equally valuable; you'll probably want some of both for techniques that depend upon fluid washes of color and long, liquid strokes. (I do wish that someone would make watercolor brushes with big, long handles!)

A soft hair brush doesn't *have* to be sable, which is expensive, especially in the large sizes. Oxhair is a lot cheaper and will do many jobs just as well as sable. Painters who are accustomed to sable—and who can afford it—often tend to look down their noses at oxhair. The standard argument against oxhair is that sable brushes are springier and hold their shape better. Oxhair is more limp. However, you may actually like a limp soft hair brush, as the Chinese masters did. It's really a matter of taste.

Soft hair brushes are important not only for wash techniques, but for fluid linear painting; for crisp accents and details; for the slow, methodical buildup of acrylic tempera; and for the rich variety of glazing and scumbling methods which are unique to acrylic. Most oil painters have a flock of bristle brushes in the studio, but just a few sables for special purposes. The acrylic painter is likely to have just as many soft hair brushes as bristles.

Synthetic Brushes

The recently developed synthetic fibers—particularly nylon—are now available in brushes that are especially suitable for acrylic painting. The synthetic brushes are incredibly durable and the best ones behave so much like natural fibers that it's hard to tell the difference. I have a set of reddish brown synthetic watercolor brushes that look and act so much like my old (and far more costly) sables that I'm not sure which is which! And the long-handled white nylon brushes—the ones that look like traditional hog bristle brushes for oil painting—are stiffer than sables, but softer than bristles. So they have a unique feel that is worth trying.

Many painters find that acrylic paint wears out their bristle and sable brushes more rapidly than oil or watercolor, while nylon can take the punishment a lot longer. But using synthetic brushes is no excuse for carelessness. You still have to work with wet brushes—never dip a dry brush into acrylic paint—and you must always clean *every* brush thoroughly, whether the hairs are natural or synthetic.

And in fairness to bristles and sables, they *should* wear as well as they do in oil or watercolor painting—if you clean them properly.

Knives and Other Implements

I've already talked about the value of a big putty knife for spreading acrylic gesso on canvas. You can buy this at your local paint or hardware store. There are several other kinds of knives which are worth having . . .

The oil painter's palette knife—either the flat type or the spatula type—is useful for mixing up batches of thick color. For example, if you're blending up a mound of tube color and gel medium, it's a lot more convenient to do this with a knife than with a brush. A palette knife is also good for blending color and modeling paste. However, you can't use it for scraping paint off the canvas or off the palette as you may be accustomed to doing in oil painting, since acrylic paint dries fast and resists scraping.

You may also like applying paint with a knife, though I certainly wouldn't use a palette knife for this purpose. Most knife painters buy the implements specially designated as *painting knives*, which come in a variety of shapes and sizes. The blades of these knives come in varying degrees of flexibility and you must experiment to see which shapes, sizes, and degrees of bounce will suit your needs. The knives must be strong enough to carry a heavy

For applying fluid color, many painters prefer brushes softer than the sturdy bristles. From left to right, you see a golden brown nylon brush; a round sable watercolor brush; a flat white nylon brush; and a round white nylon brush.

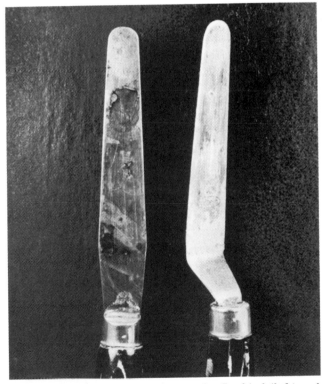

Palette knives come in two shapes: the flat kind (left) and the spatula shape (right). Use them for mixing paint with gel and modeling paste, but don't *paint with them. They're the wrong shape.*

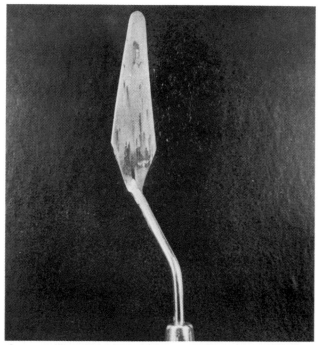

Short, resilient knives like this one are specially designed for the technique mistakenly called "palette knife painting." This sort of knife is excellent for applying thick strokes of paint modified with gel or modeling paste.

Manmade sponges (left) and natural sponges (right) are used for mopping up, for wetting the painting surface, and even for painting. The rounded natural sponge fits nicely into the hand.

The flat, rectangular, manmade sponge can be folded up (when wet) to make a rounded shape that serves well for blotting and dabbing.

bodied mixture of tube color and gel, or tube color and modeling paste.

These heavy bodied mixtures lend themselves to texturing with all kinds of tools, not just those specially designed for painting. I know painters who collect various dental tools, which are used for scratching and scraping. You can make lively marks in wet acrylic paint with ice cream sticks, kitchen knives, combs, chopsticks, beer can openers, and literally anything that will leave some sort of dent in a layer of wet paint.

Sponges, Rags, Paper Towels

Because acrylic paint is water based, it's important to have sponges, rags, and paper towels handy for cleaning up, for emergencies, and even for painting.

Have at least one manmade or natural sponge within grapping distance for wiping out an unsuccessful passage of paint before it dries, for sopping up a spill, for cleaning an area of your palette when the mixing surface gets too cluttered, and even for dabbing on paint when you think a sponge might do a better job than a brush. (It sometimes will!) Actually, I keep two sponges handy: a big, rectangular manmade sponge for cleaning up and sponging out; and a smaller, more rounded natural sponge for applying paint. It may be a good idea to have a special bowl of water just for the sponges so you don't foul the two water containers I've suggested for your brushes. Moisten the sponges before you go to work, so they're ready for any emergencies; it takes a minute or so to moisten and soften a dry sponge, and you'll find it maddening to wait this long when you need a moist sponge for an emergency.

Old lint-free rags, like those torn from old bedsheets, can also be used to apply paint and sop up spills. The manmade sponge really does a better job of cleaning up, but I find that a rag is a wonderful painting tool. If you wad a rag up into the shape of a dabber, you can use it to pat and soften a passage of wet paint, to lift a little color from the painting surface when you want to lighten something, or to add texture if the rag is rough. Wrapped around a fingertip, the rag can be used to clean away a small, fairly precise area of wet paint, or can be used to apply a small dab of color. If you like to use rags as painting tools, keep one or two nearby and make sure it's damp and ready for use; a dry rag will soak up paint too fast and the job may get out of control.

I always keep a roll of paper towels in the studio in

addition to sponges and rags. For a really big spill, half a dozen paper towels are the quickest cure. I also find that I can lay several paper towels over a passage of wet paint that needs lifting or lightening; a damp paper towel will soften the paint and lift just a bit, while a dry towel will soak up a lot more. Like a rag, a paper towel can also be wadded into a dabber for lifting or applying paint. If the dabber is wet, you can shape it with your fingers almost like papier mâché and get just the shape you want—a custom molded painting tool.

Care of Painting Tools

Once acrylic paint dries on a brush, the bristles or hairs become stiff as a board and you might as well toss the brush away; I've talked about the importance of keeping brushes moist and washing them out frequently during painting. The technique of washing a brush after painting is equally important. The manufacturers tell you that all you need to do is swish the brush around in clear water a few times, but I don't really think this is enough. Here's what I suggest.

When you're finished painting, take your brushes over to the sink and fill it with clear water—cool or lukewarm, never hot. Swish the brushes around in the sink and drain the murky water. Fill the sink again with fresh water and again swish the brushes around. Keep washing the brushes and changing the water until the last sinkful seems clear and no more paint seems to be coming off the brushes. Now the brushes *look* clean, but they probably *aren't*. Swab each brush over a bar of mild white kitchen soap—like Ivory—and then lather the bristles in the palm of one hand, moving the brush in a circle working the soap far up into the body of the brush, where dried paint is apt to accumulate. You may be surprised to discover that the lather slowly changes from white to whatever color was last on the brush. Wash out the lather in cool or lukewarm water and repeat the soaping process until the lather is really snow white. This is the only way to get rid of those invisible traces of color which gradually build up in a brush and kill its resiliency. Do this with all your brushes after painting, even if they look clean as a whistle. Then shape the bristles with your fingers so that square brushes come to a nice even edge and round ones come to a clean point.

A word about brush storage. Except in the summer months, when there are hungry moths around, I always store my brushes in jars—with the

A paper towel can be wadded up into a dabber for picking up wet paint or for applying it.

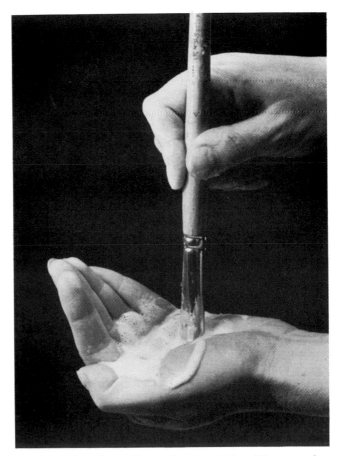

After painting, clean all your brushes with mild soap and water. Lather the bristles gently in the palm of your hand.

PAINTING TOOLS AND EQUIPMENT 59

It's simplest and safest to store your brushes, bristle end up, in a wide mouth jar. Notice that the bristles don't touch one another, so there's no danger that one brush will push another out of shape.

A closeup of John Pike's famous watercolor palette—ideal for acrylics, too—shows compartments for squeezing out tube color, plus the big mixing area in the middle. Dried color can easily be soaked off the plastic surface.

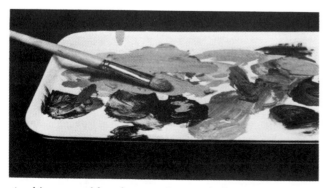

A white enamel butcher tray is a good all-purpose palette for mixing big batches of thick color, as well as runny washes.

bristles up of course. This is the best way to keep the brushes from knocking into each other and pushing one another out of shape. When the first moth turns up, I move my brushes into plastic kitchenware containers, which are boxes divided into long, narrow compartments, just the right size for brushes. These plastic units are put into drawers, with plenty of mothballs. Because the brushes are lying on their sides, I make sure the bristles don't get squashed.

It's easy to clean metal and plastic implements, like knives, dental tools, or plastic modeling tools (yes, these are splendid for texturing too). You can let acrylic paint dry on these tools because the dried color will peel off when soaked in water. You can just toss these things into the sink and let them sit for a few minutes, then peel or rub the dried paint away.

What can you do if paint dries on a really precious brush? Several manufacturers make special solvents for acrylic colors—sometimes called brush cleaners—and it's worthwhile to have a bottle around. You may just succeed in soaking off the dried paint, but I doubt that your brush will ever be the same. You can also try industrial solvents like lacquer thinner and acetone, but don't forget that the fumes are toxic, so work in a well ventilated place. Also be careful about cigarettes; these solvents have a low flash point.

Palettes and Containers

The traditional wooden palette of the oil painter is useless in acrylic painting, since the plastic paint will work its way into the fibers of the wood and never come out. The palette will end up so discolored that you won't want to mix paint on it.

The best palette for acrylics is a smooth, nonabsorbent material like metal, glass, or plastic. I like a white enamel butcher tray, bought in the housewares department of my local Woolworth's. The metal and plastic watercolor palettes sold in art supply stores are also good. White plastic ice trays—the kind used in refrigerators—are excellent. And a metal muffin tin, sprayed with a durable white enamel paint, will give you deep wells for mixing large quantities of fluid paint.

All these palettes, whether intended to be used as palettes or simply improvised from something found around the house, have the advantage that they can be cleaned very easily. Because acrylic paint won't stick for long to a smooth, nonabsorbent surface, you can simply soak these palettes in water and peel or rub away the dried color.

You can also find lots of throwaways. My wife

always saves the little plastic cups in which margarine is packaged; these are wonderful throwaway saucers for mixing washes and glazes. I also keep a supply of paper drinking cups on hand. You can cut off the bottom sections of milk containers to make square saucers an inch or two deep. I also save ice cream containers, the small cartons in which we buy prepared foods from the delicatessen, and any other paper or plastic container that might be headed for the garbage anyhow.

Painters seem to disagree about the virtues of paper tear-off palettes, like those used for oils. Some of these palettes are just too absorbent, and tend to soak up some of the water from the paint. This accelerates the drying of the paint on the palette and also curls the paper, making it an inconvenient mixing surface. Other paper palettes seem less absorbent and these problems aren't quite so serious. My main objection to the paper palette is that the fluid paint seems to run off the edges. I prefer something with "walls" around it, like a butcher tray or a watercolor palette.

You can also improvise a palette by putting a coat of white paint on the underside of a sturdy sheet of glass. You mix your paint on the clear side of the glass, but the white shines through so you feel that you're working on a white surface.

Easels, Drawing Tables, Drawing Boards

The upright oil painter's easel, which holds a canvas or a panel vertically, is fine for acrylic painting if you're working with fairly thick color. Once the color becomes really fluid—heavily diluted with water—it behaves more like watercolor and is inclined to run down the surface. The paint *doesn't* run when you dilute it with straight acrylic medium, but adding water may convert the paint to a wash which is hard to control on a vertical surface. In this case, you'll probably prefer a horizontal surface.

An adjustable drawing table, which you can tilt to vertical, diagonal, or horizontal positions, gives you a great deal of flexibility. You can tilt it to the angle that matches the fluidity of your color. A watercolor technique, for example, will probably require a slightly tilted board or one that's absolutely flat.

An even simpler, less expensive solution is a drawing board. You can buy a wooden drawing board at your art supply store, or simply go to the lumber yard and have a sheet of plywood, hardboard, fiberboard, or wallboard cut to whatever size you please. Remember that wood and hardboard resist thumbtacks and pushpins, while it's a lot easier

For mixing quantities of fluid color, an ordinary muffin tin, possibly sprayed with white enamel, makes a useful palette.

This plastic palette has two kinds of compartments: small, circular wells for squeezing out color; and slanting rectangular wells for mixing small washes.

Hang onto throwaways like paper or plastic drinking cups (left), ice cream cartons (center), and plastic margarine tubs (right). You can use them for mixing large quantities of fluid color.

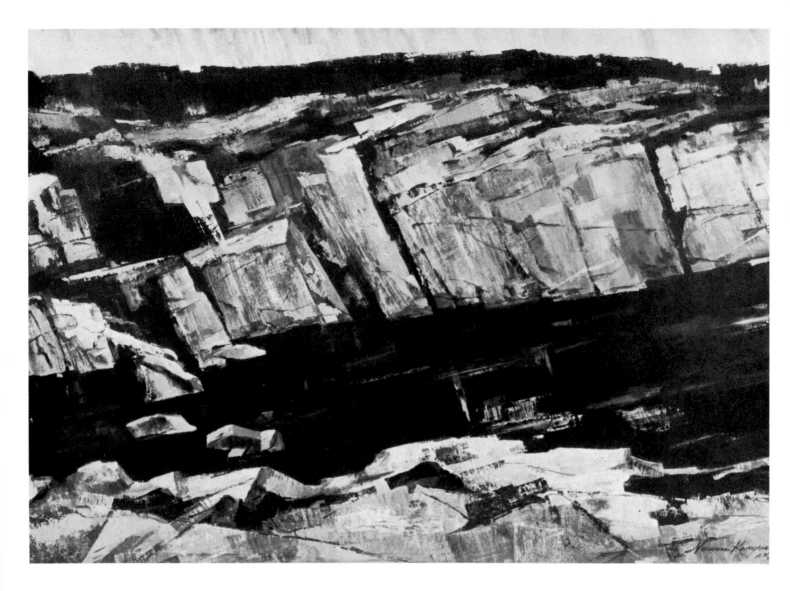

Stilled Quarry *by Norman Kenyon, A.W.S., acrylic on watercolor board, 18" x 24", collection Richard Page. Broad, richly textured, squarish, straight strokes like these suggest that flat bristle brushes or flat sables were used in a drybrush technique. Even fluid acrylic color can be applied with stiff brushes to produce textures in which the brush-mark remains distinct. Notice how the strokes follow the slant of the rocks and how they are occasionally criss-crossed by overlying strokes that move at right angles to the underlying marks. The small strip of sky at the top is also painted in diagonal strokes, more or less parallel with the slant of the rocks. You might find it worthwhile to try painting such a subject with a knife and tube color that has been thickened with gel. This National Arts Club prize-winner was painted on Arches watercolor board.*

to shove pins into a softer board like Upson, Celotex, or Homasote. A drawing board can be tilted to the necessary angle simply by piling some books under it. It's also portable, so that you can take it out into the field for painting on location.

Clothing

Clothes hardly come under the heading of painting equipment, but they present a special problem when you work with acrylics. The rule is simple: be sure to wear old clothes, clothes so old that you don't care what happens to them. By now, you know that once acrylic dries on your clothes, you'll never get it off. So save your oldest shirts and your oldest slacks, your most faded dress, your most beat-up shoes for the studio. When they get so caked with paint that you can't stand them, just toss them out. Don't waste your money on laundry or dry cleaning.

Accessories

Every painter's studio contains a lot of odds and ends which he hasn't bought in an art supply store. Here are some which may turn out to be useful for acrylic painting.

Hair dryer: A gun shaped hot air blower, the kind you use for drying hair, can be used for accelerating the drying of a wet passage. This is useful not only if you're in a hurry, but if you want to "freeze" a fluid passage before it blurs beyond recognition.

Plastic squeeze bottles: Lots of cosmetics now come in plastic squeeze bottles—like the wetting lotion for my wife's contact lenses—and I ask her to save these. I wash them out carefully and fill them with painting medium, water, mixtures of fluid color, etc. I keep these bottles near the palette when I'm working so I can squeeze out a couple of drops of medium into a mixture, a drop of water to moisten a mound of paint, or even a squirt of color right onto the painting surface. I know several painters who pour liquid color into squeeze bottles, and squirt lines of paint onto the picture the way you might squirt mustard from a plastic bottle onto a hot dog.

Eye dropper: Another way to pick up a very small quantity of water or medium—and dribble it onto a mixture—is with an eye dropper. You can keep this next to your palette as you work and simply dip the eye dropper into the big water jar or the big bottle of medium.

Mister: At the garden supply store, my wife bought a plastic bottle that's equipped with a special kind of nozzle. She fills the bottle with water and presses a lever on the nozzle to release a fine, moist mist for wetting down delicate plants. This mist can also be used to keep a passage of a painting wet or to moisten the colors on your pallette.

Tea kettle: A more complicated (but efficient) way of keeping your painting wet is to have a tea kettle bubbling on a hot plate in the studio. The jet of steam from the spout can be directed at a section of a painting to keep it from drying too quickly.

Plastic detergent bottles: An unbreakable plastic detergent bottle, carefully cleaned out, is ideal for carrying water on an outdoor painting expedition. If you have a second plastic bottle of the same size, you can cut off the bottom half to provide a water bowl. The bottle of water can be nested in the bowl when you're on the move.

Fishing tackle or tool box: If you already own a paintbox which you can take outdoors, use it. But if you don't have one, you might want to try a fishing tackle box or a metal tool box instead. These are not only very rugged, but have lots of little compartments, often in tiers, which will hold brushes and knives, plastic squeeze bottles, tubes of color, and all kinds of other small items.

This is far from a complete list of the gadgets you'll find around the house to put to work in the studio. Use your imagination. You'll think of lots more.

Woman with Terrier *by Alex Colville, acrylic on panel, 24"*
in diameter. This amazingly precise rendering of various
textures—the dog's furry coat, the chickenwire fence, the
soft fabric of the sweater and skirt, the woman's skin—is
handled in a pointillist technique. Thousands of dots, hard-
ly perceptible to the eye, were applied with the tip of a
tiny sable brush, the traditional tool for the tempera tech-
nique. Despite the hard-edged quality of the design, the
painting retains an overall softness because the miniscule
dots of paint are merged together by the viewer's eye.
(Courtesy Banfer Gallery, New York)

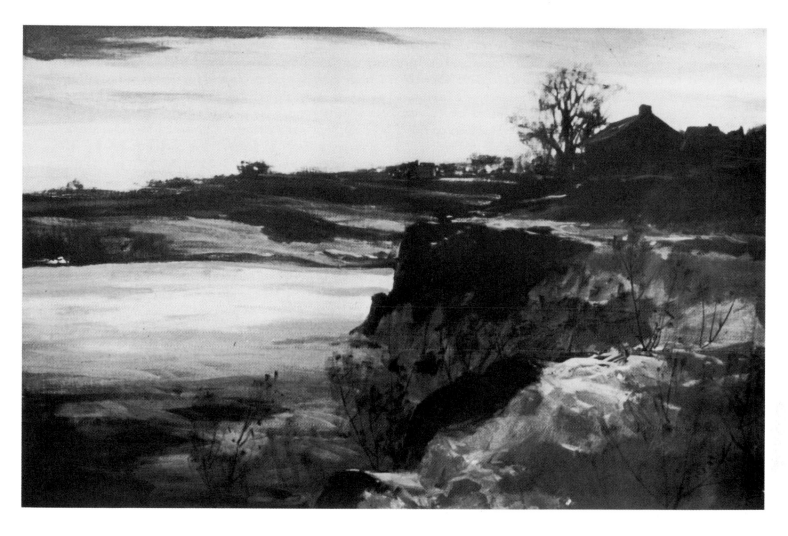

Edge of the Quarry *by Paul Strisik, A.W.S., acrylic on Masonite panel, 26" x 40", Percy H. Whitney Museum, Fairhope, Alabama. By working in opaque acrylic color, this artist produces an effect which seems, at first glance, very much like an oil painting. But the tonal subtleties are not the result of the oil painting technique of careful blending. Here, the tones are produced by quick, spontaneous scrubs of color only partially blended together. They appear as totally smooth passages of tone only when the painting is seen at a distance. The sort of scumbling stroke used to achieve this effect is particularly apparent in the lower right hand corner. There the artist has freely brushed three tones into one another to create the illusion of shadow, middle-tone, and light. This free, scrubbing type of stroke is the hallmark of the opaque technique in acrylic. The strokes are carefully planned, yet they are applied spontaneously. Good examples of this technique are the long, horizontal strokes of the distant landscape or the sky; the shorter, more vertical strokes in the right foreground; and the quick dabs and linear accents of the trees and shrubs.*

5
Opaque Technique

The simplest way to begin painting in acrylic is with the opaque technique. This is essentially the way you work with oil paint in the so-called alla prima or direct technique. You apply solid layers of color with fairly thick brushstrokes, aiming for the final effect from the very beginning, rather than building up the paint in layers of opaque and transparent color (which I'll discuss in Chapter 7). If you paint in casein, gouache, designers' colors, for example, the opaque technique will also be familiar.

The opaque technique is particularly valuable when you're learning to handle acrylics, because you can easily change your mind and cover one layer of paint with another until you get what you want. The painting moves swiftly because each paint layer dries as you work and a fresh layer can be brushed on top of it to make modifications or corrections. You don't have to worry about a wet underlayer mixing with the new layer—as you do in oil painting—and there's no danger of the underlying paint dissolving when fresh paint goes on, which is always a threat when you work with traditional opaque watercolor.

Working in the opaque technique, you're not restricted to solid planes of color. In this chapter, I'll describe the various techniques that will produce a wide range of effects, including scumbling, drybrush, broken color, gradations and blending, wet-in-wet passages, and textures you can produce with brushes and other tools.

Painting Surfaces

Because the opaque technique will cover virtually any painting surface you choose, you can work on any ground you like.

Linen and cotton canvas will be ideal if you're accustomed to these surfaces from your oil painting days. You can work on raw canvas, canvas that has been sized with acrylic medium, gesso coated canvas, or canvas which has been glued to a panel. I know several painters who also like to work on unstretched canvas, simply tacked to a big sheet of wallboard—Homasote, Celotex, or Upson—which they clamp into the easel. The only danger with unstretched canvas is that the paint may penetrate to the back and stick the canvas to the board. So steer clear of unstretched canvas if you prefer to work with very fluid paint.

Rigid materials suitable for the opaque technique include Masonite panels, coated with gesso or just sized with acrylic medium; illustration board, with or without a gesso coating; and even walls of dry, clean plaster, if you're eager to try an acrylic mural. Working on sturdy watercolor paper or drawing paper will give you an effect more like gouache or designers' colors. You may also want to try working on toned pastel or drawing paper, provided that this is carefully glued to a rigid support as I've described in Chapter 3.

The opaque technique also looks good on specially prepared, textured surfaces like those in Chapter 3. Because you're applying paint with considerable body, you can work comfortably on a sanded, granular surface; a gesso surface which has been textured with tools; or a gesso or modeling paste surface which has been imprinted by a piece of heavily textured cloth, glass, metal, or some other patterned object. Just don't work too thinly on this sort of surface, or the texture will dominate and your brushwork will play second fiddle.

Colors

Needless to say, white is the most important color in the opaque technique. Titanium white has extraordinary covering power and just a bit of it will lighten any color and turn it opaque. You may also want to try using gesso as your white: it has less tinting power, is less likely to dominate a mixture, and can be used more freely. Because a little goes a long way, I find titanium white most useful in thin, opaque passages, while gesso is worth trying for thicker paint layers.

In choosing primary colors (blues, reds, yellows), it's a good rule of thumb to have a cool and a warm variety of each. Thus, thalo blue is on the cool side and ultramarine blue is on the warm side—and I recommend both. Both of these are transparent and will need a touch of white or some other opaque color to increase their hiding power in the opaque technique. A more opaque blue, which you may want to have on hand, is cerulean.

Following the same rule of thumb, cadmium red light would be your warm red, while naphthol crimson or thalo crimson would provide a cool counterpart. Cadmium red is dense and opaque, while both crimsons are transparent. To produce solid tones, you can mix the transparent reds with either cadmium red or red oxide, which is also worth having for the opaque technique. Like Venetian red—its counterpart in oil painting—red oxide is a dense, earthy tone.

Cadmium yellow light, like all the cadmiums, is solid and opaque, ideal for this direct technique. Yellow ochre or yellow oxide will provide a more muted yellow, also opaque. Hansa yellow and azo yellow are both transparent; if you want to use them in the opaque technique, bear in mind that they'll need to be blended with a denser hue.

The one really opaque green is chromium oxide green, in contrast with the more transparent thalo green. I've said before that I consider green an optional color on the palette, but you may want to choose one of these, or perhaps both. Thalo green is cool and intense; it needs to be solidified (and toned down) by mixing with a more opaque hue. Chromium oxide green has much more hiding power and is ready made for opaque painting.

Oranges, too, are optional, but cadmium orange has the right degree of opacity for this method of painting. Hansa orange and indo orange red are both transparent and therefore less useful.

The most opaque purple is dioxazine purple, in contrast with acra violet, which is more suitable for a transparent technique.

The best opaque, all-purpose brown is burnt umber. Raw sienna also has reasonable opacity and gives you a warm counterpart to the cooler burnt umber.

The very powerful, opaque Mars black will complete your palette—if you want to have black there at all. But working with opaque color, you can *mix* wonderful blackish tones and never feel the need for a tube of black paint.

Mediums

If you're working on canvas and want your picture to look somewhat like an oil painting, you'll thin your tube colors with gloss medium or gel. Both of these dry to a luminous shine, similar to a varnished oil painting. Remember not to add *too* much gloss medium or gel to your paint, which will turn transparent if the medium outweighs the tube color. For the same reason, don't use too much water, although you should certainly have water on hand for washing brushes and for adding (in judicious quantities) to your paint.

If you prefer a non-glossy surface, more like a painting in gouache or designers' colors, then matt medium will be right for you. This medium is particularly appropriate on illustration board or paper, although there's no reason why you can't have matt color on canvas as well. On the smooth surface of a panel, I prefer matt color, but this is just a matter of taste; the museums are full of highly varnished oil paintings on panels, so I'm sure that acrylic diluted with gloss medium will look just as good on this kind of surface.

You may want to slow down drying when you work in the opaque technique, so retarder can be a useful additive. It's particularly valuable when you want time to do the kind of blending and scumbling you've learned in oil painting. But if you want to paint very directly and spontaneously, I'd steer clear of retarder; fast drying paint encourages spontaneity.

Painting Tools and Equipment

For work on canvas or on any textured surface, bristle brushes are in order. Your all purpose brushes should be the long flat bristles, although you may want the shorter bristled brights for impasto pas-

sages where the paint piles up on the surface. Synthetic brushes are also suitable for this technique.

Soft hair brushes, like sable and oxhair, *can* be used for painting smooth passages on canvas, just as the stiffer bristle brushes will make interesting rough textures on the smooth surface of a panel or illustration board. But the softer brushes are *most* valuable when they're used on smooth surfaces like Masonite, illustration board, or paper.

A palette knife is useful for mixing heaps of opaque color on the palette. Painting knives can be used for applying thick, solid passages. As you may know from prior experience in oil painting, a passage applied with a knife can look even more brilliant than one applied with a brush, since the knife can leave an absolutely smooth stroke of color, unruffled by bristles.

Since opaque color is usually stiff, it won't run off the palette (like a wash or a glaze), and you can use a paper tear-off palette if you like. A sheet of glass or an enamel butcher tray also makes a good palette for mounds of stiff color. However, I'd avoid palettes with wells, depressions, or compartments, since these are designed primarily to hold fluid color; it's a terrible nuisance to mix thick color in the depressions of a watercolor palette, a job better done on a flat surface.

Use a vertical, oil painter's easel or a drawing table that adjusts to an upright position.

Painting a Flat Tone

You may be surprised to discover that painting a flat, even tone isn't as easy as you think. If you want to lay in an absolutely solid, opaque, non-varying color area, be absolutely sure you mix up enough color at the very beginning. If you get halfway through the job and run out of paint, you'll find it practically impossible to mix up a fresh batch of color and duplicate the original hue. There's bound to be a slight, but perceptible difference between the old batch and the new—and this will be painfully obvious where the two colors meet. You'll end up having to repaint the entire passage. So I repeat: get the mixture right the first time and make sure you've got enough paint.

It's good practice to try painting a flat tone with various brushes. You'll find that the bristle brushes always leave faint, hairline grooves in the dried paint, no matter how swiftly or smoothly you work. Although acrylic does have a tendency to level out, it never levels completely unless you add a lot of water or medium. You'll get a smoother effect with soft hair brushes, since these hairs are less likely to leave their track on the dried paint.

You can also get an interesting flat tone with the painting knife, although it's never quite as smooth as oil paint. Since oil paint takes days to dry, this leaves you plenty of time to smooth out a knife passage until it's as glassy as enamel. Because acrylic dries more swiftly, you may not be able to get a knife passage absolutely smooth. But there's nothing wrong with this. Just as a flat, even tone is enlivened by traces of the bristle brush, it's interesting to see the knife strokes too. So if you're painting a flat, even tone with the knife, make a virtue of necessity: since the strokes are apt to show anyway, plan them carefully so they make an interesting pattern.

Here are some more tips about painting a flat tone. It's better to work with a flat brush than with a round brush. Each successive stroke should slightly overlap the stroke that came before. Don't scrub the brush back and forth, which *takes off* the paint instead of spreading it; to get an even coat, run your strokes in one direction. Finally, don't be unhappy if some of the painting surface or the underlying color breaks through here and there; a layer of paint needn't be mechanically smooth and an occasional irregularity in the surface makes things more interesting.

Scumbling

One of the most effective ways of applying acrylic paint is the method called scumbling. In contrast with a smooth, flat passage of unbroken color—which looks best when you move the brush in one direction only—a scumbled passage is *supposed* to look irregular, and the brush is purposely moved back and forth with a scrubbing motion. The result is a fascinating, unpredictable texture in which the strokes of the brush are always evident. A scumbled passage always has lots of breaks in it, allowing the underlying color to show through even though you're working with opaque color. A scumble is always enlivened by flecks of color working through from below.

Scumbled color needs to be thick, but fluid. It's best to dilute your tube color with matt or gloss not water. Bristle brushes—the long flats—produce more interesting scumbles than soft hair brushes. And because the essence of a scumble is its irregularity, natural bristles are more effective than the rather mechanical nylon bristles. You can also scumble with a small natural sponge, which lends its own special texture.

Experiment with different kinds of scumbling strokes. Short, straight strokes will produce a very different effect from curving arc-like strokes. Your strokes can all move in the same direction or you can change direction so that the strokes "fight" one another. The combinations are unlimited, and you'll learn by experimentation what kind of scumbles you like best. Remember, the essence of the technique is to scrub the paint on, moving the brush back and forth so that the paint is *unevenly* applied.

Scumbles are effective for all kinds of things: a clump of ragged trees, blowing in the wind; the flowing or tousled hair of a portrait sitter; the texture of a rock formation; clouds scudding across the sky; the neutral background of a portrait or figure painting, which needs an interesting texture to fill the space. Some painters scumble even a smooth subject, like the shadow side of a face or figure; a clear sky which needs some textural variety; or the skin of an apple, in which scumbling is used to blend one color into another.

Blending and Gradations

Because acrylic dries much more quickly than oil, you never have the time to brush and rebrush a passage to get those subtle, smoky gradations from light to dark—or from color to color—which are unique in oil painting. The acrylic painter must resort to other means.

If you've experimented with scumbling, you know by now that this is an effective way to produce quick, spontaneous gradations and blends. You can scumble one wet color into another, scumble light into dark or dark into light. For example, if you're painting a peach and want to merge the ruddy and golden tones of the skin, you can scrub the two tones into one another while they're still wet—if you work quickly and decisively. The result is not a smooth, even blend, but something more casual, more exciting, and more typical of acrylic.

To get a smoother gradation, try adding acrylic gel medium to your paint and brush it out like oil. If you work quickly enough, you'll get a blend that's *more* like an oil painting, but it still has a certain roughness which is characteristic of acrylic. Adding retarder will slow down drying sufficiently to allow an even smoother blend. But if you want the absolutely perfect gradation you get in oil paint, forget it; a blended passage in acrylic always retains a certain roughness, which is essential to the charm of this new medium. Don't try to do an oil painting in acrylic!

A scumble is most interesting when it retains the character of the individual stroke. Here the brush was moved in a curving, rhythmic way.

This scumble was executed with long, straight strokes, scrubbing the brush back and forth at a slight angle.

This light-on-dark scumble consists of short, scrubby strokes that move in several different directions.

Scumbling can be used as a means of blending. Here, two wet colors are scrubbed into one another where they meet.

For a rougher blend, the dark tone was first scumbled from left to right, then allowed to dry. A light scumble was then worked over the dark tone, starting at the upper right and gradually fading out.

Two different tube colors, stiffened with gel to behave more like oil paint, were roughly blended with a bristle brush. The brushstrokes are clearly shown, rather than blended out.

Two tones were butted together and rapidly blended with vertical strokes of a moist brush.

Another method which is worth trying is the wet blend. Place two passages of paint side by side, butting up against one another. While both passages are still wet—be sure to work quickly—draw a moist brush along the edge where the two patches of paint meet. Experiment with drawing the brush down the border, across the border, or both. You'll get different blends, depending upon the direction of the stroke. Once again, the transition won't be absolutely smooth, but always a bit irregular, retaining the spontaneity of the stroke. You can also scumble the two patches of color together by scrubbing a damp brush back and forth at the point where they meet.

Drybrush and Broken Color

Still another way to produce a rough, lively gradation from light to dark, dark to light, or color to color, is drybrush, although this technique has other uses as well.

In the opaque technique, drybrush means picking up just a trace of thick color on your brush, then moving the brush across the painting surface very lightly so that the bristles merely graze the fibers of the canvas or the tooth of the paper. Mere traces of paint are left, not a solid, continuous paint film. The harder you press, the more paint you deposit. And the more you go back and forth across the surface, the more the paint builds up. By pressing harder in some areas—or by going back and forth over these areas—you darken the paint and develop a gradation. You can obviously drybrush one color into or over another.

But drybrush is even more valuable for interpreting textures in your subject. I'm sure you can think of lots of subjects which lend themselves to drybrush treatment: a shaggy treetrunk; the rippling, broken light on water; the foam of a breaking wave; the coarse forms of rocks or weathered wood; the moldering walls of an old building.

Drybrush is particularly effective when applied over an underlying layer of another color. The effect is called broken color, which means that the underlying hue breaks through the drybrush to produce an optical mixture; that is, the undertone and the overtone blend in the eye of the viewer, yet each color somehow retains its identity. An obvious use for broken color would be a moss-covered rock formation, with the color of the rock breaking through the moss. It's a logical way to render an ancient wall with a layer of paint peeling off. Or why not drybrush

The rough texture of canvas lends itself to drybrush effects. A loaded brush was scrubbed up and down, moving from left to right. As the paint was depleted, the brush merely skimmed the high points of the grain, depositing traces of broken color.

Here's the same effect, but light-on-dark. Observe how the texture of the canvas determines the texture of the stroke.

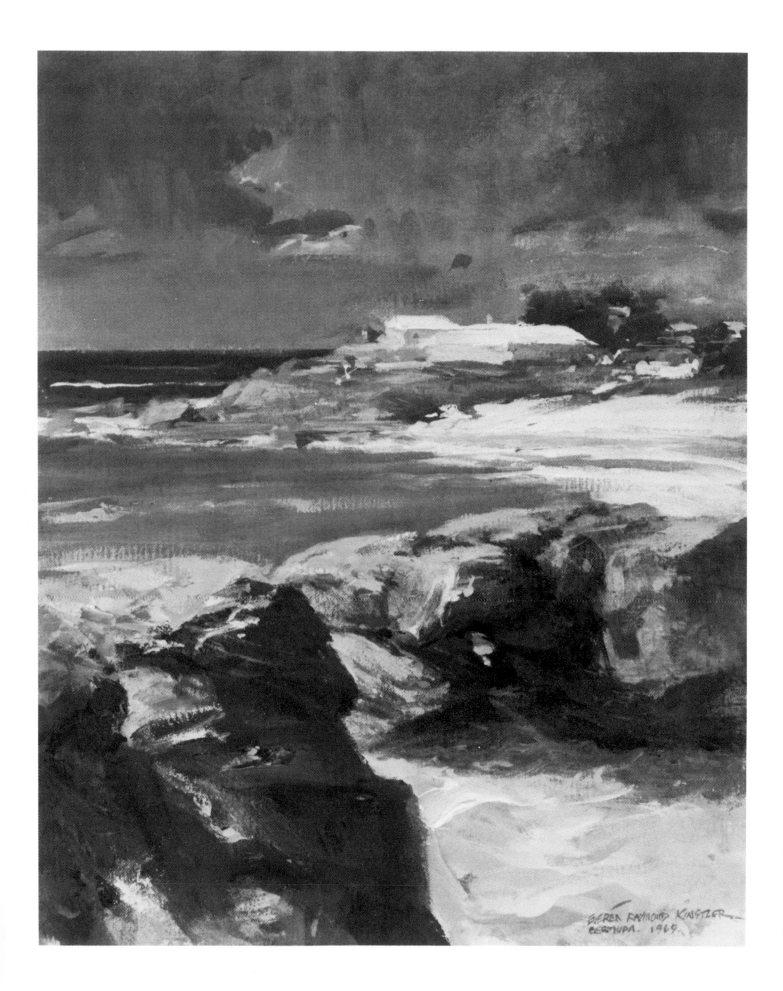

EVERETT RAYMOND KINSTLER
BERMUDA. 1969.

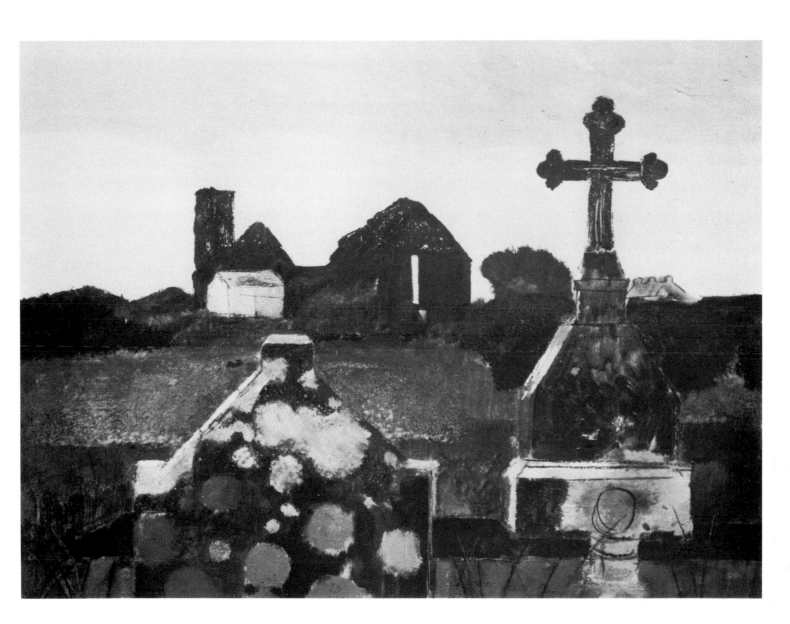

Frick's Cove, Bermuda *by Everett Raymond Kinstler,*
A.W.S., acrylic on canvas, 20" x 24". Working in thick,
opaque color, freely brushed on like oil paint, the painter
used the texture of the canvas to soften and blend his rough
scrubs of color. Notice how the edges of the strokes often
blur into the grain of the canvas. On the tops of the cliffs
and in the light strokes in the water this gives an effect
which approximates drybrush. The "feel" of this technique
is something like working with pastel on rough paper.

Churchyard *by Charles Coiner, acrylic on panel. Here, the*
opaque color was applied rather thinly, allowing either the
painting surface or underlying areas of color to show
through. There's very little blending or gradation, but the
painting has a good feeling of atmosphere because of the
changes in texture. Compare the soft, scrubby strokes on
the monument to the right with the granular, drybrush
textures of the meadow beyond. Despite the rather geo-
metric, architectural composition, all the shapes are painted
with soft, slightly feathery edges. (Photograph by O. E.
Nelson, courtesy Midtown Galleries, New York)

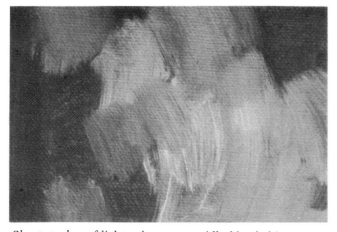

Short strokes of light color were rapidly blended into a wet field of darker color, producing a variety of intermediate tones, somewhere between the two colors.

Into a field of wet color, several strokes of lighter color were quickly brushed without blending. At some points, the lighter color blends with the undertone purely by accident; at other points, the light color retains its identity.

Water was sponged over a patch of dark color. Then strokes of lighter color were quickly applied to the wet surface. The water blurred and softened the strokes.

light over dark to suggest flecks of sunlight breaking through dark trees?

Wet-in-Wet

Another method of producing lively mixtures and gradations is the technique known as wet-in-wet. As the name suggests, this means painting a fresh color into a layer of paint which is still wet. You can do this in several ways . . .

One method is to start out with a layer of wet color and then work back into it with a second color, literally mixing the two colors on the painting surface. The mixture will be most interesting if you don't aim for a complete blend, but allow breaks and irregularities where the two colors don't quite mix. The dried passage will contain hints of the two individual colors, as well as the new color you've created. The paint will handle better if you dilute it with some acrylic medium and perhaps some retarder. Scumbling strokes will leave the most interesting texture.

Another wet-in-wet method *avoids* mixing the two colors. The second color is applied very sparingly over the first, so that the underlying color retains its identity. Let's say you're painting some wispy white clouds into a blue sky. You begin with a layer of wet blue and then work back into it with lazy, casual strokes of white which partially blend into the blue, partially cover it. The clouds have a lost-and-found effect, sometimes emerging from the blue and sometimes melting into it. This would be an effective way of painting patches of yellow light on green grass, or hair tumbling down a forehead.

A third wet-in-wet method actually allows the underlying layer of color to dry. You then brush water or medium over the dried paint and work color into the wetness. This is another way of putting soft white clouds into a blue sky, perhaps, or painting a blurry shadow against a wall.

Remember that you're working in the opaque technique, so be sure that your paint has plenty of body. There's no harm in thinning out your paint to the point of transparency, but then you're working with a wash or a glaze. In a painting which is consistently opaque, a single transparent passage may look out of place.

Corrections and Alterations

When you're working in the opaque technique, corrections and alterations are easy—a lot easier than

they'd be if you were working with transparent color.

If you end up with a passage you don't like, you can simply paint it out. You have two choices: either you can paint it out with the color of the original painting surface and start over from scratch; or you can paint it out with any other color of your choice. In the early stages of a painting, when you're just blocking in the shapes, you may want to paint something out with pure white (or tinted) gesso and thus go back to the original ground. However, suppose you're half way through painting a face and you don't like the nose; you can just cover up the nose with solid flesh tone and then start over.

Another way of altering an acrylic painting is based on the old oil painting technique of "oiling out." Just as an oil painter may rub a thin coat of medium into the surface of a dried painting and then work back in to the wet surface with fresh color, you can do the same with acrylic medium. Let's say you're painting a mountainous landscape and you find that the most distant mountain range is too sharp, too dark, too insistent. You want to soften it up and melt it back into the atmosphere. Brush some wet medium over that part of the painting and then work into the wetness with fresh color which will soften and blend nicely. This method is particularly effective when you want to soften a hard edge, like the side of a face which you'd like to blend into the background.

Drybrush and scumbling are also effective ways of correcting or altering an unsatisfactory passage. If something looks too flat and regular, try covering it with a light scumble of another color or perhaps a lighter or darker version of the same color; the scumble will allow some of the original color to break through and the two layers will blend in the eye of the viewer. Try the same thing with drybrush. You can also use drybrush to soften a hard edge: just graze the edge with a few delicate strokes of almost invisible color, which will add a faint blur. Hard edges are always a problem with any water based, fast drying medium, and drybrush can be a quick and effective cure.

The dry, dark tone was thinly coated with medium straight from the bottle. A light scumble was applied at the right and softly blended into the layer of colorless medium. Some blending was also done with the thumb.

Where the light and dark tones meet, delicate drybrush strokes soften the transition. From a distance, it looks like a wet blend.

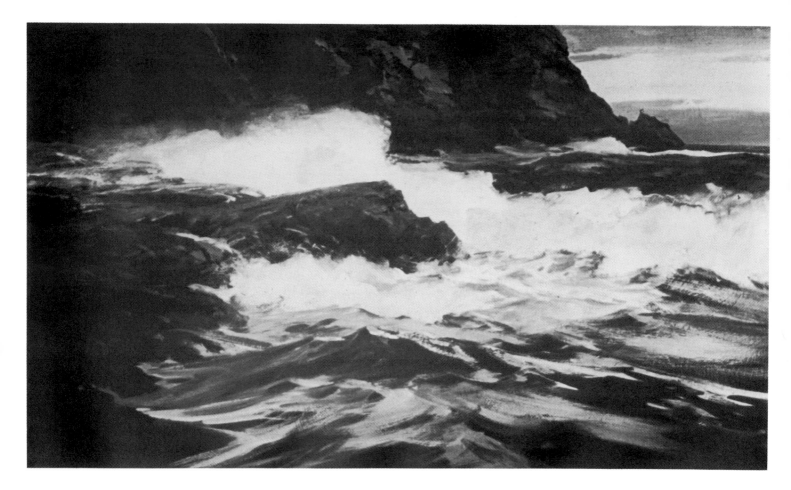

Monhegan Surf *by Paul Strisik, A.W.S., acrylic on Masonite panel, 24" x 40", collection Paul R. O'Brien. The passages of solid color in this painting are carefully planned to follow the shapes of the cliff, rocks, waves, surf, and sky. Study the rhythmic arcs of the paint strokes in the foreground, expressing the surging, choppy quality of the water. Contrast these with the long, straight strokes that form the patch of sky in the upper right. The rocky textures are represented in short, chunky dabs of thick color, while the foam is rendered in soft, blurry, scrubby paint. The exact character of each brushmark is retained because acrylic dries rapidly.*

6
Transparent Technique

Only the practiced eye can spot them, but an increasing number of paintings in watercolor shows are actually transparent acrylics. Acrylic is an ideal transparent watercolor medium for several reasons. Because an acrylic wash dries insoluble, a second, superimposed wash won't dissolve the dried color underneath; this allows the watercolorist far more freedom in laying one wash over another. Because the watercolorist can thin acrylic not only with water, but with various mediums, he gains much greater control over the consistency of his paint. Adding some medium to a wash makes the liquid color much easier to control, not only in the usual flat and graded washes, but in the wet paper technique, drybrush, and scumbling. Finally, a watercolor painted in acrylic is more durable than a traditional transparent watercolor, since the new medium is unaffected by moisture once it dries.

In contrast with the opaque technique described in Chapter 5, the essence of this technique is its transparency. Like the watercolorist, you're working with fluid color on paper or illustration board. Each wash—or layer of color—is like a sheet of colored glass. Complex color effects can be built by overlaying one wash over another. Because of the transparency of the medium, you can't cover up your mistakes, so you've got to get things right the first time. And because of the fluidity and quick drying character of the medium, you've got to work spontaneously, decisively. A transparent acrylic *looks* like a watercolor, and you'll discover that acrylic can do virtually everything that traditional watercolor can do—and it can do more.

Painting Surfaces

For this transparent—or watercolor—technique, most painters use the same painting surfaces as they use in traditional watercolor. Top quality handmade and moldmade watercolor papers are best.

Watercolor papers and boards normally come in 22" x 30" sheets, which you can easily cut into halves or quarters for smaller paintings. Light weight watercolor papers, the so-called 72 lb. and 140 lb., tend to buckle when they get wet and need stretching or mounting as I described in Chapter 3. Heavier weights, like 200 lb., 300 lb., and the very stiff 400 lb., can be tacked or taped to the drawing board, and don't need stretching; they hold their shape when wet. (Some painters stretch even 200 lb.)

Watercolor papers normally come in three surfaces; rough, which means a very coarse texture that demands bold brushwork and broad color areas; cold pressed, which still has a distinct texture, but isn't nearly so rough; and hot pressed, which is so smooth that liquid color flows across it like lightning, and only an experienced hand can control the flow. It's best to start out with the cold pressed or the rough (for your experiments with drybrush and other kinds of bold brushwork) and save the smooth paper for a later date, if ever. Few watercolorists work on hot pressed paper.

Acrylic watercolors can also be painted on smooth fabrics like silk and muslin. It's best to mount these—actually glue them down—on a sheet of Masonite, using acrylic medium or white glue as the adhesive, following the instructions in Chapter 3.

I think it's also wise to give these fabrics a thin coat of size—diluted matt medium—so that the liquid color will rest on the surface of the fabric, rather than soaking in like ink into a blotter. A coat of size, which is transparent, will preserve the natural color and texture of the cloth, which is worth having when you're painting on the delicate beige of raw silk, for example. On the other hand, if it's the texture of the cloth that you want, not the color, the cloth can be preserved—and made more receptive to acrylic paint —with a couple of thin coats of diluted acrylic gesso.

You should also try the fibrous, highly absorbent Japanese papers, which are now widely sold in American art supply stores. Some are as thin as paper towels, while others are as thick as blotting paper. You can't stretch any of these papers, but you may want to mount the thinner ones. Actually, I find that it's usually enough to tape the paper down onto the drawing board; even if the paper loses its shape when wet, the best Japanese papers will shrink smooth when they dry. It's important to remember that these Oriental papers are much more absorbent than Western papers. A wash or a stroke is absorbed into the surface of the paper as soon as the brush touches down, so a painting must be carefully planned and the execution must be quick and decisive. This is good discipline.

An acrylic watercolor can also be painted effectively on a gesso panel, which means a smooth layer of gesso on Masonite or illustration board. Before applying the gesso, the board should be roughened slightly so that the fibers stand out from the surface; then, when the gesso is applied, the board will have a slight tooth, which will hold the liquid color far better than an absolutely smooth surface. You may also want to coat the panel with gesso that's thick enough to retain the traces of the bristles of the big nylon brush used for preparing panels. If you apply one vertical coat and one horizontal coat of gesso (as described in Chapter 3), using this stiff brush so that there are hairline furrows in the dried gesso, the panel will have a crisscross texture that will keep the fluid color from running out of control. You'll find that working with fluid color on an absolutely smooth surface is extremely difficult.

Colors

In selecting your colors for the acrylic watercolor technique, it's important to pick the most transparent hues from the list given in Chapter 2. Al-though it's true that even the most opaque color becomes transparent when you add enough water or medium, it's a lot better to start out with a color which is inherently transparent.

Following the same rule of thumb given in the preceding chapter, you'll need a warm and a cool variety of each primary. For your warm blue, ultramarine is generally regarded as indispensable, while thalo blue is the best cool counterpart. A much more delicate, cool blue is cobalt, which is light and airy and more transparent than cerulean. Another delicate, transparent sky blue is manganese. I'd regard thalo and ultramarine as essential, cobalt and manganese as optional. And if you love cerulean blue—as some watercolorists do—there's no harm in having a tube around for special occasions.

Cadmium red light is on the palette of many watercolorists despite its relative opacity; this color is hard to replace. If you find cadmium red too dense, try naphthol red, which is far more transparent. Naphthol crimson or thalo crimson will give you a bright, transparent, cool red. For an earthy red-brown, I prefer burnt sienna, which is more transparent than red oxide.

Cadmium yellow light is another one of those indispensable cadmiums, which many watercolorists like, but which others find too opaque for transparent painting. Hansa yellow and azo yellow are more delicate and more transparent; you may choose one of them in preference to cadmium. Yellow ochre and yellow oxide are a bit opaque, though many watercolorists choose one of them because an earth yellow seems indispensable; you may want to try the slightly more transparent raw sienna instead—although it's more like a yellow-brown.

If you must have green on your palette, thalo is a good, transparent, all-purpose green. As I've said, another favorite of watercolorists, particularly for landscape, is Hooker's green. Chromium oxide green is too opaque; even if you add enough water or medium to make it transparent, this dense green becomes terribly washed out.

Hansa orange and indo orange red are vivid, transparent colors, which I prefer to the more opaque cadmium orange. Neither one of these strikes me as essential, since you can mix transparent oranges with Hansa or azo yellow and naphthol red, naphthol crimson, or thalo crimson.

A rich, transparent violet is acra violet, which isn't nearly as dense as Mars violet or dioxazine purple.

In the brown family, it's hard to get along without

Waterfront Composition *by Larry Webster, A.W.S., acrylic on gesso board, 30" x 40". The sheet of Strathmore hot pressed board used for this painting was coated with acrylic gesso, leaving a faintly streaky, irregular, nonabsorbent surface. The washes and strokes of fluid, transparent color then settled into the texture of the gesso, leaving a fascinating pattern of streaks and droplets. The effect seems spontaneous and accidental, but comes under the heading of "controlled accidents", which are often the essence of good watercolor painting. The streaky, spattered quality of the paint is perfectly united to the representation of the weathered texture of the old wood. This acrylic watercolor was an American Watercolor Society prizewinner.*

Palisades, Washington *by Harry Bonath, A.W.S., acrylic on watercolor paper, 22" x 30". Rough or cold pressed watercolor paper is the usual surface for an acrylic watercolor, but this broadly painted landscape takes full advantage of the irregular, slightly absorbent, handmade surface of 300 lb. Arches paper for a variety of effects. The sky is wet-in-wet. The massive rock formation combines flat washes with wet-in-wet effects. Throughout, there are linear accents and touches of drybrush. The appearance of this painting is indistinguishable from a traditional, transparent watercolor. However, there's a difference in the handling qualities of the paint. Among other things, it's easier to get thick, juicy darks in acrylic and a wet-in-wet effect is more likely to hold its place. (Photograph by Darrel Wood)*

burnt umber; though it's somewhat opaque, it's the best all-purpose brown.

Mars black is the standard black in acrylic painting, though you may find it too dense for the transparent technique. Use it with care if you use it at all. Payne's gray, like Hooker's green, is one of those colors which only watercolorists use, and it's worth having on your palette if you want a cool, transparent, atmospheric blue-gray.

Having talked so much about the importance of selecting transparent colors, I'll reverse myself for the moment and suggest that a tube of titanium white is worth having. Oddly enough, it *does* have its place in transparent painting. If you're unhappy with a passage, a smooth, thin layer of this very opaque white will restore the whiteness of the paper and allow you to start again with a fresh application of transparent color. In a roundabout way, this dense white will also give you transparent accents. Let's say you'd like to add a cluster of lightstruck flowers in a shadowy portion of the painting, or perhaps a patch of light on a meadow covered with cloud shadows. A touch of titanium white, allowed to dry and then glazed over with transparent color, will look even more transparent than a wash on white paper.

Mediums

Since the transparent acrylic technique is really synonymous with watercolor technique, your most important medium is water. Be sure to have lots of water on hand and discard a bowl of water as soon as it turns murky. Don't thin tube color with dirty water! In a technique that relies on washes of transparent color, clarity is essential.

For the painter working in traditional watercolor, water is the *only* medium—and this is one of the limitations of the technique. In acrylic watercolor painting, acrylic medium becomes the revolutionary factor. Later in this chapter, when I describe the basic watercolor techniques and how you execute them in acrylics, you'll find out why. At this point, I'll simply recommend that you keep a jar of matt medium near your water jar. Matt medium is preferable to the glossy variety, which always dries to a slight shine, even when heavily diluted with water; most watercolorists find this shine objectionable, since a watercolor is supposed to dry matt.

Although gel medium is theoretically made for impasto painting—which doesn't happen in watercolor—this thick, gummy additive turns out to be extremely useful for drybrush effects, broken color, and other kinds of rugged brushwork.

Painting Tools and Equipment

For nearly all watercolorists, soft hair brushes (sable, synthetic, and oxhair) are the basic tools. Since you're constantly washing out your brush, you need only a few brushes to do the whole job. If you've got to watch the budget, you can get by with just two or three brushes: a 1" flat or a number 12 round, or both; and a number 7 or 8 round for smaller, more precise work.

In traditional watercolor painting, bristle brushes aren't much use because they're designed to carry thicker color than the usual watery wash. But acrylic watercolor is often blended with matt or gel medium, which produces paint thick enough to be pushed around by a bristle brush. I use two long bristle brushes for acrylic watercolor painting; one is about an inch wide and the other is about half that width. Buy flats or filberts, not the shorter brights.

Because acrylic watercolor paint is often thicker than traditional watercolor, you may want to push a wash around with a blunt tool. Butter knives, ice cream sticks, chopsticks, and plastic or wood modeling tools can scrape away wet acrylic paint— particularly if it contains matt medium or gel. They can squeeze out a white line or literally act like a squeegee and push the paint from one spot to another. A sharp knife or a razor blade will make a dark line when you scratch into wet paint, but it scrapes away a white line in dried paint.

Always keep a large, manmade sponge nearby for wetting the painting surface, sponging out an unsuccessful wet passage, cleaning the palette, or sopping up spills. A small, round natural sponge can be used to remove paint from a small area or apply paint, if you wish. I've recently bought a large, rectangular manmade sponge and cut it into a variety of shapes with a scissors to create painting tools that will reach into all kinds of odd corners.

If you have a watercolor palette or compartments for mixing colors, this is equally suitable for acrylic watercolor painting. I actually keep three different kinds of palettes in the studio: a white enamel butcher tray for mixing big washes that can be allowed to run into one another; some little porcelain saucers for mixing bigger washes; and a plastic watercolor palette with compartments for squeezing out color and mixing small washes.

If you can afford one, an adjustable wooden draw-

A touch of acrylic medium—added to acrylic tube color and water—makes a flat wash far easier than it is in traditional, transparent watercolor.

Experiment with your colors to see which ones will settle into the valleys of the paper to produce a "granulated wash" like this one.

ing table—with a top that tilts to various angles—is ideal for acrylic watercolor painting. You can change the angle of the top, depending upon the technique you're using: a diagonal tilt for laying a flat or graded wash; a horizontal position for working wet-in-wet; perhaps even a vertical position if you're working with thick color modified by "gel" that won't run down the paper. A simpler, less expensive solution is a big sheet of wallboard—Celotex, Upson, or Homasote—that's soft enough to take tacks or pushpins. Books of different thicknesses, propped under the board, will give you different working angles.

Other essential items are a roll of 2" or 3" wide brown wrapping tape if you're going to stretch paper (see Chapter 3); a fistful of thumbtacks or pushpins for tacking down thicker paper that doesn't need stretching; a roll of masking tape for taping down unstretched paper if you don't like pushpins; a roll of paper towels for cleaning up, for lifting wet paint, and occasionally for applying paint; and perhaps an eyedropper for adding medium to a mixture. I also use my stock of old ice cream containers, plastic margarine tubs, and discarded dishes for 100 odd purposes, like storing damp sponges, holding crumpled paper towels, and even mixing colors.

Flat Wash

The first technique that every watercolorist learns is laying a flat wash, which means an area of color that's more or less consistent throughout: the same hue, value, and density. If you've painted in watercolor before, you know that this isn't easy for the beginner to do. I'm going to review this—and other basic watercolor techniques—not merely to refresh your memory, but to suggest how these techniques can be simplified and enriched by acrylics.

The usual method of laying a flat wash is this. You mix up a wash in a saucer, making sure that you've got more than enough color, so you won't run out. You then load one of your larger brushes, zero in on the area to be covered by the flat wash, and draw a slow, steady stroke across the top of the area. The drawing board should be tilted slightly (say 15° to 30°) so that the color drifts down the paper and forms a long, narrow pool along the bottom edge of the stroke. You then load the brush again and draw a second stroke beneath the first, slightly overlapping the pool at the bottom of the first stroke. The long, narrow pool that forms at the bottom of the first stroke now rolls down across the second stroke and reforms along the new bottom edge. You keep re-

peating this process, overlapping the strokes and bringing the pool down, until you get to the bottom of the area you want to fill with color. At the bottom, you sop up the pool with the tip of a clean, moist brush, which acts something like a blotter.

The beginning watercolorist always finds it terribly difficult to get even coverage when he tries to lay a flat wash. There are usually dark spots, light spots, spots which are improperly covered, and all kinds of irregularities which mar the smoothness of the wash. If you've been through this nightmare, you'll be relieved to discover that a brushload of matt acrylic medium, added to the saucer that contains the wash, makes the whole job a lot easier. The wash seems just as fluid, but it's imperceptibly thickened by the brushload of medium. The wash is just a bit creamier and therefore rolls down the paper more smoothly, giving much more even coverage. Try it and you'll see. But remember that the wash now contains three components—color, water, and medium—so be sure to stir each time you dip your brush into the saucer, in order to make sure that the components are properly blended before you apply color to paper.

A graded wash is even harder to execute successfully than a flat wash. Dilute your acrylic tube color with water and a touch of acrylic medium.

Graded Wash

Even harder than the flat wash is the graded wash, which means a color area that moves from light to dark, from dark to light, or from one color to another. The usual method is to mix up a saucer of color once again, load the brush, and draw that first stroke across the top of the color area. With the board slightly tilted, the long, narrow pool forms at the bottom of the stroke as it did when you painted the flat wash. But this time, when you recharge your brush, you pick up some water and then some color from the saucer. The brush is now loaded with slightly diluted color and the second stroke is therefore lighter than the first. With each successive stroke, the brush carries more water and less color; the pool that forms at the bottom of the stroke gets paler and paler and finally ends up as pure water by the time you reach the bottom of the wash. You then sop it up with a moist, clean brush to eliminate the pool.

To grade one color into another, you actually lay two graded washes. Let's say you want a sky which is dark blue at the zenith, and becomes paler and paler toward the horizon, where a pink glow appears. You start out with a blue graded wash from the top of the paper and taper it down to pure water. When the

Applied to a wet surface, a stroke of tube color heavily diluted with water (top) quickly blurs. Diluted with matt medium (center), the stroke is even more distinct, despite the underlying wetness.

Here's another example of how mediums affect wet-in-wet painting. The pale, indistinct strokes (left) are tube color and water. The darker, more precise strokes (center) are tube color and matt medium. The dark, heavy strokes (right) are tube color and gel.

Adding matt medium to a wet-in-wet passage gives you more freedom to push color around, add color, or remove it.

blue wash dries, you turn the paper around so the picture is upside down, and then work a pinkish graded wash from the horizon down over the blue, starting with pink and ending up with pure water.

This sounds difficult and it *is* difficult. Matt acrylic medium makes the job a lot easier. Not only do you mix your colored wash with a brushload of acrylic medium, but you fill a saucer with clean water which has also been modified with a brushload of medium. Instead of adding pure water to the brush as you lighten the wash, you add the mixture of water and medium. The wash won't look or feel particularly different, but it definitely goes onto the paper more smoothly and the gradation is a lot easier to control.

When you're painting a graded wash—particularly if you're working with two colors—acrylic has distinct advantages over traditional watercolor. If you don't get the graded wash dark enough the first time (which often happens) or the color isn't exactly right, just let it dry and put a second graded wash on top of the first. The new wash will modify the old one without disturbing it. If you're laying a two color graded wash, like the sky I described a moment ago, you always have to worry about one color dissolving another when you work in traditional watercolor. When you work in acrylic, you just let the first wash dry and then put down the second wash; there's no danger of their coalescing and turning to mud.

Wet-in-Wet

The most exciting and unpredictable watercolor technique is wet-in-wet (the wet paper method). You sponge or brush a wash of clear water onto the painting surface—or a wash of color—and plunge back into the wetness with brushloads of fresh color. The strokes spread and blur while you fight to steer them into the right places, dabbing on more color, picking up or wiping away color where you don't want it to go, tilting the board this way and that way to move the color onward or roll it back. You're never sure how a wet-in-wet passage will turn out until it's dry, which is why this technique is so dramatic and often so frustrating.

Painters who work wet-in-wet soon discover that the thicker their color, the more control they have. This is where the acrylic mediums become enormously valuable. If you work into the wet surface not simply with tube color, but with a blend of tube color and matt medium, you find that your strokes

hold their shape more precisely. The color still blurs and moves across the paper, but more slowly and with greater control. There's less danger of the stroke running away with itself or blurring beyond recognition. It's also easier to wipe away a stroke with a clean, moist brush or sponge. You can have even greater control if you blend tube color with gel medium and then work into a wet passage with this extremely gummy color. The stroke will soften slightly, but hold a definite shape.

In short, the acrylic mediums give you a remarkable range of paint consistencies to choose among. If you want a wet-in-wet passage to be blurry and evanescent, then you can work into it with tube color diluted only with water. If you add a little matt medium, the stroke will hold its shape a bit better. The more medium you add, the more precise the stroke will be. And if you switch to gel medium, the stroke will retain maximum solidity.

The best way to lay a dark, flat wash is in a series of light, flat washes, gradually building up to the density you want.

Multiple Overwashes

Because a fresh, wet overwash won't dissolve a dry underwash as it often does when you work in traditional transparent watercolor, you have much more latitude to experiment with multiple overwashes when you work in acrylic.

The most dramatic example is that bane of the watercolorist's existence, the dark wash. Before I tried painting in watercolor, I always wondered why I saw so few night scenes in watercolor exhibitions. Then, when I tried putting down a dark wash for a night sky, I understood. It really takes a master to lay a dark, even wash, whether flat or graded. Light washes are easy, but a really deep, solid tone is agony. You mix up a saucerful of deep color, work fast, and pray. Once the color is down, you can never touch it again for fear of picking up that thick, fragile layer of tone, so your mistakes are there forever. And working with color of such density, you *will* make lots of mistakes. Almost inevitably, dark washes are full of smudges and blotches.

Working in acrylics, you'll find that laying a dark wash—whether flat or graded—is infinitely easier because you can build the wash in a series of stages. In traditional watercolor, you've got to make it on the first try and get just the degree of darkness you want, or scrap the painting and start over. But acrylic allows you to build a dark wash by overlaying a series of light washes, one upon the other, until you get the density you want. One wash won't dissolve another, no matter how much paint you've got piled

A dark, graded wash (even harder to paint than a flat one) can be a series of light, graded washes, one over the other.

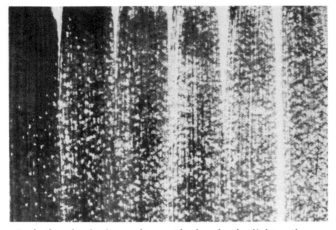

In drybrush, the less color on the brush, the lighter the stroke will be. These strokes move gradually from a loaded brush (left) to a semi-moist brush (right). Acrylic medium was added to make the paint just a bit thicker.

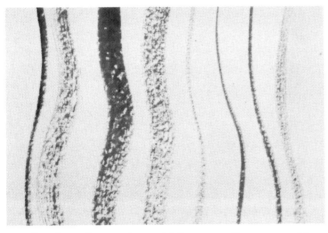

Drybrush strokes can be as thick as your finger or as thin as a wisp of hair, depending upon the thickness of your brush and how hard you press down on the paper.

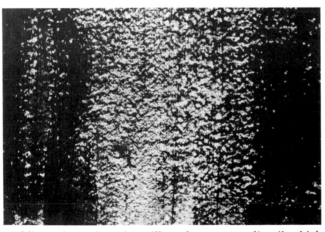

Adding gel to tube color will produce extraordinarily thick paint for extremely coarse drybrush passages.

up on the surface. To get a dark flat wash, you merely lay a series of light washes. To get a dark graded wash, you can either put down a series of light graded washes, or start out with a couple of graded washes and then cover these with a series of flat washes, which will allow the graded washes underneath to show through.

Acrylics will also allow you to put one type of wash over another with complete abandon. You can not only put a flat wash over a graded wash—or vice versa—but you can lay a groundwork of one color, let it dry, sponge it with clear water or coat it with a fresh wash, then work wet-in-wet. No matter how much you scrub and move around the wet-in-wet passage, you won't dislodge the underlying color. Such a combination of flat, graded, and wet-in-wet passages might be just right for painting some complicated subject like a stormy sky at sunset.

Although most watercolorists agree that it's dangerous to lay more than two or three washes over one another, acrylic allows you to put down as many washes as you please. This can be particularly important when you're struggling to get exactly the right color. Suppose you put down a blue wash, to be followed by a yellow wash in a certain area to produce a particular green. If you haven't put down quite enough yellow, you can go back again with a second yellow wash. Or you can go back again with a new blue wash. Or you can tone the whole thing down with a pale wash of some earth tone. You can keep going indefinitely, provided that you stop just short of the point where your color turns to mud.

Drybrush, Scumbling, and Broken Color

In the traditional watercolor technique, drybrush is an important but limited technique. You can dip your brush into fluid color; wipe the hairs on a paper towel or a sponge until just a trace of paint remains; then skim over the surface of the paper so that the paint just touches the highpoints of the paper's texture. Or you can dip your brush into gummy tube color, more or less undiluted with water, so the paint leaves the brush reluctantly and you deposit only a faint trace of color as you skim the painting surface.

You can work the same way with acrylic watercolor, skimming the paper with diluted color or with color straight from the tube. But two acrylic mediums make it possible to adjust your paint consistency much more precisely. Tube color diluted with matt medium retains its transparency, yet handles more like oil paint, so you're actually work-

ing with thick, transparent color—a paint consistency which is a lot more cooperative than color straight from the tube *or* color diluted with water. And for really rugged drybrush textures, you can blend tube color with gel medium, which produces really dramatic drybrush strokes. By diluting your paint with varying degrees of water and medium—whether matt or gel—you can produce exactly the paint consistency you want for a particular drybrush passage. Gel may be just right for the craggy texture of cliffs along the shoreline, while color diluted with water and matt medium may be right for the more subtle drybrush textures of a rotting wooden wharf.

In the preceding chapter on the opaque technique, I've already described the scrubbing, back-and-forth stroke known as scumbling. I hope you've tried out various kinds of scumbling strokes. This technique is rare in traditional watercolor because the paint is too fluid; if the paint is thick enough for scumbling, the color is likely to turn opaque. But matt medium permits transparent scumbles in acrylic watercolor painting. With just a touch of color and a great deal of medium, you can produce scumbles of extreme transparency and delicacy. A more even balance of tube color and medium will produce richly textured, vivid, transparent hues. And you can build one transparent scumble over another—as long as you allow the underlying color to dry. Try various combinations, like a transparent scumble over a flat wash; a wet-in-wet effect over a scumble; a flat wash, followed by a scumble, followed by drybrush. I'm sure you can think of lots of combinations.

Both drybrush and scumbling are ideal for broken color effects. Painted over an underwash of another color, a scumble or a series of drybrush strokes will contain scores of little breaks through which the underlying color will shine. Think of some complicated effect of color and texture, like the shadow side of a ship which is picking up reflected light and color from the water: a flat or graded wash might be just right for the local color of the ship, followed by a couple of scumbles for the shadow and reflected light, completed by a few touches of drybrush for the rust that accumulates on an old hull.

Tube color which has been modified with matt or gel medium also lends itself to texturing with tools other than brushes. This slightly gummy paint can be pushed around with the blunt knives, ice cream sticks, chopsticks, or modeling tools I mentioned earlier. You can also use your fingers—until it dries, it can be handled almost like fingerpaint. Brush out a passage of tube color blended with medium, put

What might be called a "drybrush wash" is produced by a semi-wet brush held roughly parallel to the paper. You pull the brush across the painting surface as you press the bristles down against the paper with the fingers of your other hand.

For a transparent scumble, it's best to mix tube color with medium and water. Many of the irregular flecks of color are actually bubbles produced by the scrubbing motion of the brush.

A layer of wet color, thinned with matt or gel medium, can be scraped with various blunt tools, ranging from a toothpick to a butter knife. Don't dig into the paper; just squeeze or push the color away.

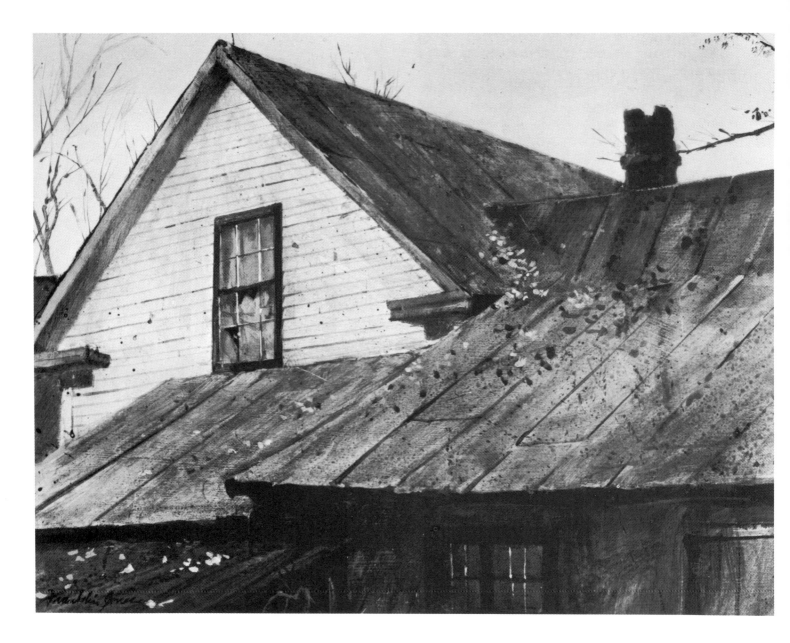

The Attic Window by Franklin Jones, acrylic on Masonite panel, 11" x 14". The artist recalls: "I saw this place in upstate Vermont on a gray, cold day, and the window suggested to me that this might be an attic just like the one I crawled up to on such days in my youth." The painting was done without any preliminary studies. The roof was blocked in first with opaque red-orange tones, and then overpainted with a number of tranparent washes of silvery gray. For the lower area of the building the artist used transparent umber tones; the clapboard area was painted in a series of delicate washes, warm and cool, applied after the boards were indicated. A little spatter work was applied to the roof before the autumn leaves that had been caught on the wet surface were indicated. The window—the focal point of the composition—was carefully rendered with opaque color. Although there are obvious opaque passages, the painting has definitely transparent quality. This is, in a sense, an acrylic watercolor on a gesso ground. One of the great advantages of acrylic as a watercolor medium is that the color retains its transparent flavor even when combined with opaque passages. Glazed over with a wash of fluid color, an opaque passage suddenly appears transparent.

down the brush, and see what you can do to the color with various improvised tools.

Corrections and Alterations

Correcting a traditional watercolor is never easy; you can try sponging out an offending passage, scrubbing it out with a wet bristle brush, or even dunking the whole sheet in the tub and starting over—but the odds are against you. Corrections always look like corrections and it's usually best to chuck the painting and start over.

In one sense, corrections are even harder on an acrylic watercolor. You can't sponge anything out once it's dry; nor can you soak anything out. But you can reach for that tube of titanium white or that can of acrylic gesso and paint out the part that's gone wrong. If you do the job carefully, you create the illusion that you've gone back to the bare paper. You now have a chance to repaint the passage and get it right, though you'll find that washes on gesso handle differently from washes on paper, which is obviously more absorbent than white paint.

Instead of painting out a passage entirely, you can also try laying a semi-opaque wash of titanium white (perhaps tinted with another color) which will reduce the passage to a kind of ghost. You can see just enough of the original form to follow it with the brush, yet you're free to modify the color and texture, as well as add detail.

Of course, the ultimate correction is to chuck the painting altogether, as you often have to do with an unsuccessful watercolor. Here's where acrylic gesso becomes a money saver. A couple of thin coats of gesso will obliterate the painting and give you a fresh, white sheet for a new picture. You're now working on gesso rather than on bare paper, but if you apply the gesso thinly enough, the original texture of the paper will come through. I've always found it a great comfort to have that big can of gesso available for those terrible moments when I've spoiled a costly sheet of 300 lb. paper. A few cents worth of gesso will rescue my investment.

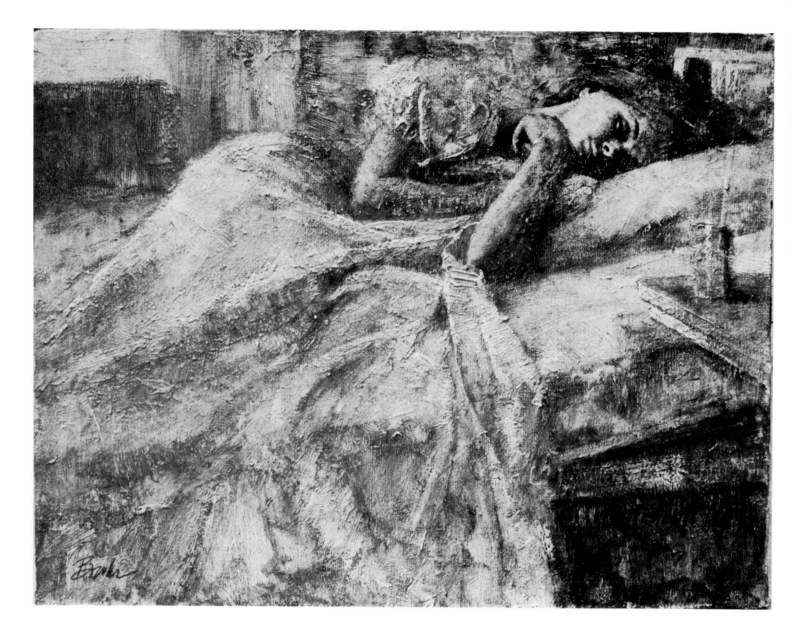

Illustration for McCall's *by Joe Bowler, casein and acrylic medium on canvas, textured with acrylic modeling paste, 12" x 16". This very elaborately textured example of underpainting and overpainting began with a rough layer of granular acrylic modeling paste being applied to the canvas. The rough strokes of paste are combined with the weave of the canvas to provide an impasto pattern that follows the forms painted over it. Compare the texture of the girl's sleeve with that of the blanket: in each case the underlying impasto strokes match the subject. Instead of working directly with acrylic tube color to complete the painting, the artist combined tube casein with liquid acrylic medium. The forms were then built up in a series of glazes that settled into and around the underlying textures. The final effect is a surprising combination of roughness and delicacy.*

7
Underpainting and Overpainting

The old masters often divided the execution of a painting into several distinct phases. A portrait was often begun in monochrome—just shades of gray or brown—with the artist concentrating entirely on problems of drawing, light and shade, and likeness. Once he got the forms right, the artist would allow this monochrome underpainting to dry, and then move on to tackle the problems of color. Working with glazes of transparent and semi-transparent color, and with scumbles of semi-opaque color, the artist would transform the monochrome underpainting into full color with one or more overpaintings. The overpainting was just transparent enough to allow the underpainting to show through. The technique was something like washing transparent color over a black and white drawing.

Of course, there are lots of other underpainting and overpainting methods. You can underpaint something in one color and then overpaint it in a different color, creating the kind of optical mixture I've already described. Thus, many old masters underpainted their flesh tones in a soft, earthy green, then overpainted this cool tone with warmer color. The green lent a delicate coolness to the shadows and heightened the warmth of the contrasting light areas.

The range of possibilities is limited only by your imagination. You can underpaint in warm colors and overpaint in cool ones. You can paint warm over cool. Or you can alternate warm and cool colors like Titian, who claimed to use as many as thirty or forty glazes in a picture. You can also paint one warm color over another to produce a hotter tone than either color would give by itself. You can use a cool underpainting to reinforce a cool overpainting. You can work with colors that support each other, con-trast with each other, subdue each other, or heighten each other.

The techniques of underpainting and overpainting may be familiar to many oil painters. You probably know that certain oil colors, like certain hues in acrylic, are more transparent than others. Well diluted with painting medium (usually a blend of linseed oil, damar or copal resin, and turpentine), these transparent oil colors can be made into glazes that are brushed over the dried color beneath. A more opaque color can also be thinned with medium to produce a somewhat less transparent glaze, which still allows the underlying form or color to shine through. The problem with oil paint, however, is drying time. A fresh layer takes a day or more to dry. If you're planning a series of underpaintings and overpaintings, the job can take weeks, even months, when you consider the drying time required for each layer.

Although we associate acrylic with rapid-fire contemporary painting methods, this new medium turns out to be ideal for the traditional underpainting and overpainting techniques of the old masters. The various acrylic painting mediums—gloss and matt medium, as well as gel—will turn tube colors into beautiful glazes. The miraculous titanium white will turn any glaze into a semi-transparent or semi-opaque mist, allowing you every possible degree of transparency from glassy-clear to an effect like colored fog. And acrylic dries so rapidly that you can put down a dozen layers of paint in a single day, or even more. Not only can you break the underpainting into several stages, but whiz through all the stages of the overpainting in a single day, if you can work that fast. Titian's thirty or forty glazes literally took

months to dry; acrylic will let you get the job done in a few days.

Painting Surfaces

If you're planning a picture that's going to require a long series of opaque, semi-opaque, semi-transparent, and transparent layers of color, canvas is usually the best painting surface. Multiple layers of paint retain more vitality on the irregular weave of linen or cotton canvas than on the smooth surface of a panel. I'd strongly recommend that you work on canvas which is well coated with acrylic gesso, not on the beige or brown tone of the raw fabric. When you're applying so many layers of color, you're going to want the inner light of the gesso to shine through and keep your color fresh and vibrant. It's too easy for multiple underpaintings and overpaintings to turn muddy, and the luminous white of the gesso helps to counteract this tendency.

For a simpler underpainting and overpainting technique, perhaps just two or three layers of color, the smooth surface of a Masonite panel is just as good as canvas. But once again, I urge you to work on gesso to retain that inner light. The old masters liked their gesso panels as smooth as ivory for maximum light reflection. If this is what you want, apply your gesso in a series of very thin, smooth coats, using the softest nylon brush you can find. On the other hand, if you like a panel with a certain amount of texture, apply your gesso more thickly in one horizontal and one vertical coat, as I've already described. On the latter surface, liquid glazes have an interesting way of settling into the brushmarks left in the gesso, lending a certain irregularity to the color, similar to the irregularity of the weave in linen canvas.

There's no reason why you can't try underpainting and overpainting on illustration board or watercolor paper. This is really what the watercolorist is doing when he puts one wash over another. In the preceding chapter, I suggested obliterating an unsuccessful watercolor with a layer of gesso in order to save that expensive paper. This is a splendid surface for this complex technique, since the gesso coating will stand more punishment than the bare paper.

I might add that an unsuccessful transparent watercolor can sometimes be "saved" by switching to a technique which combines opaque and transparent color. Try repainting the unsuccessful parts in opaque color and then glaze over them with transparent color. It may no longer look like a watercolor—more like a painting in designers' colors, gouache, or tempera—but you might just turn a failure into an effective picture after all.

For the multiple phases of underpainting and overpainting, I think it's pointless to select a very rough fabric like jute or burlap, and equally pointless to try a super-smooth fabric like silk or muslin. If you're working with brilliant color, the roughness of the fabric will fight you and subdue the brilliance; on the other hand, if you're working with veils of subtle color, the insistence of the texture will obscure the subtlety. A smooth fabric will be wasted because the weave will quickly disappear under the repeated paint applications, so you might just as well start with a smooth gesso panel.

Colors

In the preceding two chapters, I've tried to isolate those colors which are dense enough for the opaque technique and those which are transparent enough for what I've called the acrylic watercolor technique. For the underpainting and overpainting method, you'll want *both* types of colors: the more opaque colors for the early stages of the picture and the more transparent ones for the later stages.

Because of its limited tinting strength, ultramarine blue is probably the best all-purpose blue for underpainting mixtures; although ultramarine is transparent in itself, it mixes well with the more opaque colors which are the norm in an underpainting. The bright, very transparent thalo blue is more suitable for transparent glazes, though ultramarine is also a good glazing color. Cobalt and manganese blues are optional, as I've said before, but will give you airy, atmospheric glazes. The denser cerulean blue can produce subtle mixtures for your underpainting and interesting semi-transparent tones in the overpainting.

Cadmium red light can be equally useful in the earlier and the later stages of the picture. Its dense opacity can lend weight to the underpainting; thinned with medium, cadmium red light still retains enough strength for an effective glaze. The dense, earthy red oxide also lends body to underpainting mixtures. The clarity of naphthol red, naphthol crimson, and thalo crimson makes them beautiful glazing colors. Burnt sienna, a fiery red-brown earth tone, takes lovely glazes, but also warms more opaque mixtures for underpainting.

Like cadmium red light, cadmium yellow light is

SUGGESTING TEXTURE AND DETAIL

Forgotten *by Claude Croney, A.W.S., acrylic on watercolor paper, 14" x 20". Working on 300 lb. rough Arches watercolor paper, Croney uses the extremely ragged texture of the sheet as a basis for very bold drybrush strokes. The painting surface breaks up the stroke in a way that suggests the weathered wood in the foreground and permits a particularly interesting passage of broken color—combining warm and cool—in the upper right. Notice the slight spatter effect in the lower right, which harmonizes easily (and almost invisibly) with the drybrush. The twigs in the immediate foreground are scratched and scraped into the painting with a sharp instrument.*

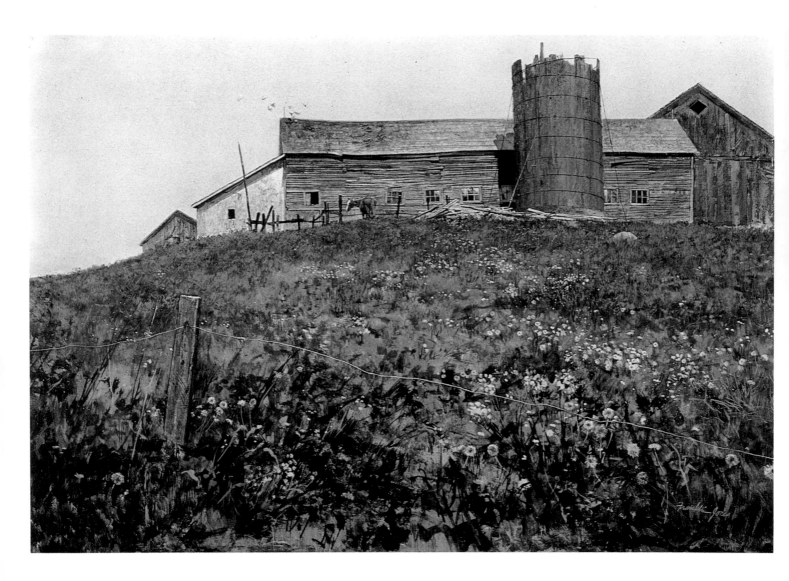

ENRICHING COLOR WITH GLAZES

Vermont Memorial *by Franklin Jones, acrylic on Masonite, 24" x 30", collection Mrs. Albert Dorne. "In this painting," the artist explains, "I wanted to suggest lots of texture in the buildings, even though they're quite distant. In order to concentrate on this and not lose the simple tonality of the value pattern, I first painted the entire subject in almost a single color. Then, when I was satisfied with the degree of texture, I added color with transparent glazes: ochre tones for the long barn; a faded red for the silo; and a blue gray for the barn at the right. The color in the field was built up with successive transparent glazes of greens, blues, and ochre tones. The blossoms of the dandelions were added last. The sky was first put in as a pale blue, flat tone; then a transparent, almost invisible glaze of red orange was brushed on."*

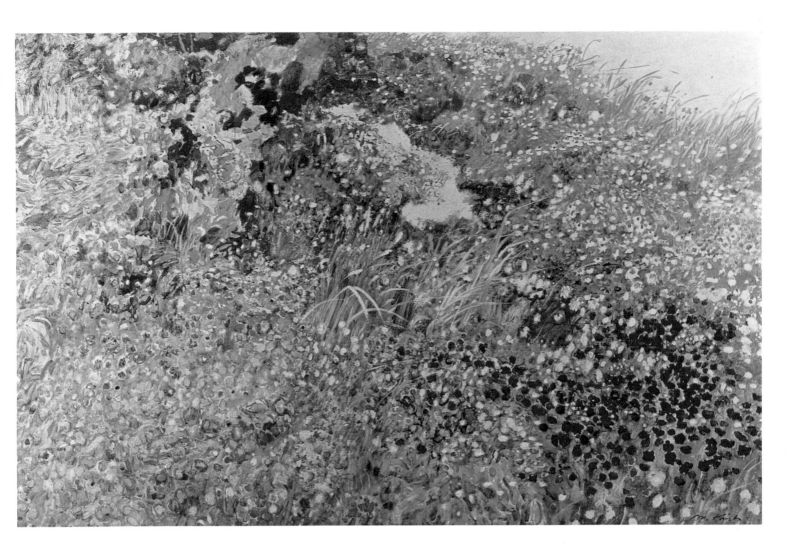

CONTROLLING BRUSHWORK

Wildflowers, Quiberon *by Morton Kaish, acrylic on gesso panel, 48" x 72", collection Mr. and Mrs. John S. Hilson, New York. The fantastically elaborate and detailed pattern of the flowers never degenerates into chaos in this beautifully controlled painting. The brilliant touches of the brush are carefully clustered—like the red flowers in the lower right and the orange flowers in the lower left— to maintain a subtle sense of order. There's also surprising variety in the strokes: compare the round blobs of color in the foreground with the long, graceful strokes in the center and in the upper right. And nothing is more important than that tiny area of calm in the upper right hand corner. (Courtesy Staempfli Gallery, New York)*

ADDING SAND FOR TEXTURE

River Passage by Edward Betts, N.A., A.W.S., acrylic and sand on Masonite panel, 36" x 40", Indianapolis Museum of art, Indianapolis. The granular texture of the sand is almost invisible, disappearing beneath the intricate color of this semiabstract landscape. You can see a slight hint of the sand in the irregular texture in the lower right. But the sand is never used as a gimmick, never allowed to dominate the painting and strike a false note.

Far more dramatic are the seemingly accidental—but carefully placed—notes of texture like the blobs of paint that suddenly appear at odd places in the foreground. These textures, like the splashes of color in the distance, are the kind of "controlled accidents" that may be more familiar in watercolor painting, but which can have great impact in textural painting and collage. (Courtesy Midtown Galleries, New York)

COMBINING COLLAGE WITH TUBE COLOR

Coastal Reef *by Edward Betts, N.A., A.W.S., acrylic, collage, and sand on Masonite panel, 32" x 48", collection Atlanta University, Atlanta, Georgia. In planning a combination of painting and collage, the most difficult thing is to decide where the collage elements should integrate and perhaps disappear beneath the paint—and where they should leap out and identify themselves. Here, the one clearly defined collage element is the green, squarish shape below. In the rest of the painting, it's difficult to tell where paint ends and collage begins. There are two opposite points of view about how to use collage. Some painters plan their design carefully and place the collage elements in predetermined spots to enhance the design. Other painters cement the collage elements to the painting surface in a random, purposely unplanned way which becomes the point of departure for the pictorial design; the "accidentally" placed shapes trigger the artist's imagination and suggest the picture.*

GRANULATED WASH

Shelter Rock Farm by John Rogers, acrylic on watercolor paper, 22" x 28". The blue shadows on the foreground snow are a so-called granulated wash, with the pigment settling into the valleys of the paper to form a granular pattern. The deep shadows on the dark sides of the buildings are particularly easy to render in acrylic, which permits the painter to put down a series of washes, one over the other, until he achieves exactly the right density.

PRODUCING VARIED WASHES

Larry by Seymour Pearlstein, acrylic on watercolor paper, 19" x 24". Although acrylic watercolor lends itself to thin, relatively textureless washes—like those in the upper part of this painting—slightly thicker color, or a slightly dryer brush, will produce the lively, streaky textures seen in the lower left. As in his more opaque acrylics, painted on canvas, this artist applies his color with a minimum of modeling, but designs his compositions as a series of fairly flat areas. However, each flat area is enlivened by free brushwork that ranges from the mottled wash at the right to the streaky, scrubby areas at the left.

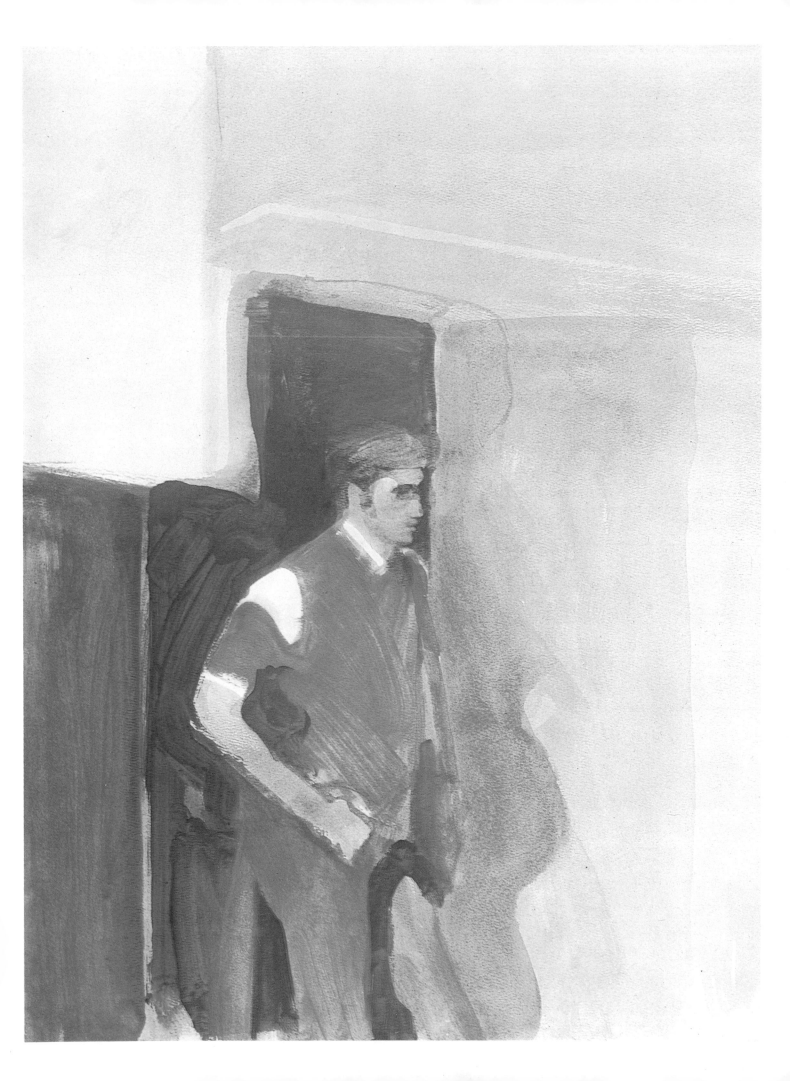

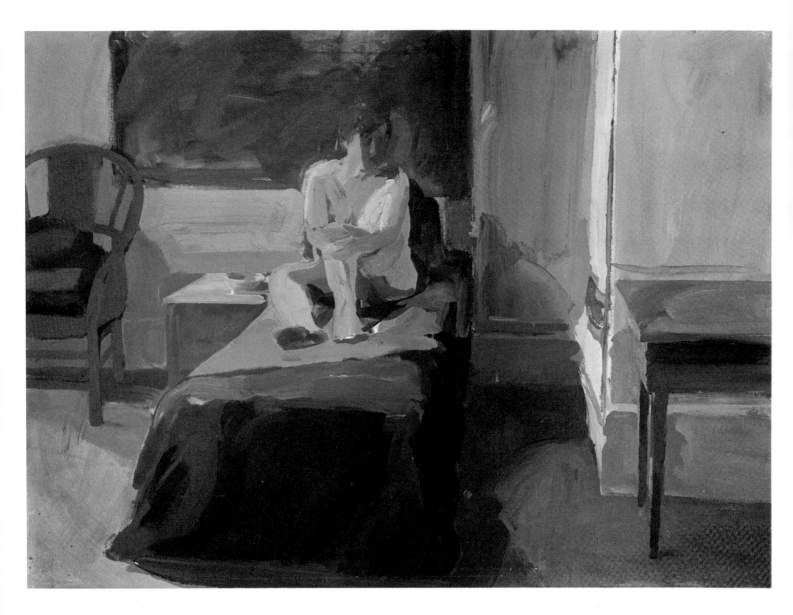

BRUSHSTROKES MAKE THE DESIGN

Margaret *by Seymour Pearlstein, acrylic on canvas, 50" x 67". This bare compositional scheme is essentially an arrangement of rectangular shapes, relieved only by the free form of the figure, the folds of the drapery in the lower left, and the round back of the chair. However, the geometry is greatly enlivened by the free brushwork, which breaks all the shapes into ragged, unpredictable textures. On one side of the figure, the brushwork consists of long, vertical strokes, while on the other side of the figure, the strokes suddenly become horizontal. In the warm shape directly behind the figure, the strokes keep changing direction.*

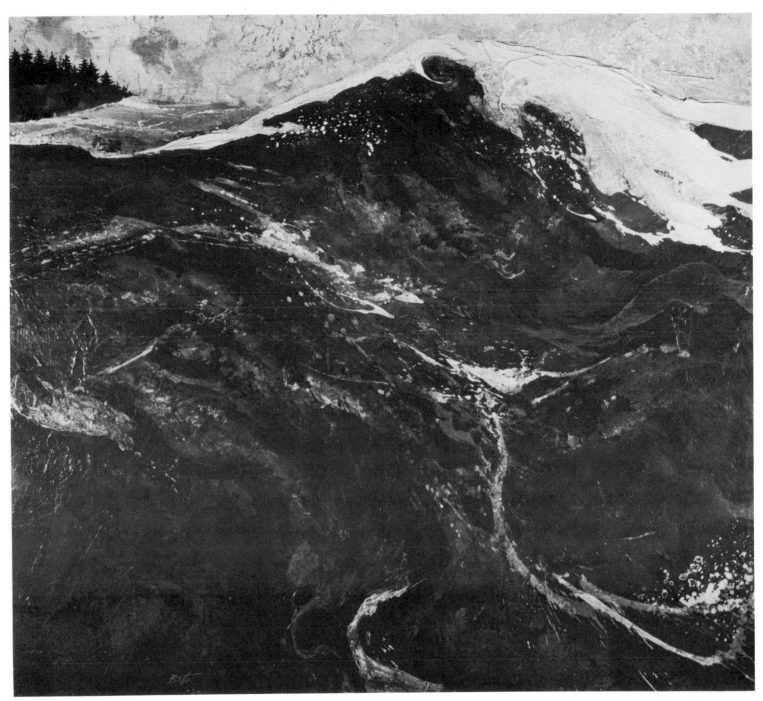

Great Wave *by Edward Betts, N.A., A.W.S., acrylic on Masonite panel, 36" x 40". To produce luxuriant effects of color and texture, this artist often begins with an "underpainting" of crumpled tissue, stuck to his board with acrylic medium, then washed over with layer upon layer of luminous, transparent color. The series of glazes produces a feeling of depth—of color within color—that communicates the sense of deep water. The thick crest of foam at the top of the wave in this painting is an impasto passage that can be achieved with gel medium or even with modeling paste. Notice the spatter effects in the lower right hand corner and beneath the crest of the wave. (Courtesy Midtown Galleries, New York)*

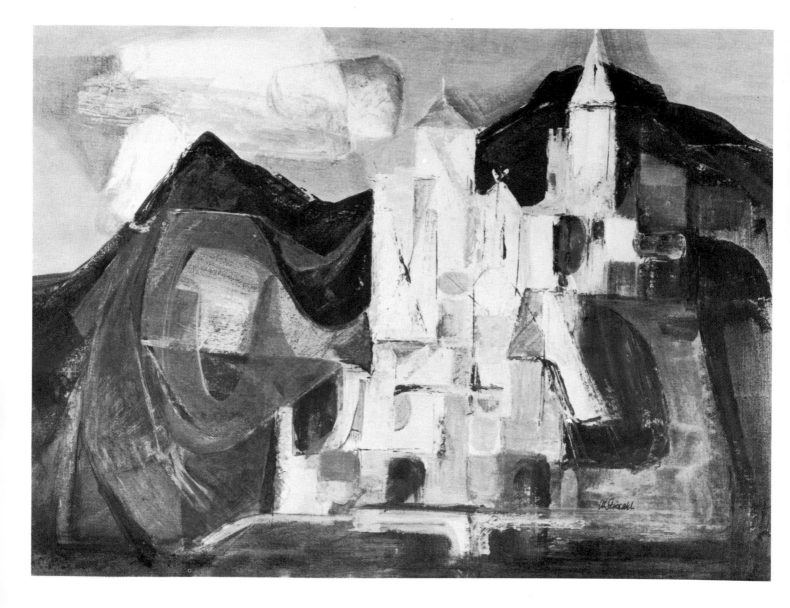

Mountain Town *by William Strosahl, A.W.S., acrylic on gesso panel, 22'' x 30''. The painter established his design in flat, slightly scrubby tones that broke the painting surface into a series of color areas. Over this rather abstract underpainting, he applied various glazes and scumbles: passages of transparent, semi-transparent, and semi-opaque color that permit the underlying tones to break through. Most interesting are the broken color effects in the buildings, where darker undertones constantly shine through the light areas. Throughout, the painter has used a method familiar to oil painters: thin, fairly fluid color is applied first, building up toward final passages of thicker, dryer color.*

equally useful in underpainting and glazing. Either yellow ochre or yellow oxide seems essential for a dusty, earthy tone, whose subdued warmth is ideal for underpainting. Hansa or azo yellow, both pure and transparent, are superb glazing colors.

The opaque chromium oxide green is primarily an underpainting color, while the brilliant, transparent thalo green is best for glazes. If you're accustomed to viridian in oil, you'll find that thalo green can perform many of the same functions.

Cadmium orange is equally useful in underpainting and overpainting, while Hansa orange and indo orange red are essentially glazing colors because of their extreme transparency.

Mars violet and dioxazine purple are both dense colors with considerable hiding power, though I find it hard to imagine much use for violet in an underpainting. The more transparent acra violet makes handsome magenta glazes.

Burnt umber is a workhorse color, the most useful brown for underpainting mixtures. Although it's fairly opaque, burnt umber can be diluted for glazing and for mixing with transparent colors. Raw umber is too subdued for overpainting, but adds a subtle note in underpainting mixtures. Although raw sienna is somewhat opaque, and therefore lends itself to underpainting mixtures, it can also be diluted with medium to make a handsome transparent tone.

Mars black is too dense and too powerful for overpainting; keep it out of your glazes, or it'll turn them to mud. There may be times when you'll want a touch of black in an underpainting mixture, although browns or blues make far better grays.

Because underpainting and overpainting require both opaque and transparent colors, you may want a more diversified palette for this technique. Let me review the colors that strike me as essential. Among the blues, only thalo and ultramarine seem indispensable. Cadmium red light is the best opaque red, naphthol or thalo crimson the most useful transparent reds, and burnt sienna serves well as an all-purpose earthy red-brown. Cadmium yellow light is the ideal opaque yellow; Hansa or azo can serve as your transparent yellow; and yellow ochre is the dense, earthy yellow you can't do without. Greens always strike me as optional, although thalo green is a beautiful glazing color. Oranges and violets are optional, too, but Hansa orange and acra violet make lovely glazes. Burnt umber is your indispensable brown. And I think you can get along without black altogether. So the list isn't quite as long as it might have looked.

Mediums

For this multiple-phase painting technique, you'll want the full range of mediums. Each of them has its own special use.

In the underpainting, I find matt medium best, because I want the early stages of a picture to dry without any shine. At this stage, you're usually working with subdued color, and a shiny surface seems out of place. Particularly when I'm working with subtle tonal effects, like warm and cool grays, I find a shiny surface confusing.

For the transparent glazes that finish off the picture, I like gloss medium. Glazes, after all, are supposed to be shiny and luminous. Gloss medium seems to heighten the amount of light that bounces back from transparent color.

Gel medium, which is transparent too, will also lend luminosity to transparent color in the later stages of the painting. But gel has the additional virtue of adding texture, since it thickens the paint. For this reason, you may want to try gel for the richly textured impastos which often characterize the underpainting; and you may want to blend your transparent color with gel for an effect which is unique to acrylic—an impasto glaze. Gel is also perfect for those thick accents and final touches, like an impasto highlight on a metal still life object or a thick burst of reflected color where the sun flashes across the sea.

To give you additional time to brush out a glaze, retarder can be valuable; but if you want to apply one glaze after another, you've got to remember that retarder slows down drying time and may delay the job.

Painting Tools and Equipment

Because the underpainting is usually thick, opaque, and sometimes roughly textured, this is the place for bristle brushes and painting knives. The long flats and filberts are your general purpose brushes for underpainting, but you may also want to pile on thicker gobs with the shorter bristles known as brights. Even bolder textures can be built up with the painting knife, particularly if you blend your color with gel medium.

For the later stages—which means glazes and scumbles—you may want your long flats and filberts once again, but this is also the place for soft hair brushes like sables, synthetics, and oxhairs. These softer brushes will hold lots of fluid color and will move freely over the rough surface of the underpainting.

A moment ago, I mentioned something which will seem like a contradiction in terms to the experienced oil painter: an impasto glaze. In oil painting, a glaze is *always* thin, since it's mostly medium. But acrylic gel is both transparent and *thick*. You can blend it with tube color to produce a transparent paste that goes on with a painting knife.

It's also worthwhile to try glazing with a sponge. A small, natural sponge (bought at the drugstore) will rub a glaze into the surface almost as deftly as your fingertips. And once again, I might mention the big manmade sponge that I cut into a variety of shapes for pushing liquid paint into odd places. In fact, it's easy to underestimate the sponge as a painting tool.

Rags and paper towels are useful not so much for applying paint as for wiping it away. On a richly textured surface, covered with the grooves left by bristle brushes, you may want to apply a glaze that sinks into the grooves, but doesn't rest on the high points. You can get the effect you want by brushing liquid color over the entire area, and then lightly wiping the high points with a rag or paper towel, so that the color settles only into the valleys. This technique accentuates textures like tree bark, weathered rocks and wood, or even a head of bushy hair.

For the underpainting and overpainting technique, I find that it's best to have two different types of palettes. For the thick, opaque mixtures used in the underpainting, something like an enamel butcher tray, a sheet of glass or metal, or even a paper tear-off palette, is best. It gives you plenty of mixing space, and there's no danger of fluid color running off the mixing surface. But for mixing the more fluid glazes and scumbles you'll use in your overpainting, I'd recommend a plastic or metal palette with wells, depressions, or compartments that will hold liquids. For really big glazes, when I want lots of fluid color, I keep little saucers or discarded margarine containers handy. This is also a good use for the discarded muffin tin I recommend in the chapter on painting equipment. A paper cup is good for mixing glazes, provided that the cup is white; a colored or patterned cup will confuse you and make it difficult to judge the color of your mixture.

Unless your glazes or scumbles are very thin and running, the upright easel used by oil painter's is best for the underpainting and overpainting technique. Paint diluted with liquid medium, whether matt or gloss, is fluid enough to brush freely, but won't run uncontrolled down a vertical surface.

Imprimatura and Toned Ground

The simplest kind of underpainting is nothing more than a colored painting surface, like the imprimatura and the toned gesso ground that I described in Chapter 3 on painting surfaces. The color of the canvas or panel is chosen to unify the colors that go over the surface. The whole idea is to paint rather loosely, working in color which is never completely opaque, but ranges from lucid transparency to smoky semi-opacity. The undertone is always allowed to peek through, tying together all the colors that are laid over it.

In portrait and figure painting, the imprimatura or toned ground is usually a middle tone, not quite as dark as the shadows, and not quite as light as the flesh tones. Shining through the darks and the lights, this middle tone ties them together. There are also old master portrait and figure paintings on grounds of earthy red and red-brown, which add inner fire to the semi-opaque flesh tones.

When you're painting a landscape, you may want to choose a unifying undertone that accentuates the light or atmosphere of your subject. Perhaps you'll pick a blue or blue-gray tone for a seascape; a golden yellow for a mid-summer landscape; a coppery orange for an autumn landscape. However, many painters find it just as effective to work against a contrasting undertone. It can be fascinating to paint the smoky blues and grays of a seascape over a reddish imprimatura, as Whistler sometimes did. An olive green undertone might cool the shadows and accentuate the lights of a reddish autumn landscape.

Since an imprimatura is nothing more than a wash of transparent color over white acrylic gesso, there's no reason why the wash must be just one color. In painting a landscape, for instance, you may want to put a wash of one color beneath the sky, and another color beneath the land. To reinforce the green of the landscape, you may choose a yellow imprimatura. But to warm the blue of the sky, you may decide on a contrasting imprimatura of pink or light brown. It can be fun to pick the "wrong" imprimatura color on purpose just to see how it turns out. You may be in for a pleasant surprise.

Glazing

Glazing may be an unfamiliar process, so you may want to try some small experiments to discover the range of possibilities. Here are a few things to try.

Squeeze out all the colors on your palette and set out a little paper cup of gloss medium. Thin each

color with a little water and draw a long stripe, about an inch wide and a foot long, on an illustration board. If you've got a dozen colors on your palette, you'll have a dozen stripes. Now thin each color on your palette with a bit of gloss medium, and paint a short stroke across each of the dozen stripes, so that each stripe has a dozen little strokes crossing it.

Now go back and look at what you've done. The long stripe is the underpainting; each little stroke, overlapping the stripe, is an example of overpainting —in this case, a transparent glaze. Where the overpainting crosses the underpainting, you've got an optical mixture: instead of being stirred together on the palette or on the surface of the painting, the two colors are sandwiched together and add up to a third color.

If you look at the results of these tests carefully, you'll be disappointed to discover that the optical mixture doesn't work too well when the underpainting color is darker than the glaze. A glaze of pale yellow over dark blue doesn't give you much of a green. Now paint the test stripes once again, this time blending each color with white, so that the stripe is a lot paler than it was in your first experiment. Again, dilute each of your colors with some acrylic medium and paint those short strokes of glaze over the long test stripes. This time, you'll find that the underpainting is light enough for the glaze to dominate—in *most* cases, at least—and the overpainting really sings.

You've not experienced the most important single rule about glazing. The most effective glaze is a dark, rich color over a lighter, more subdued color. This is why underpainting colors almost always contain a certain amount of white. In the process of these brief experiments, you've also seen how each color on your palette behaves as an underpainting tone and as a glaze—and how they affect one another.

Scumbling

I've already described scumbling as a kind of scrubbing back-and-forth stroke that can be used for blending, broken color effects, or textural variety. In the underpainting and glazing technique, scumbling has an additional meaning.

A glaze, as you now know, is a transparent or a semi-transparent layer of color applied over a lighter underpainting. In contrast to a glaze, a scumble can be a semi-opaque light tone, which you casually brush over a darker underpainting. The underpainting is only partially covered and shines through to

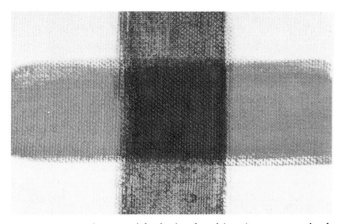

You can experiment with glazing by this crisscross method. First paint a solid, horizontal band of one color. Then thin some other tube color with matt or gloss medium until the paint is transparent. Brush a vertical band across the horizontal one to see what color you produce where the two bands meet.

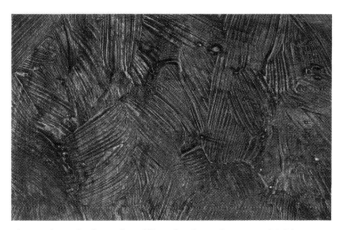

An underpainting of undiluted tube color was thickly applied, retaining the texture of the brushstrokes. The glaze that followed, when the underpainting was dry, sank into the valleys of the strokes and accentuated the texture.

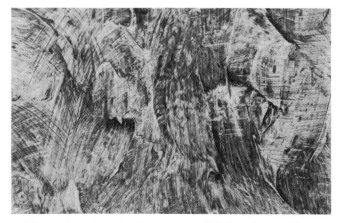

This rough underpainting was glazed (when dry) with a darker tone and then carefully wiped with a smooth, lint-free cloth. The high points of the texture were wiped clean and the glaze remained only in the valleys, accentuating the contrast between light and dark.

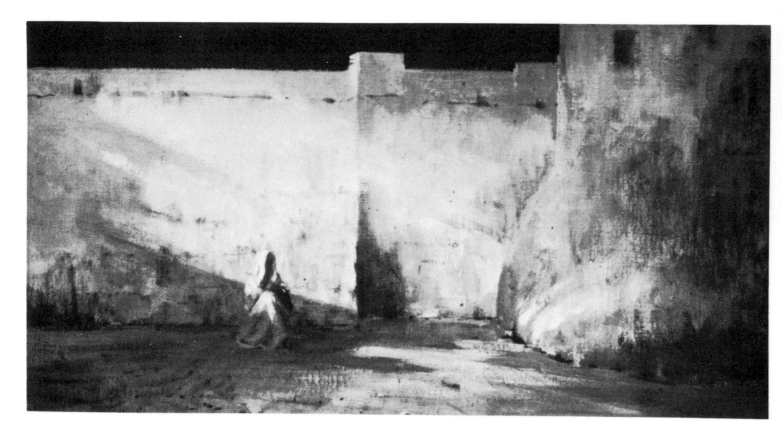

Morocco by Paul Strisik, A.W.S., acrylic on canvas, 16" x 30", collection Dr. Jay B. Moses, Rochester, New York. This artist normally begins by underpainting with a series of thin, fairly transparent washes of color, very much like the imprimatura of the old masters. When these areas of tone and color are clearly established, he blocks in his colors more thickly. In this painting, flat areas of color provide the undertones for a subtle buildup of drybrush and broken color. Examine the interplay of dark-on-light and light-on-dark drybrush on the wall, the ground, and the tower to the right. The splashes of light on the ground are strokes of thick color, broken up by the texture of the canvas. On the tower dark drybrush strokes are broken by the weave of the fabric.

produce an effect that has a special kind of magic.

To experiment with scumbles, choose a few dark tones from your palette, or mix some dark tones that you like. On some pieces of illustration board, paint 6" squares of each of these dark colors, and let them dry. Then choose some of the lighter colors on your palette, add a touch of titanium white to make them slightly more opaque, thin them with acrylic medium, and scrub them over the dark patches. You can also pick some of the darker colors on your palette, reduce them to tints with lots of white, and then thin them with a fair amount of medium to cut the opacity of the white; try scumbling these over those dark squares.

The effect of a scumble is hard to describe and hard to visualize, until you've tried it. The effect of a light veil of semiopaque color over a dark underpainting has a mysterious, now-you-see-it-now-you-don't quality which lends extraordinary depth and atmosphere. An obvious use for scumbling would be a foggy, seaside subject or a stormy sky. Instead of glazing red over yellow to render the skin of a peach, the peculiar fuzzy quality of the peach might be caught more effectively by scumbling light yellow over dark red.

But why restrict glazes and scumbles to separate parts of the painting. It's possible to *combine* glazes and scumbles to produce an effect of even greater richness than they can produce by themselves. Pick several brilliant glazing colors, dilute them with gloss medium, and then brush them over those scumbled patches. You now have the threefold interaction of a dark underpainting, a light scumble, and a brilliant glaze. Now, if you want to go even further, you can scumble over the glaze, then glaze again over that scumble, ad infinitum. Going back to that peach once again, you can lighten it, darken it, redden it, or turn it more toward gold, yet never lose that sense of inner light, since a glaze over a scumble always looks transparent.

Grisaille

For painting any subject that requires accurate drawing—a portrait, a figure, or an architectural subject, let's say—the old master method called grisaille can be enormously helpful. Grisaille means underpainting entirely in grays, then glazing over the completed underpainting in transparent or semi-transparent color.

Let's say you're painting a very complicated architectural subject with difficult perspective, a plethora

When the dark, textured underpainting was dry, a light scumble was applied at the left. The light tone settled into the valleys of the brushstrokes and also picked up a faint ridge of dried paint in the lower right hand corner.

Ralph Fabri

of window detail and decorative moldings, and a complex pattern of light and shadow planes. Just getting it all down accurately in black and white is enough of a chore for most painters, without having to worry about the color. So the solution is to paint the entire picture in shades of white and gray so you have something like a black and white photograph. With all this behind you, you can then worry about applying color, which goes over the grisaille underpainting in transparent glazes, so that all the underlying form and detail can come through.

Although grisaille *means* gray, there's no reason to restrict yourself to a steely, metallic mixture of black and white. To underpaint flesh tones, where you want warmth, the right gray may be a mixture of ultramarine blue, burnt umber or burnt sienna, and titanium white, perhaps with a golden touch of yellow ochre. Try adding even more yellow ochre or increasing the ratio of brown to blue, and you open up all sorts of possibilities: gray-browns, golden grays, and subtle mustard tones which aren't gray at all. Ingres concocted a mysterious violet-gray for underpainting the sultry flesh tones of his nudes.

So then, experiment with a complete tonal underpainting not only in shades of gray, but in a variety of other warm and cool neutrals. Try adding touches of other colors to your neutrals, like a hint of red, orange, or even violet for flesh tones. Don't take the grayness of grisaille too literally.

Nor must you feel obligated to underpaint a complete picture in grisaille. In a portrait study that includes clothing, furniture, and props, only the head and hands may need to be underpainted in grisaille. You may want to underpaint the brown leather of a chair in red or golden yellow, the green of the sitter's dress in blue. Nor does every part of an underpainting have to be carried to a precise finish, with shadows carefully modeled, or details sharply drawn. You may decide to block in the lights and shadows on the face and hands, but underpaint the chair and dress as flat patches of color.

Color and Texture

The purpose of the underpainting and glazing technique is to provide effects of color and texture that you can't get by a more direct approach. In the opaque and transparent techniques, you may aim for the final color from the very beginning; you're aiming for spontaneity, directness, simplicity, boldness. But underpainting and glazing is an indirect technique, slower and more methodical, which aims at richness and complexity.

Such a picture takes planning and lots of experience. If you're mixing a shade of orange on the palette, you can see immediately what color you've got. But if you're planning to "mix" an orange by glazing red over yellow, you may be in for some surprises before you get what you want. An indirectly painted orange—underpainted and glazed—does look different from a mixed orange. If you then add a scumble and another glaze, you have a passage which is unthinkable in any direct technique. But you must be patient. You must be prepared to make a lot of mistakes, backtrack, and try again until you learn what all the different underpainting and glazing combinations can do.

As you become more experienced, you'll also want to experiment with different kinds of underpainting textures. Adding gel to your underpainting colors, then working with knives and bristle brushes, will enable you to express the *texture* of your subject, not just the color. These textures may not be apparent during the underpainting stage, but they'll bounce forth when the glazes go over the rough brushwork and sink into the crevices left by the bristles.

Explore different kinds of knife and brushstrokes. Try short, stabbing strokes of thick color for clumps of leaves; long, lazy, rippling strokes for still water; rhythmic, wavy strokes for your model's wavy hair. The bristles will leave their tracks behind them and the glazes will settle into the tracks and reveal the expressive character of the stroke.

Cambodian Dancers *by Ralph Fabri, N.A., A.W.S., acrylic on panel, 28" x 22". Working on a multimedia board that carries a granular texture, the artist built his composition working from dark to light. All but one of the dancing figures are in shadows created by transparent glazes through which a few selective details emerge. Touches of light are rendered in thick, crusty paint, applied in drybrush strokes that ride on the grain of the board. The one lightstruck figure to the left is rendered almost entirely in this manner. The painting as a whole is executed in the old master tradition of painting light areas in opaque color and shadows in transparent color. (Photograph by Peter A. Juley & Son)*

April Morning *by Donald M. Hedin, A.W.S., acrylic on Masonite panel, 16-5/8 x 22". Acrylic is ideal for the so-called "magic realist" technique which we frequently associate with tempera. This meticulously detailed still life was executed on Masonite coated with very smooth gesso; this is the usual painting surface for this technique. The composition was gradually built up by a series of strokes so small as to be almost invisible. There's very little blending or scumbling, as in the opaque technique, but gradations are achieved by placing one tiny stroke over another in a method similar to crosshatching, familiar to pen and ink draftsmen. The tempera technique lends itself particularly well to the interpretation of elaborate textures like the moldering walls, the cracked paint, and the mysterious, semi-transparent windows of the building in this painting.*

Tempera Technique

Many painters are attracted by the precision and detail possible with tempera painting, but they're quickly discouraged by the mechanics of traditional egg tempera. It's a slow, tedious business, which takes enormous patience, and ability to persevere through the gradual buildup of strokes necessary to make a picture. Working with dry pigment, water, and medium—which may be egg yolk, whole egg, or a more elaborate concoction of egg, oil, and varnish— the tempera painter literally manufactures his paint as he works, stirring these ingredients together and applying them to the painting surface in thousands of small, delicate strokes. The paint is so thin and dries so rapidly that there's no possibility of blending or modeling. All gradations are built up very gradually with scores, or even hundreds, of tiny or dots. There's no way to speed things up, no way to build up texture, and no way to "let go" and really swing the brush. Because of its egg content, the medium is perishable. And the painting surface, traditionally glue gesso, is so fragile that it needs constant protection from chips and scratches.

So it's no surprise that the small fraternity of egg tempera painters has so few members. Most of us admire them from afar, envy their patience, and turn to painting media that produce more rapid results.

Painting a "tempera" in acrylic goes faster if only because it's a lot more convenient to work with tube color and a bottle of medium. You can also brush your color onto the painting surface a lot more freely and more thickly—although a tempera is supposed to be thin—without any danger of the cracking that threatens egg tempera when it's applied in a solid coat. Because acrylic paint has more body than egg tempera, it's easier to push the new medium around: blending, drybrush, scumbling, and broken color effects are all easier. And even though the buildup of small strokes always takes time, it goes faster in acrylic simply because the paint is more convenient to handle.

Technically, I suppose, it's wrong to speak of an acrylic tempera; tempera means using egg. But there's no question that acrylic, more than any other medium, can produce a picture that looks so much like an egg tempera that only the artist, himself, knows the difference. But even when you work with acrylic, I hasten to add that there's no quick way to paint a picture in the tempera technique. It still takes a great deal of time to make all those tiny strokes. Acrylic does go faster than egg tempera and the process feels less frustrating. But it's still a slow job. You've got to have the right temperament.

Painting Surfaces

The tried and true surface for tempera painting is a rigid gesso panel. Untempered Masonite, 1/8" or 1/4" thick, is the support which most contemporary painters now use for this technique. To give the panel a slight, but practically invisible texture, sand the smooth side lightly—just enough to raise a bit of fuzz. Then coat the panel with a series of milk-thin layers of acrylic gesso—there's no need for traditional glue gesso—until you build up a snowy white surface in which there's no trace of the underlying brown. When gesso is applied this thinly, you can even sandpaper it a bit between coats, making sure that the latest coat is dry before you touch it with any abrasive.

You can also make an inexpensive gesso panel

with a stiff sheet of illustration board carefully coated on both sides to seal it up completely. But Masonite is a lot tougher, and more permanent if you see yourself painting for posterity. The point is that this technique will work on any smooth, tough surface. Thus, there's no reason why you can't try it on stiff, smooth, white drawing paper or even hot pressed watercolor paper. Working on such a surface, you may want to skip the gesso. However, remember that once you work on paper or illustration board, the framed picture will need a sheet of glass for protection. The leathery, dried acrylic paint is tough, but the paper isn't. On a Masonite panel, properly coated with gesso and properly cradled from behind, your acrylic tempera stands a much better chance of surviving over the years.

Colors

There's no law that tempera must be either opaque or transparent, and theoretically you can select any of the colors listed in Chapter 2. It's really a matter of taste. However, the color of a traditional egg tempera painting has a very special quality which you might like to aim for. In the temperas of the old masters, there's a wonderful soft, airy, high key feeling: no deep, rich, ringing tones, but rather a sense of delicacy and freshness of color which every tempera painter strives for. It's possible to select your colors with this feeling in mind.

One way is to choose a limited palette of colors which are known for their airiness and delicacy, rather than for their strength. You'd skip thalo blue and turn to the much gentler cobalt blue, although ultramarine is always worth having. For the same reason, the powerful cadmium red and thalo crimson would be deleted from the palette in favor of the naphthol reds and the more subdues earth reds, like burnt sienna and red oxide. You'd choose Hansa or azo yellow over cadmium yellow, and also choose an earth yellow or yellow-brown like yellow ochre or raw sienna. Thalo green would be out in favor of the earthy chromium oxide green. Those powerful purples and oranges would be out altogether, while black would be used sparingly, if at all. For most purposes, burnt umber would be the darkest color on the palette.

A surprising number of tempera painters—whether they work in egg tempera or in acrylic—have selected a palette which consists almost entirely of earth colors, which harmonize almost automatically and lend a wonderful feeling of authority and re-

straint. Except for your two blues, cobalt and ultramarine, just about everything could be an earth color or its modern equivalent. Your reds would be burnt sienna and red oxide. Your yellows would be yellow ochre and that peculiar yellow-brown, raw sienna. Chromium oxide green is something like a modern equivalent of the green earth of the old masters. Once again, burnt umber could be your darkest tone, though black might be worth having if used sparingly. No oranges or violets, of course.

So far, I haven't mentioned white. Titanium white is indispensable for the acrylic tempera technique. Because the paint is meant to be applied thinly and smoothly, titanium white is ideal. Just a touch of it will lighten your fluid color without making it thick and pasty. A heavy-bodied white with low tinting power, like acrylic gesso, is wrong because you need too much of it to lighten your color and this thickens the paint, which you want to keep thin.

Speaking of limited palettes, this might be the time to experiment with *really* restricted color selections. The old masters had far fewer colors than we have, yet produced pictures as colorful as ours. Try painting with just three subdued primaries—like ultramarine or cobalt blue, red oxide or burnt sienna, and yellow ochre—plus white.

Experiment with a favorite trick of the old masters: working without any *really* cool colors, yet producing cool tones by placing grays next to warm colors. If your palette consists of Mars black, titanium white, red oxide, yellow ochre, and burnt umber, your only grays will be mixtures of black and white, occasionally warmed with one of the earth tones. Yet if you surround these grays with the right warm colors, you can get colors which actually *look* blue or green. Centuries ago, blues were scarce and expensive, so the old masters learned to create the illusion of cool color by contrast.

This may be hard to visualize, so it may help you to try a few experiments. On a piece of illustration board or thick white paper, paint a series of 2" squares of different warm colors: browns, reds, yellows, oranges, red-browns, yellow-browns, red-oranges, yellow-oranges, and so on. When these are dry, mix up a batch of medium gray, using nothing more than Mars black and titanium white, then paint a stroke of this gray in the middle of each square. The stroke will turn out to be a different color on each square, looking warmer, cooler, greener, or bluer, depending on its surroundings. If you repeat the experiment, modifying the gray with a slight touch of some warm tone like yellow ochre or burnt

June Noon by Alex Colville, acrylic on panel, 30" x 30"
To develop the illusion of roundness in the human figure—
or in soft, billowing forms like the walls of the tent in this
painting—an artist depends upon precise modeling. This
means exact control over gradation from light to dark. By
interweaving an infinite number of tiny strokes or dots—
Colville prefers dots—the acrylic tempera painter can gradu-
ally move from light to dark, and back again to light, by
controlling the touches of his brush. The movement of light
on the model's arm is a good example of this technique.
The tiny touches of color register on the viewer's eye like
crystalline points of light and suggest a luminosity which is
quite different from the inner light of transparent glazes.
(Photograph courtesy Banfer Gallery, New York)

Winter Field *by Arthur Biehl, acrylic on panel, 16½" x 23¾", collection Dr. and Mrs. Harold Brandaleone, New York. The acrylic tempera technique encourages extraordinary precision in drawing—or rather demands it. It's very much like working with the tip of a hard pencil. You must know exactly what you're doing and be prepared to consider every detail with the greatest care. In this handsome, geometric design, the artist has carefully modeled every form to give it three-dimensional solidity. The soft, grassy hill is treated as a rounded form and graded from dark to light as it moves from foreground to horizon. The fenceposts are also painted with this dark to light gradation, and even the wires move from dark at the bottom to light at the top, modeled like slender cylinders. Observe how the strokes vary not only in tone, but in density: in the darks, the strokes are closer together and overlap so that they become less distinct. (Photograph by Geoffrey Clements, courtesy Banfer gallery, New York)*

Pine Plains Farm *by Donald M. Hedin, A.W.S., acrylic on Masonite panel, 17" x 28", collection Mr. and Mrs. A.L. Ring. The artist began by laying in the broad areas of color with large brushes, both bristle and nylon. With the basic design established, the artist then switched to small sables, both flat and round. Thus, the painting began as a series of glazes and scumbles which ultimately disappeared completely beneath the fine web of tiny strokes that cover the completed picture. The Masonite panel was prepared with three coats of acrylic gesso, sanded absolutely smooth. His palette consisted of cadmium yellow, light; cadmium yellow, deep; yellow ochre; cadmium red, light; cadmium red, medium; thalo crimson; thalo blue; manganese blue; chromium oxide green; Hooker's green; burnt umber; raw umber; burnt sienna; Mars black; and titanium white.*

sienna, your range of "cool" tones becomes even greater. As you can see, it's the contrast that produces the illusion of coolness.

Mediums

Although you can thin tube color for the acrylic tempera technique with water alone, a more effective medium is a half-and-half blend of water and matt medium. This improves the brushing consistency of the paint without making it too thick. Occasionally, you may wish to dilute your tube paint with medium and no water, but I think this would be something you'd reserve for passages or strokes that require special emphasis.

I suggest the matt medium over the gloss medium because a tempera painting traditionally has a satin finish. It really shouldn't have the luminous shine of an oil painting. However, if you'd like a finish which has just a slight gloss—as many temperas have—you can mix matt and gloss mediums half-and-half or in any other combination you choose. This blend can be mixed with water to whatever consistency you need for a particular section of the painting.

Because the primary purpose of gel medium is to produce thick, pasty paint, I'd steer clear of this when you're painting in the acrylic tempera technique. I'd also avoid retarder, which slows drying and therefore impedes the rapid buildup of strokes; this buildup takes long enough as it is!

Painting Tools and Equipment

Because tempera is normally applied thinly, the most important painting tools will be soft hair brushes: sables, if you can afford them; oxhair or synthetics if you're on a budget.

For blocking in broad areas of color in the early stages of the painting—to provide a foundation for the buildup of small strokes to follow—you'll need a couple of large brushes. Two flats, one of them about an inch wide and the other about half an inch, will do the job; for this kind of work, I think oxhairs will do just as well as sable. If you want to invest in just one large brush, choose a number 12 round, which will not only cover broad areas, but comes to a sharp point that will work into some tight corners. When you shop for these large sizes, ask for watercolor brushes.

Having blocked in your large shapes with big brushes, you'll then switch to much smaller brushes to build up detail. Although a number 8 round is con-

sidered a medium size brush in watercolor painting, it's by far the biggest brush you're likely to use in the later stages of an acrylic tempera; save it for covering large areas of solid color, for glazing and scumbling, and for special effects where a large body of hair is needed to create textures. Most of the painting will be completed by small brushes that make strokes not much thicker than a pencil line: numbers 0, 1, and 2. The finished picture should give the impression of a vast network of tiny strokes which conceal the broad areas of color that were blocked in during the early stages. These small brushes can be either the short handled watercolor type or the longer handled oil brushes. Sables are inexpensive in these sizes, to stick to the best.

You can get along without bristle brushes altogether, although they have their uses. Instead of blocking in the broad color areas at the beginning with soft hair brushes—which leave smooth, even tones—you may prefer the scrubbier look of thin color blocked in with bristles. This leaves an interesting, accidental looking texture which enlivens the network of little strokes that will go over the initial lay-in. Smaller bristle brushes, ¼" wide or even less, have their uses for textural effects, drybrush, and occasional emphatic strokes. Just don't overuse them. They *can* disrupt the overall delicacy of the painting's surface.

Painting knives? Forget them. Knives mean impasto effects and these don't belong in tempera. A palette knife can be useful for mixing up small batches of color, but keep it away from the picture.

For the early washes of color used to block in the broad shapes of the painting, my old standby, the white enamel butcher tray, is the most convenient palette. You can use this same mixing surface to squeeze out your tube colors, although from this point on you won't be mixing washes but simply picking up wisps of paint on tiny brushes. If you prefer a compartmented watercolor palette of metal or plastic, that's up to you, but I think it's an unnecessary luxury when the white enamel tray is cheaper and gives you more elbow room. You'll be applying so little paint in a day's work that there's no need to have saucers or any other large containers around.

John Pellew, in his excellent book, *Acrylic Landscape Painting*, suggests some other tools: "a kleenex tissue, crumpled in the hand, dipped in paint, and touched to the surface of the panel, will leave a textural effect that would be difficult to execute with a brush. This texture can be used in many ways

when painting landscapes or seascapes. Bits of rag, especially rough towelling, are also useful. I've even used steel wool, patting and dragging it along the picture surface. Sandpaper, rubbed over a dry area, will bring some of the light undercoat through; I've seen this used to suggest the sparkle of distant water."

It's purely a matter of personal convenience whether you use the oil painter's vertical easel or the watercolorist's adjustable drawing table. Remember that you're going to get very close to the painting surface as you apply all those little strokes. If you don't mind working while you stand up, keeping your nose just a few inches from the surface of the panel, the vertical easel is fine, but some painters find this exhausting and would rather risk a crick in the neck, sitting down and bending over the diagonal surface of the drawing table. The advantage of the drawing table too, is that you've got a place to rest your hand while you're making those hundreds of precise stokes.

Washes

There's no particular skill necessary to lay in those washes of flat color that establish the composition in its early stages. Just thin your color with matt acrylic medium (or a half-and-half mixture of medium and water) and brush the color on freely. It may help to establish these color areas first with light pencil lines or thin strokes of a number 0 round sable brush.

If you want these color areas to be absolutely smooth and regular, then follow the procedure described for laying a flat wash in Chapter 6 on the acrylic watercolor technique. But there's no harm if the color goes on a bit unevenly, leaving behind a slightly scrubby texture. It'll be covered up later on, anyhow. You may actually prefer a scrubby look and choose a scumbling type of stroke on purpose.

In one sense, an irregular, scumbling stroke is preferable for the preliminary lay-in. In the early stages of any painting—even something as precise as an acrylic tempera—it's wise to avoid too many hard edges, too much precision. It's usually best to keep things just a bit vague so you're not imprisoned by a rigid design which won't let you change your mind or make a spontaneous decision. Visualize these first color areas as a kind of imprimatura—like that described in Chapter 7 on underpainting

In the tempera technique, hatching and stippling are done with your smallest sable brushes.

This example of hatching consists of hundreds upon hundreds of tiny strokes, applied more or less in the same direction, but never exactly parallel. In the darker area, several layers of strokes are piled over one another, intersecting at various angles.

and overpainting—which reinforces or purposely fights the colors that come next, but which always retains a certain washy softness.

Hatching

Limited to black ink on white paper, the masters of pen and ink drawing build their tones and textures by a technique called hatching. Scores of tiny strokes are crisscrossed over one another—not only at right angles, but at all sorts of angles—to develop an elaborate fishnet of black lines. The more strokes the artist piles on, the darker the network gets, and the more velvety the texture of the drawing becomes. The finished drawing has a beautiful consistency of surface, a unified weave of strokes like a rich, tightly-woven fabric.

This is the way a tempera painting is done, too. Wispy strokes, many no bigger than an eyelash, are laid one over the other to produce an intricate weave of color and tone. In various parts of the picture, the strokes can go in different directions, depending upon how you decide to handle your subject. On the wall of a building, you may choose strokes which are all parallel or at right angles with one another, reflecting the architectonic character of the subject. On the rounded form of an arm or a neck, the tiny strokes can all be slightly curved, arc-like, following the curve of the form, perhaps intersecting with one another like fish scales. The direction, angle, and shape of the stroke—straight, curved, longer, shorter, thicker, thinner—are all up to you. But the individual stroke should always be small enough so that it melts into the total weave of the picture.

For your first experience in hatching, simply try crisscrossing small strokes of a single color at different angles. Begin with a 2" square covered with short, parallel strokes. Then work over these with an equal number of small strokes that move at right angles to the earlier ones. Work with one of your smaller brushes—number 0, 1, or 2—first dipping it into the cup of medium (half water, half matt medium) and then picking up a small quantity of tube color on the tip. You may want to make a couple of strokes on the palette to be sure the medium and paint are properly blended before you touch the brush to the panel. The paint will be thin and somewhat transparent. So the second layer of strokes will automatically darken the first layer.

Having seen how two layers of strokes become darker than one, you can now experiment with a gradation of strokes. If you gradually work across your 2" square, piling on more and more strokes as you get from one side to the other—or from top to bottom—the passage will gradually darken as the strokes multiply.

So far, you've been working with strokes at right angles to one another; now try overlapping strokes at different angles, say a 45° angle, a 30° angle, even a 10° angle where the strokes are almost parallel, but not quite. You'll see that the *greater* the angle, the more insistent the strokes look, the more conflict between them.

Having worked with just one color, now you can switch to two colors. Try hatching a dark color and a light color into one another to produce an optical mixture of the two. Try hatching a light color from one side of the square and a dark color from the other, merging and overlapping them so you get a gradation from dark to light. Try these strokes at different angles.

Earlier in this chapter, I discussed the value of beginning with a freely brushed solid tone which forms an imprimatura that complements or contrasts with the pattern of overlying strokes. Paint a few 2" squares of flat color—whatever colors you like. Then try the same hatching techniques over the solid colors, using some colors that harmonize with the imprimatura and others that conflict. Try one warm color over another, cool over cool, warm over cool, cool over warm, light over dark, dark over light, and more complicated sequences of light-dark-light, dark-light-dark, and so on, until you've exhausted all the color possibilities you can think of.

In these hatching exercises, try to use all the colors on your palette as the solid undertones and also for hatching, so you'll find out what they can do. Try to keep your color thin and semi-transparent, so all the strokes interweave and the inner light of the gesso ground comes through.

Stippling

Another way of building up tone is with a network of fine dots, called stippling. Instead of making small strokes, you touch the painting surface repeatedly with the tip of the brush until thousands of touches merge into tones and colors that vibrate and sparkle.

Begin by filling a 2" square with dots of a single color, using one of your smallest brushes. Do your best to space the dots evenly and keep them more

or less the same size so that the color has a consistent texture and density. Hold the brush at something like a right angle to the painting surface and just touch the tip to the surface; if you press too hard, you won't get a dot but a blob.

Now try building up a gradation of dots, so there are more touches of tone or color at one end of the square than at the other. The dots should gradually increase in density, but not in size, so that you maintain a consistent texture even though the tone changes.

Another way to get a gradation, of course, is to interweave two colors or two shades of the same color, working dots of one color from the left and dots of the other color from the right, perhaps. They should overlap and merge, working their way into one another so the gradation is gradual, not abrupt.

Whether your graded tones consist of strokes or dots, remember *never* to scrub your colors together or try to blend them as you would oil paint. Each dot or stroke remains intact and the blending takes place in the eye of the viewer. You're aiming for a mosaic of individual strokes or dots which intermingle, but never dissolve into one another.

Finally, as you did with the strokes, you can experiment with various combinations of dots over different squares of color and tone. Do your best to use all the colors on your palette and keep your paint fluid and semi-transparent.

Does stippling always have to be done neatly with the tip of the brush? Once you've mastered this very demanding technique, it may be fun to set yourself free and find other methods. If you have an old, worn, ragged brush that doesn't come to a neat point, but whose bristles are all splayed out, this will give you a very different kind of stipple. Dip this brush into semi-liquid color, touch the ragged tips to the painting surface, and you get not *one* dot, but a collection of ragged little dots which can be built up like the neater, more precise dots I've just described. The effect is more casual, more unpredictable, and has its own special charm. It may also occur to you that this same played-out brush can be used to make clusters of little hairline strokes which can be built up and interlaced to produce a passage slightly more irregular, but just as attractive as the hatched effects I described in the previous section.

Another fascinating tool for stippling is that small, natural sponge I've mentioned so frequently. Moisten the sponge and dip it into slightly gummy

In this stippling technique, only the very tip of a tiny brush was used. In the darker areas, the dots are no bigger, but are simply piled one over the other for an effect of greater density.

You can also stipple with a small, round, not-too-irregular sponge. The paint should be fairly stiff (diluted with medium, not water) and the sponge is pressed repeatedly against the painting surface, then lifted carefully to avoid any scrubbing motion. The texture of the sponge leaves dots of paint.

A rougher stipple is produced by a wad of crumpled wrapping tissue—the crisp kind, not soft cleansing tissue. Press and lift; don't scrub. Use fairly stiff paint and don't let the tissue get too wet.

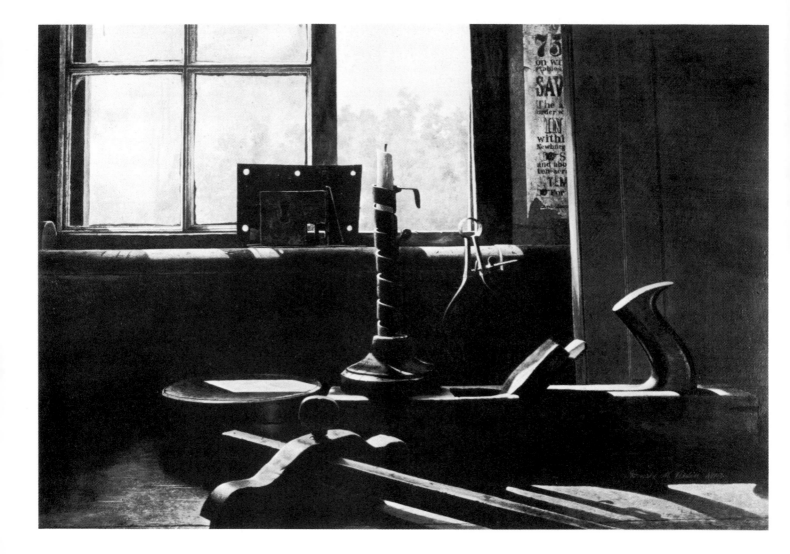

Lowell's Bench *by Donald M. Hedin, A.W.S., acrylic on Masonite panel, 17½'' x 26''. A painting as tightly organized and precise as this one requires the artist to plan every element and leave nothing to chance. The rough, intuitive brushwork of the opaque technique and the "controlled accidents" of the transparent technique are both out of the question. Here the artist began with a pencil drawing that carefully delineated all the shapes and indicated the tonal scheme. This statement becomes the basis of the final painting because the building up of the paint is so laborious a task that it would be terribly discouraging for an artist to change his mind when he's halfway through. The painting as a whole is a study in textures, ranging from the polished handle of the tool to the crumbling paper tacked to the wall. The direction of the light is critical, backlighting each of the shapes and picking out bright edges here and there.*

Burn-off *by John McClusky, acrylic on panel, 30" x 31½", Cummer Gallery of Art, Jacksonville, Florida. It's instructive to study the modeling in this amazingly precise rendering of shapes and textures. Examine the way in which the small strokes of the boards in the foreground follow the direction of the grain. Hundreds of tiny touches with the* tip of the brush model the two rows of rocks in the middle ground; the brushmarks grow darker and denser as the rocks move into shadow. The rendering of the beach, with its wealth of tiny detail, is by itself a tribute not only to the artist's craftsmanship but to his perseverance. (Photograph by Geoffrey Clements, courtesy Banfer Gallery, New York)

Crumpled aluminum foil can also be used as a dabber to apply rough, irregular passages like this one. The wrinkles in the foil deposit tiny flecks of color.

An old, ragged, splayed brush—with the worn bristles sticking in all directions—can be used to stipple a light color into a dark one (or vice versa) as you see here.

That old, ragged brush—useless for any other purpose—can also be used for a slightly rough hatching technique. Each bristle leaves its own tiny stroke. You keep moving the brush in different directions so the strokes cross and overlap one another.

On a dark layer of dry paint, sandpaper can lift a bit of color to produce an interesting texture and reveal the color beneath.

color—tube color diluted with medium alone—and then press this irregularly textured painting tool lightly against the gesso surface. Each dab of the sponge will leave a textured blur, like a cluster of ragged stipples. Keep dabbing and lifting, overlapping blurs until you have the texture and density that you want. Don't scrub the sponge back and forth; simply press and lift, press and lift. You can work with a single color or dab one color over another. You can also produce graded tone and color by piling on more dabs in one area than another.

Drybrush

On an absolutely smooth gesso panel like the one I've suggested for acrylic tempera painting, drybrush is practically impossible to execute successfully. You need a bit more tooth to your painting surface. If you like drybrush effects and plan to use them in acrylic tempera painting, then you should prepare your gesso panel by following the method I'm going to describe.

Begin by roughening the smooth side of the panel sufficiently so that a lot of fuzz really sticks up. You can then apply your gesso in either of two ways. A series of very thin coats will stiffen and preserve the fibrous surface, which gives you an irregular tooth that's receptive to drybrush. Or you can apply your gesso rather thickly in one vertical and one horizontal coat, leaving behind a crisscross pattern of strokes which will make a drybrush effect look as if it's done on canvas. Either technique will produce a suitable painting surface. It's a matter of taste.

When you've got the textured painting surface you want for drybrush, you must still remember that you're working in the tempera technique. This is no place for big brushes and bold, rugged drybrush strokes. Practice the same buildup of small, interlocking strokes described in the section on hatching. The difference, of coure, will be that your small strokes are broken up by the texture of the painting surface. Your brush will glide across the surface, depositing color on the high points and skipping the valleys. The more you go over a particular spot, the darker it will get, so you can produce gradations by piling on more strokes—or pressing harder—in one area than another.

Grisaille

In Chapter 7 on the technique of underpainting and overpainting, I described the classic method of painting the complete picture in tones of gray, gray-brown, or some neutral tone in that family. In the precise, controlled medium of acrylic tempera, this can be particularly effective. It can also be a shortcut.

One approach would be to block in all your shapes in flat tones of gray, perhaps faintly blended by scumbling wherever a soft edge is needed. Over these flat tones would go a network of strokes or dots in shades of gray once again to establish the characteristic "weave" of a tempera painting. At this stage, all subtleties of modeling, texture, and detail would be completed, with only color lacking. On the dried grisaille underpainting, color would then be added in the form of glazes and occasional scumbles, brushed on freely as you would in the underpainting and overpainting technique. The final color application would have to be transparent enough so that the interlaced strokes are apparent throughout the picture.

Another variation would be to block in the composition with flat and graded tones of grays, establishing all the shapes with their patterns of light and shade. Over this, the color would be applied in the form of strokes or dots which are just translucent enough for the underlying form to come through.

Still another idea is to paint your entire picture in monochrome drybrush, using the tooth of the gesso panel to help you build your tones. Over this drybrush underpainting, you can glaze or scumble color which remains translucent enough for the complete drybrush effect to come through. Or you can work over the drybrush underpainting with a network of strokes or dots in color.

Glazing and Scumbling

In the acrylic tempera technique, glazes and scumbles must be handled with great care to avoid obscuring the network of strokes which is essential to the character of this kind of painting. When you brush on a glaze, don't aim for the final color density all at once. Dilute the glaze with a great deal of medium so that it's weaker than the final color you're aiming for. Build up this transparent layer of color in gradual stages, working very thinly, with lots of water to dilute your matt medium. In this way, you can see whether the network of underlying strokes is in any danger of being obscured. You can also see exactly when to stop.

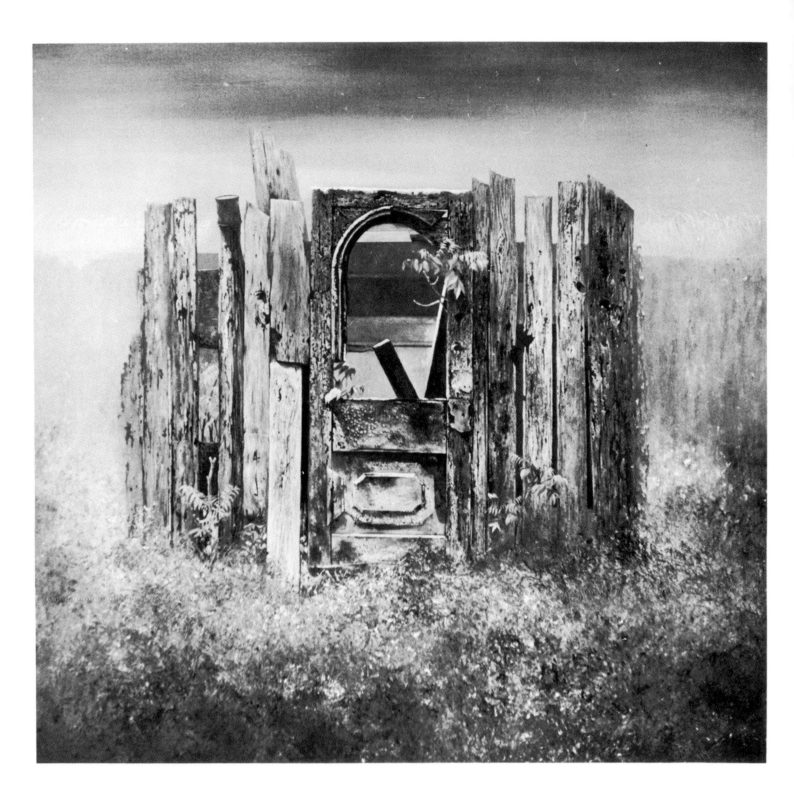

Portal by Anthony J. Vaiksnoras, A.W.S., acrylic on Masonite panel, 48" x 48", private collection. The web of small strokes so typical of the tempera technique can be used not only to render detail, but to create an atmosphere of mystery or phantasy. This ruin emerges from a mysterious sea of tiny brushstrokes, which represent the wild growth of a deserted field. The softness of the foliage contrasts with the sharp focus of the weathered boards. The artist has been selective in his use of detail: the central area of the painting has been handled with great precision, while the edges of the ruined building melt away into the distance.

This gradual buildup is even more important when you're working with a scumble, which means slightly more opaque color, applied like a mist over a darker underpainting. It's essential that the scumble be built up in very gradual stages and applied very thinly to be sure that the passage doesn't turn opaque. At most, the scumble should be a delicate haze.

9
Textural Painting and Collage

Because acrylic is so easily blended with thickeners like gel and modeling paste, working in acrylic gives you richer textural possibilities than any other painting medium. It's not merely that you can build up a layer of gel or modeling paste virtually to the thickness of a bas relief, but that every conceivable kind of texture can be scratched, scraped, incised, imprinted, built up, or carved down into a thickly textured acrylic painting. The range of possibilities becomes broader still when you remember the adhesive qualities of gel, modeling paste, matt or gloss medium, or simply the paint itself. Any found material or found object—from a scrap of paper to a hunk of scrap metal, provided that it's not so heavy that it pulls the painting off the wall—can be stuck to the surface of an acrylic painting. Thus, experimentation with textures soon leads you into collage, and even assemblage.

This is a territory in which no holds are barred and it's really impossible to describe specific techniques, as I've done in the preceding chapters on opaque paintings, transparent painting, underpainting and overpainting, and acrylic tempera. The best I can do is describe some of the basic materials and how they're used, then present a kind of smorgasbord of techniques which you can sample to get you started.

Painting Surfaces

For most collage and textural painting methods, the best surface is one that doesn't have too much texture of its own. If you're working to create unusual surface effects, you don't want the weave of coarse canvas, the tooth of rough watercolor paper, or the patterned side of Masonite to dominate the show. So it's a fairly good rule to pick a smooth, unobtrusive surface.

If you're working mainly with thin collage materials like paper and cloth—perhaps in combination with acrylic color—a sheet of stiff paper or illustration board will be inexpensive and convenient, provided that the collage isn't too big and that you don't mind framing it under glass. Remember that paper always needs protection and that illustration board, after all, is essentially just a very thick sheet of paper. Working on such a surface, I don't think I'd make a collage bigger than 20" x 30", a standard size in illustration boards, or 22" x 30", which is the standard size for watercolor paper.

Once you begin working on a larger scale, a sheet of untempered Masonite is a lot more convenient. It's less apt to wobble like the illustration board—especially if the Masonite is properly cradled as I described in Chapter 3—and the surface is tough enough so that it won't need protection by framing under glass.

If you're going to build up really thick textures with gel, a flexible surface like canvas, paper, or illustration board represents no threat, since gel is even more elastic than the surface you're working on. But if you're working with gel and modeling paste at the same time, or with modeling paste alone, you must bear in mind that the paste is *not* particularly elastic; a rigid support like Masonite is best. It's also silly to pile a thick layer of paste onto something as thin as paper or illustration board: the paste will soon outweigh the support!

Any of these surfaces—paper, illustration board,

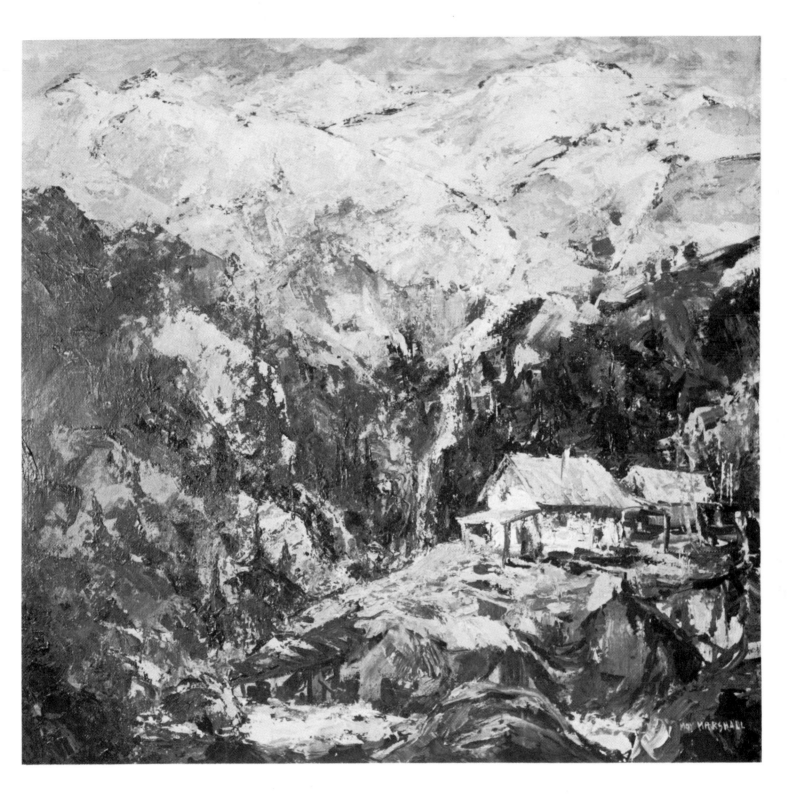

Mountain Home by May Marshall, A.W.S., acrylic on board, 35½" x 36". The thick, crusty, irregular texture of this type of painting is the result of using acrylic color straight from the tube, or of adding a thickener like gel medium or modeling paste to the color. Working with such pasty paint, the artist can use either stiff bristle brushes or the painting knife. It's essential to work quickly and decisively, without changing your mind and going back into the paint, or you'll run the risk of overworking the surface. Such indecisiveness not only leads to muddy color, but turns rugged textures to mush. This artist has carefully avoided these traps and created textures of great power and dash.

Masonite, or even canvas—can be used without further preparation. But if you've tried the various painting techniques I've described so far, you've discovered that acrylic always sticks best to acrylic. For this reason, I recommend that the painting surface be prepared with a coat or two of medium (matt or gloss) if nothing else. It's a lot easier to paste collage papers or cloth to this dried coat. And the coat of medium will also be more receptive to heavy applications of gel or modeling paste.

But you can do a lot more to your painting or collage surface with acrylic gesso and tube color. Used alone, one or two layers of gesso will provide an intense white which adds luminosity to collage papers, fabrics, and the tube color with which collage elements are often combined. If the gesso is modified with some tube color, you can create an underlying tone which integrates and unifies the various elements that you stick to it—if you allow the surface to show through here and there. Naturally, if you're going to cover the entire surface, it doesn't really matter what color you're working on. But many collage and textural painting techniques are casual and irregular (on purpose), allowing the ground color to break through at certain points.

Although a smooth, neutral surface is best for most purposes, there may be times when you want just the opposite. What if you find a marvelous piece of weathered wood whose craggy texture lends itself to some idea you have in mind? Or what if you find some piece of heavily textured cloth which you want to convert into a collage or painting surface? Far from wanting to smooth out these surfaces, you want to preserve their powerful personality.

The way to handle the wood is to clean it thoroughly and get rid of any loose particles that might come off in the process of painting or pasting; a wire brush often helps and can even accentuate the texture. Then apply a series of thin coats of diluted matt or gloss medium, which will soak into the surface and preserve it from wear.

Unless the cloth is very sturdy, I don't think I'd stretch it on a wooden frame like a fresh piece of canvas; to preserve the texture and protect it against wear, paste that fascinating piece of cloth to a sheet of Masonite with a layer of acrylic medium, and then apply a second (or even a third) layer on top to seal and harden the fibers. For all these improvised painting or collage surfaces, a coat of acrylic medium is good insurance.

Colors and Mediums

Textural painting obviously requires more than gel and modeling paste; these are normally blended with tube color. There's no point in prescribing a specific palette of recommended colors; since this kind of painting is a free-for-all, any of the colors in Chapter 2 will do.

The same is true in collage, where any color can be combined with found materials like paper and cloth. However, it's important to remember which are the opaque and which are the more transparent tube colors. If you're interweaving passages of color with paper or cloth, the *transparent* colors can be particularly useful in making subtle modifications of your found materials. Let's say you've stuck down a scrap of green paper which needs to be just a bit bluer. You don't want to obliterate it with a coat of opaque blue-green, since then you're converting your collage to a painting; but a delicate bluish glaze will tint the paper and still preserve the feeling of a collage. A combination of collage elements with glazes and scumbles can be particularly effective.

In collage, matt and gloss medium will function primarily as adhesives. You simply brush them onto the surface, stick down your found material, and then brush on a second coat for a really tight seal. Whether you use matt or gloss medium—or a compromise blend of the two—is a matter of taste. The matt medium looks better if your collage is going to be framed under glass. Either medium looks good if there isn't any glass. Both will preserve your collage equally well.

Gel and modeling paste are not only thickeners for tube color in textural painting, but can also serve as adhesives. If you want to paste something thick and heavy to your collage surface, like a scrap of metal, squirt a dab of gel from the tube onto the surface or onto the object, instead of using the thinner matt or gloss medium. If you actually want to embed a number of heavy, irregularly shaped found objects in your surface, the solution might be to trowel a layer of modeling paste onto a sheet of Masonite with a putty knife, then press the objects into the wet, clay-like layer, which will hold them tight when it dries.

Painting Tools and Equipment

In textural painting, where you're working with a gummy blend of tube color and gel or modeling

paste, you really need two kinds of working tools: tools to apply paint and paste; and tools to work back into the wet surface and create a variety of textures. The most useful brushes are long or short bristles, which can carry a substantial load of painting material. Soft hair brushes like sables and ox-hairs have more limited use, though you may find them helpful for washing thin layers of color over textures which are already built up. For building up even thicker, more powerful textures, palette knives, painting knives, and even a big putty knife can shovel on far more thick paint or paste than any brush.

I've already mentioned a number of tools for working back into a wet layer of paint or modeling paste, but let me review and amplify the list. Ordinary kitchen knives, forks, and spoons will push thick color around, leaving a variety of dents, grooves, ridges, and scratches. You can buy a whole assortment of plastic modeling tools—the kind used by sculptors—which can work a layer of wet modeling paste almost like clay. Dental tools come in a variety of shapes; our family dentist is under strict orders never to throw away a worn out tool, dozens of which are now in my studio. Nor do we ever throw out the sticks from ice cream pops or lollypops, old chopsticks, or plastic bottles—which I cut up with a scissors to make painting implements of odd shapes and sizes. You can also make your own painting and texturing tools out of thin sheet metal, which you cut up with shears; out of old credit cards, which can be cut to shape with scissors; even out of old food cans, squashed flat, then cut up with scissors.

For pasting down collage paper and cloth, as well as other found materials, the most important implements are your fingers and some brushes for applying adhesives. A nylon utility brush, 2" or 3" wide, is best for most purposes, except when you're dealing with very delicate, fragile papers; in this case, an inexpensive soft hair brush, like ox-hair, is less likely to damage the paper. For pushing around heavier adhesives, like gel or modeling paste, use a palette knife, a putty knife, or even a wooden ice cream stick.

If you're pasting nothing heavier than paper or cloth, then integrating these collage elements with tube color, a vertical easel is best. To get the total picture, you can simply step back and look at your collage the way you'd look at a painting. If you like to sit down, a tilt-top drawing table may suit your needs. But if you're pasting down heavier

A layer of wet modeling paste can be textured with an ordinary pocket comb (left), with dental tools (center), or even by rolling a textured glass jar over it (right).

Modeling paste, tinted with dark tube color, was roughly applied with a brush and allowed to dry. A lighter color was drybrushed over the surface, picking up the high points, but leaving the dark valleys untouched.

Modeling paste was tinted with a light color and roughly brushed on. When the surface was dry, a very fluid, dark glaze was applied and the entire surface was wiped with a cloth, leaving the glaze only in the valleys.

Tube color, thickened with gel, was applied in very heavy strokes and allowed to dry. A pale scumble was allowed to settle in the valleys, but wiped off the high points. These high points were then drybrushed with a dark tone.

objects, which are likely to slide down the vertical surface of the panel on an easel, use a flat tabletop. A horizontal or slightly tilted surface is also best if you're working with a heavy layer of modeling paste. Paint thickened with gel works equally well on a vertical, diagonal, or horizontal surface, whichever you prefer.

For working with liquid color (to be combined with collage paper and cloth), with color and gel, or with color and modeling paste, a large, flat palette is best. Get the biggest white enamel butcher tray you can find, or perhaps a sheet of glass; you'll need lots of elbow room, especially if you're working with big batches of thick color.

For collage techniques, the most useful palette is a large sheet of glass that's painted white along the underside, or simply placed on a white surface which thereby makes the glass look white. You can use this glass sheet for brushing adhesive on paper or cloth before sticking the piece onto your paper, board, or panel; you can also use the glass as a work surface for brushing color onto collage materials. If anything happens to stick to the glass, pour on some water; a brief soaking in water will allow you to peel off paper, cloth, or even a dried layer of acrylic paint or medium. At the end of the work day, the glass may be covered with smears of paint and medium, stray bits of paper, and other debris; a brief soaking will allow you to peel off everything—which you can either throw away or hold onto if you feel that these scraps are promising collage materials in themselves.

Some other accessories worth having are single edge razor blades for cutting collage materials, for peeling them off the glass palette, and for peeling wet pieces off the collage when you want to move them elsewhere; a pair of tweezers for picking up and moving around small, delicate collage pieces; a rubber or composition roller for smoothing out items glued to the collage surface; sandpaper for adjusting the texture of a collage or an impasto effect; and the usual palettes and saucers for squeezing out and mixing acrylic tube color.

Now here are some suggestions about materials and methods of textural painting and collage.

Working with Gel and Modeling Paste

If you've already tried gel medium—as described in earlier chapters—you know that it's a thick, gummy material which looks milky when you squeeze it from a tube, but which dries

transparent. You can make an entire painting with colors that have been thickened by gel. The result is a picture that looks like a thick oil painting. If you know exactly what you want to do and you work with big, bold strokes, applied quickly and decisively, you can achieve effects of great power and spontaneity. There are just two things to watch out for . . .

Above all, you've got to apply your paint with the minimum number of strokes and let them lie just as they are. You mustn't keep going back into that passage and rebrushing it to get it "just right." Each time you try to adjust a wet impasto passage, you soften it, blur it, iron it out, and destroy the freshness and strength of its texture. To do this kind of painting successfully, you've got to plan your strokes in advance; decide their direction, their thickness, their color; and then apply your paint without faltering. Don't find yourself hesitating and changing your mind in the middle of things. If you're working in oil, of course, you can scrape off the offending passage and start again. But acrylic dries too fast and you've got to get it right the first time.

The other problem is that gel dries transparent. When you mix it with most colors, it's just like diluting them with liquid gloss medium. A lot of gloss medium or gel produces a glaze, the only difference being that gel makes an impasto glaze. A painting done entirely in thick glazes often turns out to have a cheap, peppermint candy look. In the underpainting and overpainting technique, an occasional impasto glaze can be exciting, but it's a mistake to make the entire painting this way. So if you work with gel impastos throughout the picture, try to work with opaque color; choose a palette of opaque colors from those listed in Chapter 2, or solidify the more transparent colors with titanium white.

Modeling paste will produce even thicker paint than gel. Although you can squeeze out the gel and quickly mix it with your colors as you work, it's best to pre-mix your colors with modeling paste. Scoop the paste out of the can and blend it with each color on your palette, using a palette knife. You then have a row of mounds of color, already to intermix and apply. Better still, work out the entire color scheme of the picture and pre-mix all the colors you want to appear on the surface of the panel, getting them to just the right thickness by adding modeling paste in advance. In this way, you can work spontaneously, lifting color off the

Pale tube color, stiffened with gel, was applied and allowed to dry. An even paler tone was rubbed into the valleys and wiped off the high points. These high points, as well as the smooth area around the strokes, were then drybrushed with a dark tone.

Over a flat middletone, thick strokes of pale, tinted modeling paste were applied and allowed to dry. The high points were then drybrushed with a darker tone.

Strokes of modeling paste, tinted with dark tube color, were brushed onto a pale background. When the paste was dry, a middletone was brushed over the high points.

Tube color, blended with gel, was knifed onto bare canvas and allowed to dry. A lighter tone was then drybrushed over the high points, highlighting the texture of the canvas as well.

Modeling paste, used straight from the can, was knifed onto a dark background. When dry, the strokes were lightly brushed with a darker tone, then wiped. The dark tone remained only on the lower levels, while the high points were wiped clean.

Modeling paste was knifed onto a panel, allowed to dry, and glazed with a darker tone, which was then partially wiped away, so that the darkest darks settled in the valleys. The edges of the strokes were then highlighted with pale drybrush.

palette with your brush or your knife, not wasting time mixing this dense, pasty material, which is a slow process.

After a while, you'll find that working entirely with heavy impastos has its limitations. You may find yourself missing a lot of the subtleties which are possible with thinner paint. This is the time to remind yourself that textural painting doesn't mean working with thick paint *exclusively*. Many artists find that the most effective use of impasto effects is in an underpainting and overpainting technique like that described in Chapter 7. The trick is to build up a richly textured, opaque underpainting, using tube paint thickened with gel or modeling paste—or both—and then to work over this with glazes, scumbles, and drybrush. The glazes and scumbles sink into the texture of the underpainting and accentuate the peaks and valleys. The drybrush effects, riding only on the peaks, add even further drama. Brushed over with fluid color and brightened with drybrush, a heavily textured painting looks even more three dimensional.

Knife and Brush Textures

If you're going to work seriously at textural painting and develop a style based on this technique, you've got to spend some time finding out exactly what your knives, brushes, and other implements can do. Here are some things to explore.

(1) Pick up each stiff bristle brush in your studio and try making various strokes with heavy color, a blend of tube color and gel or modeling paste. See how much color each brush will carry comfortably, how long a stroke it will make, how comfortably you can make straight and curved strokes, and how much of a dent the brush leaves in the painting surface. Try to develop a whole vocabulary of strokes; long, short, straight, curved, very thick, and not so thick. In this way, you'll know which tool to reach for when you're planning a particular impasto passage.

(2) Do the same thing with each of your knives and other implements. You'll find that some blades are best for short, quick strokes, while others are better for long, lingering strokes. Some knives lend themselves only to straight strokes, while others are good for curving or jagged strokes. Just as you did with your brushes, you're finding out what each knife can do, and thus you're building up a vocabulary of knife strokes for different purposes.

(3) Experiment with glazes and scumbles over various kinds of impasto passages. Remember that the best glaze is a deep, rich color over a lighter, more subdued color. Equally important, remember that a scumble is a light, semi-opaque color over a darker color. See what happens when you brush these fluid colors over a heavily textured passage and the overpainting sinks into the valleys of the underpainting. Now try wiping off the peaks—with a sponge or a rag—so that the glaze or scumble is only in the valleys. This will not only accentuate the texture, but provide fascinating broken color effects where the underpainting strikes through.

(4) Experiment with drybrush on a heavily textured underpainting. Try drybrushing dark over light, light over dark, warm over cool color, and cool over warm. Try intermingling two drybrush applications of different colors. For a really complex color effect, you might even want to drybrush over a glaze or a scumble, which has already been applied over the impasto. This is the way to get maximum mileage out of a heavily textured underpainting.

Embedments, Printed Textures, and Painted Relief

I've said that you can embed a tremendous variety of found objects in a layer of acrylic modeling paste. Let's explore this a bit further. There are really a number of ways to take full advantage of this technique.

The simplest method is to coat a sheet of Masonite with a layer of modeling paste and then press various found objects into the paste while it's still wet. You can stop here, or go even further to create an effect something like a mosaic. Let's say that your entire surface is studded with embedded objects that protrude from a ¼" layer of paste and produce a bewildering, jagged surface. Just as a mosaic designer spreads a layer of grout over his tiles and between them, then wipes it off so that each tile is surrounded but not covered, you can do the same thing with modeling paste. When the first layer of paste is dry and the objects are firmly embedded, spread a second layer over the entire composition—or any part of it—carefully pressing the paste down into the valleys between the embedments, and then wipe away the paste from the objects themselves. The paste will then neatly surround all the elements in your design, providing textural unity and even a unifying color, if you've taken the time to blend the paste with tube paint.

A sheet of aluminum foil was tightly crumpled and then carefully unrolled to preserve the small wrinkles without tearing. The crumpled surface of the foil was then pressed into a layer of wet modeling paste and peeled away. A dark glaze was applied and then wiped away, so that it settled only in the valleys. The ridges were accentuated with light drybrush.

Modeling paste was roughly knifed onto a panel, and an ordinary kitchen potato masher was pressed into the center. A dark glaze settled into the valleys, followed by light drybrush strokes that accentuated the high points.

White modeling paste, straight from the can, was knifed onto a panel. Nails were pressed into the wet surface, which was allowed to dry, holding the nails securely. The entire surface was then painted white, followed by dark drybrush strokes to accentuate the nails and the knife strokes.

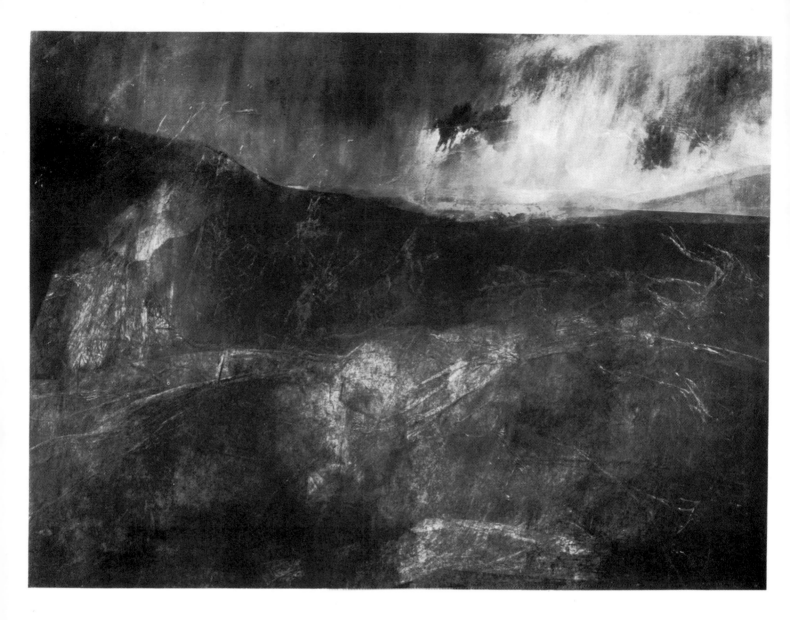

Prelude *by Richard Kozlow, acrylic and paper on panel. The craggy texture of this brooding landscape, with its suggestion of jagged mountains and looming rock formations, is the actual texture of wrinkled paper, carefully glued down to the rigid surface of the board. Although such thin paper is likely to be fragile, a layer of acrylic medium beneath it and another layer on top will seal the paper off from the elements and harden it so that the surface resists a surprising amount of punishment. Strokes, scrubs, and washes of color partially obliterate the paper, but the texture of the wrinkles comes through sufficiently to create the illusion the artist seeks. The pattern created by the paper is random, unplanned, and the wrinkles run into the sky, where they're partially, but not completely, painted out. It's often interesting to begin with paper wrinkled in this way and to see what forms it suggests—rather than to plan the landscape in advance. (Courtesy Rehn Gallery, New York)*

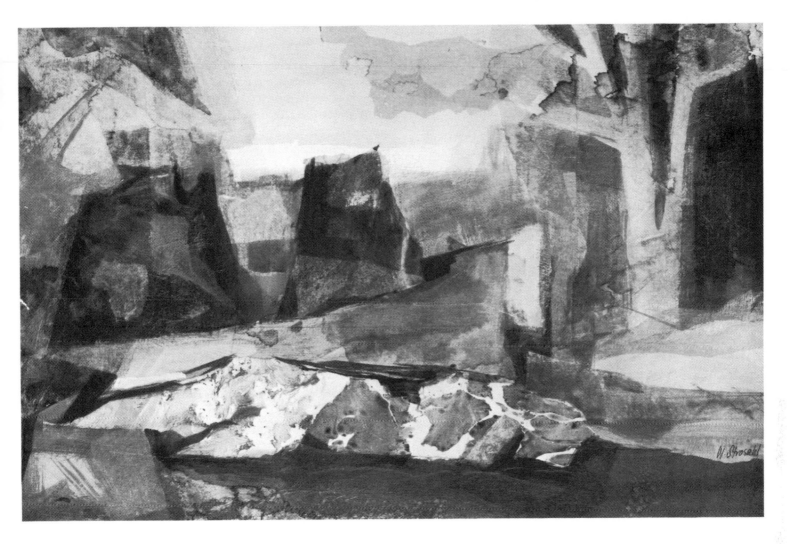

Outside *by William Strosahl, A.W.S., acrylic and collage on gesso board, 18" x 26". The underlying pattern of jagged shapes consists of torn paper, which the artist pasted down with acrylic medium. Over his pattern, Strosahl freely brushed broad passages of color, diluted to transparent or semi-transparent washes, to modify, but not conceal, the shapes underneath. In some areas, the torn tissue melts into the liquid color; for example, the rocky shapes in the center of the composition. Elsewhere, the tissue retains its identity, as in the ragged clouds in the sky. The brilliant white gesso coating on the board shines through the washes of color and lends inner luminosity to the semi-opaque tissue.*

Wrapping tissue was crumpled, partly unfolded (still retaining the wrinkles), and stuck down onto a panel that had been precoated with acrylic medium. A second coat of medium was brushed over the surface of the wrinkled paper. When the tissue was dry, a dark tone was drybrushed over the high points.

Dried paint rags—used for wiping away various glazes and scumbles—were torn apart and reassembled on a panel coated with acrylic medium. A second coat was brushed over the rag collage to make the cloth stiff and impervious to wear.

Powdered kitchen herbs were dusted over a layer of wet modeling paste. When the paste was dry, the entire surface was brushed with medium to further solidify the adhesion of the herbs and protect them from wear.

Nor do you have to stop once you've embedded various objects and surrounded them with modeling paste. Because acrylic paint will stick to almost anything, you can now work over the embedded objects with glazes, scumbles, or drybrush, just as you did over the heavily textured layer of modeling paste. If you're worried about the adhesion of paint to metal found objects, for example, you can treat them with a layer of acrylic medium before painting over them.

Instead of embedding objects in a layer of modeling paste, you can just use these items to imprint their shapes and textures. Often, the imprint is more interesting than the object itself. Try things like a repeat pattern of screwheads, which you can do simply by pressing a screwhead into wet modeling paste until you've left several rows of impressions and covered the area with little circular imprints. You can produce the same kind of repeat texture with a scrap of ragged wood, a piece of bark, a weathered stone, and scores of other items found inside the house and out.

A painted relief is really a cross between a painting and a piece of sculpture. The first stage is a careful drawing, preferably on tracing paper, which you transfer to a rigid panel of Masonite. You then build up your sculptural forms in layers of modeling paste, between 1/16" and 1/8" thick. If you apply the paste any thicker, it tends to dry on the outside while remaining moist within; there's also danger of shrinking and cracking, though you can easily fill the cracks with more paste once the entire layer is dry. When you've built up the completed relief in a series of applications, you can then paint over the sculptural design with opaque color, transparent color, glazes, scumbles, drybrush, or any other technique you choose. You can also sand, file, or carve the surface of the dried relief. I might add that the wet paste can be handled more or less as you handle clay, applying and shaping it with knives, sculptor's modeling tools, improvised tools from the kitchen, or (best of all) your fingers.

Collecting Collage Materials

The fascination of collage is that the whole world provides your "painting" materials. The most obvious materials are the richly colored and textured papers found in your local art supply store: colored drawing papers, decorative Oriental and European papers, so-called cover stock and other

papers used for commercial printing, etc. But artists who work regularly at collage collect every interesting scrap of wrapping paper that comes into the house, clippings from newspapers and magazines, exotically colored mail order advertising, old wallpaper, colored tissue papers, scraps of cardboard and corrugated board. Literally *any* kind of paper can be used for collage, though you must bear in mind that certain dyes and printing inks will fade on prolonged exposure to light. Thus, if you've collected a batch of some paper which you expect to use extensively, it's worthwhile to test it by the method I suggested in Chapter 3.

Cloth is also a very appealing collage material. Collage addicts never throw away old clothes, linens, drapes, towels, or even scraps of fabric left over from sewing. They spread word among their friends to save any piece of fabric that has an interesting color or texture. The worst thing about working in collage is that although your "painting" materials are free for the asking, the studio turns into a warehouse!

The list of found materials for collage could go on indefinitely. If you have the patience and the imagination, you can find all sorts of household items which may be worth saving: bits of string, coffee grounds, dried corn husks, seeds, peas, beans, dried herbs, broken crockery and glass, discarded food containers (squashed flat and cut up), sawdust and wood scraps, metal filings, even dust! Outdoors, the list grows even longer: dried leaves and flowers, the wings of dead moths and butterflies (the Japanese use these in making paper), dirt in all of its different hues and textures, pebbles, seashells, sand, gravel, and all kinds of manmade waste from rusty bits of hardware to the weathered debris of a wrecked house.

A fascinating list of potential collage materials, plus intriguing ways of making your own materials, will be found in Anne Brigadier's stimulating book, *Collage: A Complete Guide for Artists.*

Preparing your Own Collage Materials

Although the world of manmade and natural objects provides an endless source of collage materials, you can broaden your vocabulary of color and texture by preparing your own or by modifying the materials you find.

It's often particularly hard to find the exact color you want. Even if you find a scrap of paper or fabric that has the right texture, the right pattern, or something that *approximates* the right color, you still may want to do further work on the scrap. Here's where a solid layer of acrylic paint can turn any scrap into exactly what you need. If you like the pattern, but not the texture, a transparent layer of acrylic paint will preserve the pattern, but change the hue. Or if the color is almost right, but not quite, a transparent glaze or misty scumble can effect a partial transformation. This job can be done on your glass palette before the scrap is stuck to the painting surface, or you can paste the scrap down and then make the necessary color adjustment.

Another problem is that you may find a scrap that *looks* just perfect, but which is too fragile to work with. This is often true of very thin papers, worn paper or cloth, or some material which is inherently perishable, like newspaper or magazine pages. Here's where that glass palette really comes in handy. Brush a layer of acrylic medium onto the bare glass, press the fragile scrap into the wet medium, and then brush a second layer of medium over the scrap. The fragile paper or cloth will be sealed between two layers of plastic in a kind of transparent sandwich. Apply another layer or two of medium, let it dry, and then soak off the plastic sandwich with water, perhaps using a razor blade to peel up the corner. You now have a tough, leathery collage element that handles as easily as a thick, sturdy sheet of new paper or cloth. In the process of toughening this fragile material with medium, you might also want to alter the color slightly by turning one application of medium into a transparent glaze or scumble.

In my list of found materials, I've included a number which don't come in workable pieces, as paper and cloth do: dried leaves, which crumble and flake; granular materials like coffee grounds or kitchen spices; bits of bark or string. Of course, these can be worked right into the painting surface; you can sprinkle or press them into a wet coat of medium. But you can also coat a collage paper with wet medium, sprinkle the surface with these materials, and then have a sheet which you can cut or tear into smaller pieces to fit particular parts of your design. Try shredding string, bark, or leaves and then pasting them down.

I've just talked about making a plastic sandwich in which a fragile scrap of some kind is sealed between two layers of acrylic medium. You can also make an "open faced sandwich" out of a newspaper or magazine clipping. Let's say you find

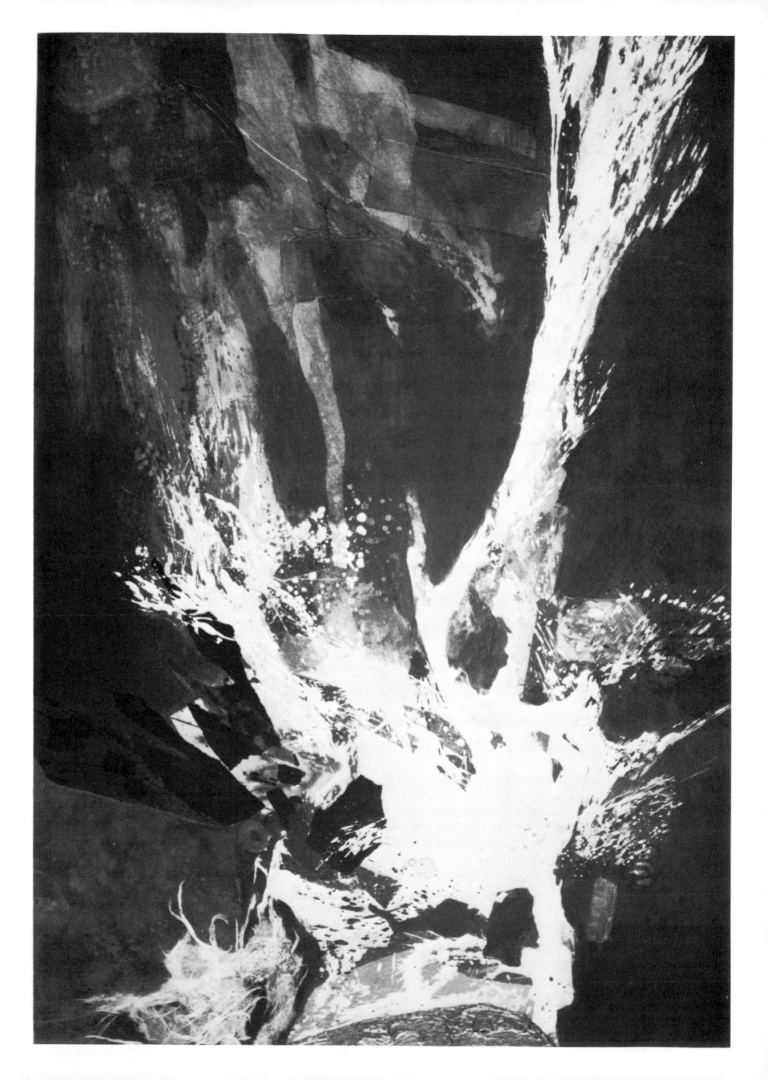

a color photograph, reproduced in a magazine, and you want to incorporate part of it into a collage. Just coat the face of the page—the side where the picture is reproduced—with several layers of acrylic medium until the page becomes fairly thick and leathery. When the medium is absolutely dry, take the page over to the sink (or into the shower with you) and soak it in hot water. Eventually, the paper will become soft and spongy, so you can rub it off with your fingers. In a few minutes, you can rub off all the paper, but the colored printing ink will remain embedded in the sheet of dried emulsion, which remains unaffected by the soaking and rubbing. In effect, you've transferred the printing ink from the paper to the back of the plastic. The result is a transparent picture, which appears to be printed on a sheet of plastic film. You can then paste this sheet down on a luminous white gesso ground or a sheet of illustration board, whose inner light intensifies the colors of the ink. You can also glue it to a colored background which will shine through the transparent plastic. Or you can overlap one transparent image on another to get a surprising double image.

Still another type of collage material, neither paper nor cloth but something like both, is just plain dry paint. By now, you know that the acrylic color that's accumulated on your palette at the end of the day—the accumulation can be quite thick—will peel off in sheets and strips when the glass or enamel surface is covered with water for a while. Why throw these scraps of paint away? They can be saved just as you preserve paper and fabric, then torn up or cut up when you're working on a collage. You can even manufacture these palette leftovers. Just daub some thick layers of acrylic paint on a sheet of glass or an enamel butcher tray, let the paint dry, then soak it off.

Nor should you ever throw away an unsuccessful painting if it's on paper or canvas. If there's nothing you can do to save the painting itself, tear it or cut it into pieces small enough to store, and keep them until you find some reason for pasting them into a picture. Many painters get ideas for new pictures in this way. They tear up an old one, put it away for a while until they've forgotten the composition, then pull out the pieces and move them around like a jigsaw puzzle on a new painting surface. Then they glue down some of the pieces, discard others, paint over some, modify others, and come up with a new and refreshing version of an old idea.

Finally, remember that acrylic paint itself has powerful adhesive qualities which make it possible for you to create your own collage materials spontaneously as you work on a picture. If you keep some stacks of collage papers—especially tissues—near the palette while you're painting, you can spontaneously pick up a scrap and press it into the wet paint when the impulse strikes you. Translucent tissues, in particular, blend unobtrusively with wet paint and it's often hard to discover where the paint ends and the collage begins.

White Burst *by Edward Betts, N.A., A.W.S., acrylic and collage on Masonite panel, 39¾" x 27½". The apparently random placement of the collage elements on the panel—for example, the rectangular pieces placed slightly askew in the upper part of the picture—enhances the "accidental" quality of the entire painting. The foam of the crashing wave is quite literally a splash of paint, carefully directed by the artist to produce smaller spatters and splashes all around the periphery of the white shape that dominates the picture. The blurred, fibrous shape in the lower left appears to be a scrap of Japanese paper. However, few of the collage elements retain their identity; they melt into the sea of color. (Courtesy Midtown Galleries, New York)*

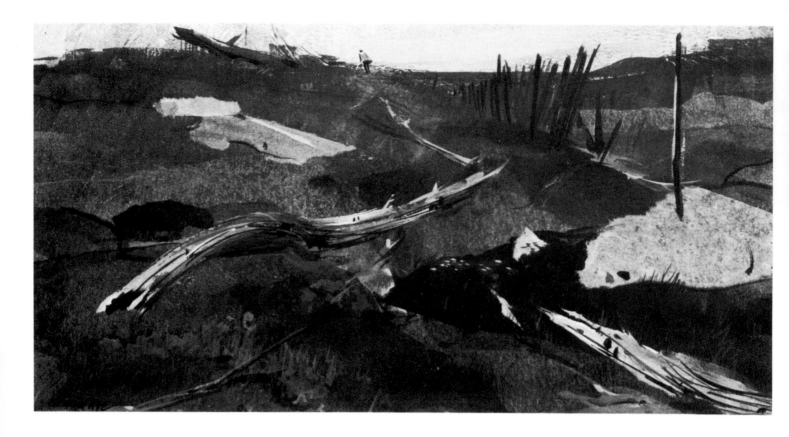

Driftwood Hunter *by Vernon Nye, A.W.S., acrylic and tissue paper on board, 13" x 24". It's practically impossible to find any trace of the ragged pieces of tissue which provided the "underpainting" for this landscape. The acrylic color and the tissue paper merge so completely that the viewer doesn't feel that this combination of paint and collage is a mere technical trick. In this case, the function of the tissue paper was to provide the underlying patches of tone and color on which the composition is built. A freely wielded brush knits everything together and leaves the personal stamp of the artist. This painting has won prizes at the M.H. de Young Memorial Museum and the University of California.*

Because acrylic paints and mediums are so versatile, they lend themselves to more mixed media applications then any other materials available to the artist. Painters and craftsmen are constantly discovering new ways to use acrylic in combination with other painting and drawing materials, as well as with craft materials like metal, plastic, and glass. In this chapter, I'm going to suggest a number of mixed media applications to give you some idea of the range of possibilities. This is hardly a complete list. However, it will give you some points of departure for your own experimentation. Having tried a few of these methods, you may be encouraged to develop mixed media techniques that suit your specific needs.

Oil over Acrylic

One of the traditional methods of underpainting and overpainting is to begin with a water based medium, then work over it with oil paint. Many painters begin with an underpainting in egg tempera, which defines forms, edges, light and shadow precisely. They then glaze over the tempera underpainting with tube oil paint, modified by a medium which generally combines linseed oil (frequently in some processed form, like stand oil or sun-thickened oil), a resin like copal or damar, and a volatile thinner like turpentine. You can also scumble over a tempera underpainting, using this same oil-resin-turpentine medium.

Just as many painters feel that acrylic produces better "tempera" paintings than egg tempera itself, many are now experimenting with acrylic underpaintings, followed by glazes and scumbles of oil paint. If you've already explored the techniques described in earlier chapters of this book, you know that such an underpainting can be executed in the opaque technique, the transparent technique, a combination of opaque and transparent, or the precise tempera technique.

Because a dried layer of acrylic is flexible—unlike the more brittle egg tempera—such an underpainting can be executed on a flexible surface like canvas or on the rigid surface of a Masonite panel. You can underpaint in monochrome (or grisaille), in muted color, or in a full range of colors. The underpainting can be applied smoothly, using fluid paint, or it can be roughly textured, using paint which has been thickened with gel or even with acrylic modeling paste. In short, there are no holds barred. And the dried underpainting is tough enough to resist the roughest attack by bristle brushes and knives when you execute the oil overpainting.

Let me add one important word of warning, however. A number of painters have made the mistake of trying to reverse the process I've just described, beginning with oil then overpainting in acrylic. Remember that acrylic won't stick to an oily surface. An acrylic overpainting on an oil underpainting is likely to be doomed. The acrylic may stick for a while to the oily underpainting, but don't count on it to last.

Acrylic and Pastel

When acrylic medium first appeared on the market, a number of painters experimented with it as a pastel fixative. They first made a drawing or paint-

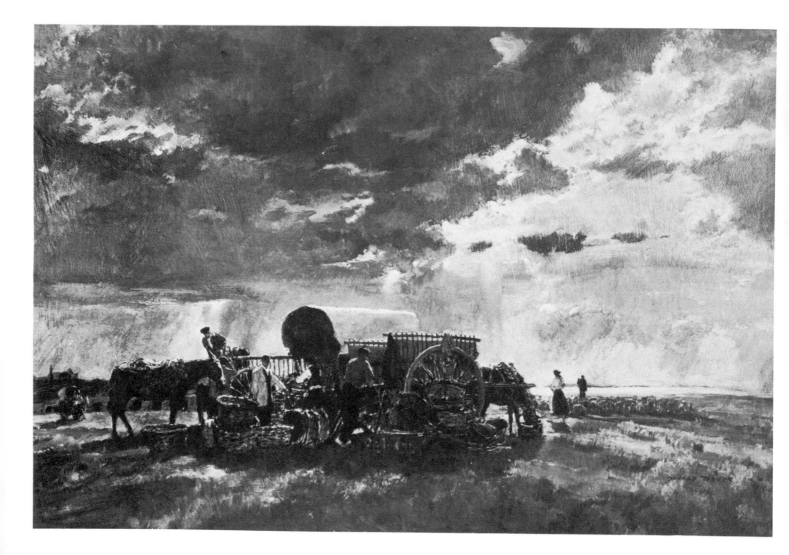

Spanish Evening *by Donald Teague, N.A., A.W.S., acrylic and casein on gesso panel, 24" x 36". Acrylic tube paint and medium combine beautifully with any other type of water based paint. Many artists find casein a frustrating medium to work with because of its non-resilient brushing quality, and its tendency to crack when applied too thickly. However, in combination with acrylic, casein brushes out more freely and can be built up to produce lively textural effects. The sky of this dramatic landscape is painted with the type of scrubbing, scumbling stroke that gives so much "personality" to acrylic in the opaque technique. Similar brushwork is seen on the ground beneath the figures, animals, and wagons. All the forms in the central groups are painted quite flatly, but the artist's selective use of linear accents implies a wealth of detail. The underlying gesso gives an inner light to the glowing sky. (Photograph by Julian P. Graham)*

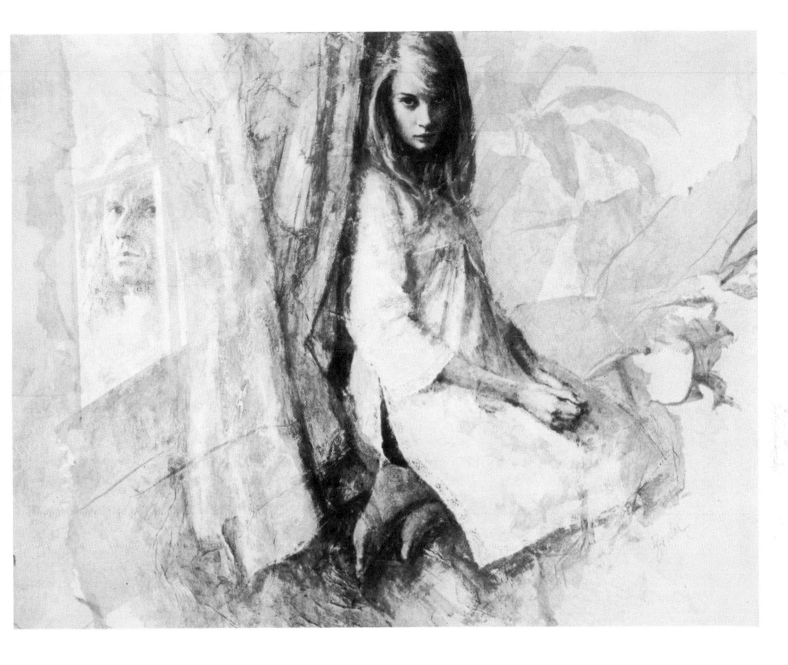

Illustration for McCall's *by Joe Bowler, acrylic, casein, and tissue collage on gesso coated Masonite panel, 20" x 30" The pale, ghostly, torn shapes of the tissue interweave behind the figure, framing her in an abstract setting that harmonizes with the curtains and the leaves. The wrinkled tissue—particularly evident beneath her feet and to the left of the figure—provides a kind of "impasto underpainting," over which liquid glazes, that sink into the crevices and skim the ridges, can be brushed. With the aid of acrylic medium, the normally brittle casein can be built into thick, crusty passages which can be glazed with transparent color. The crusty casein and the fluid acrylic glazes make an attractive mixed media combination.*

A rough underpainting of tube color and gel was applied to canvas, leaving the brushstrokes as distinct as possible. A gradated glaze of oil color, diluted with copal medium, was brushed over the surface, settling into the valleys and accentuating the weave of the canvas.

Diagonal strokes of soft pastel were applied to canvas (left) and then brushed with acrylic medium (right), which merged and blended the strokes, converting them to semi-liquid paint.

ing in pastel on a sheet of paper or board, then sprayed it with a greatly diluted solution of acrylic medium—some acrylic medium, mostly water. Diluted acrylic medium, preferably the matt kind, works reasonably well as a fixative, but has the usual problems of all fixatives: once the pastel gets wet, its character changes and you end up with a painting which is quite different from what you started out with.

Here's what actually happens. A stick of pastel is a blend of powdered pigment and water soluble adhesive, made into a paste, then rolled into a cylinder, and allowed to dry. A pastel chalk is essentially a stick of dry paint. When you stroke the chalk over the surface of paper or board, some of the dry paint crumbles off the end of the stick and is gripped by the "tooth" of the painting surface. The chalk remains on the surface in the form of tiny, separate granules which give a pastel painting that wonderful, dusty, peach fuzz quality. But when the granules get wet, they tend to dissolve, coalesce, and form a continuous paint film. The individual granules melt away and so that peach fuzz texture is lost. Except for Degas—who had a special fixative for which the formula has been lost—every pastel painter has this problem with fixative, and many simply don't think it's worth it to fix their pastels at all.

But this problem can actually be turned into an advantage. If you don't mind seeing your strokes of pastel melt into paint, the combination of pastel and acrylic medium can give you a new and refreshing way to produce a picture which is somewhere between a drawing and a painting. You can actually build up an extraordinarily rich effect by alternating layers of pastel and acrylic medium. Let's say you start out with your first layer of pastel, blocking in the basic shapes and colors. You then spray or brush on a layer of matt medium, which melts the pastel so you can work back into it with brushes, wood or plastic tools, or even your fingers. Let this dry, apply some more pastel, work back into it with acrylic medium once again, and keep repeating this process until you reach the final effect you want. It won't look like a pastel, nor will it look like an acrylic painting, but it's somewhere in between—and something very special.

Actually, this is directly related to Degas' own unusual pastel painting technique. Unlike other pastellists, Degas was constantly wetting his painting surface, pushing color around with brushes and

other tools, even wetting his chalks and making wet strokes on a wet surface. He was no purist—which probably explains why he was the greatest pastellist of them all.

Nor is there any reason why you must restrict yourself entirely to pastel and acrylic medium. Pastel combines equally well with acrylic paint. Why not try an underpainting in acrylic tube color, just as traditional pastellists often begin with an underpainting in watercolor or gouache? Or if you're alternating layers of chalk and acrylic medium, why not introduce acrylic tube color at one of the intermediary stages? Having sprayed a layer of pastel with liquid medium, you can work back into the wet surface with acrylic tube color. You can try glazes, scumbles, drybrush, or broken color effects, all of which will integrate beautifully with the rough texture of the pastel.

Acrylic and Transparent Watercolor

Although many painters find acrylic an ideal watercolor medium others prefer to combine the old medium with the new. Here are several ways you might like to try.

If you prefer the feel of traditional, transparent watercolor, but you like to use acrylic medium occasionally, there's no reason why you can't simply keep a bottle of medium handy for mixing with washes whenever you wish. A brushload of matt medium will make a flat or graded watercolor wash flow a lot more easily and cover more smoothly. Blending watercolor with acrylic medium—or even a bit of gel—will also give you much more control over a wet-in-wet effect, as I've explained earlier. Yet you still have the freedom to leave acrylic medium out of your washes if you prefer to have a wash that remains water soluble. After all, many watercolorists really *like* the fact that they can sponge out a passage, scrub away at it with a bristle brush, or try other techniques that take advantage of the fact that traditional watercolor remains soluble even when dry. They add acrylic medium *only* when they want a passage to dry insoluble. In this way, they can retain certain advantages of the other medium, yet enjoy some of the advantages of the new medium whenever they choose.

Other watercolorists actually combine passages of traditional watercolor and passages of acrylic. They may begin a painting in traditional, transparent watercolor, blocking in the broad shapes and colors, yet leaving themselves free to sponge out, lighten, or otherwise adjust a wash of soluble color. Then, when the design is firmly set, they go back and finish the picture in washes of acrylic. They may also prefer to use watercolor for thin, loose, transparent passages, reserving acrylic for heavier, tighter, more solid passages.

You can also reverse the process, beginning your picture with washes of acrylic that dry insoluble. When these first washes are dry and immovable you can then work over them with washes of watercolor, which you can sponge away at will. The toughness of the underlying acrylic gives you greater freedom to experiment with washes of watercolor, which won't lift the color underneath.

Inks, Dyes, and Acrylic Medium

A favorite combination of leading illustrators is a blend of matt or gloss acrylic medium with powerful drawing inks and dyes. This combination gives the illustrator the intense, vivid color he needs for reproduction on the printed page, plus the attractive brushing qualities of acrylic.

If you've ever tried painting with bottles of drawing ink or dye, you probably know that the brushing qualities of these materials are very frustrating. They're as fluid as watercolor, dry very quickly, and the color is often too powerful to control. On the other hand, the powerful color is exactly what you want, or you wouldn't be working with these materials in the first place. Although many of these colors fade on prolonged exposure to light, they're far more vivid than most of the permanent colors on the painter's palette. Since you're working for publication, the permanence of the original doesn't count nearly so much as the impact of the picture on the printed page.

But how do you make these colors easier to apply, easier to push around with the brush? The answer, of course, is a bottle of matt or gloss acrylic medium. This medium adds just enough body, just enough creaminess, to convert ink or dye into paint. Yet the glassy transparency of dry acrylic medium preserves the vividness of the transparent color.

Acrylic and Opaque Watercolor

There are really two kinds of opaque watercolor. One is essentially the same thing as transparent watercolor-powdered pigment and a water soluble

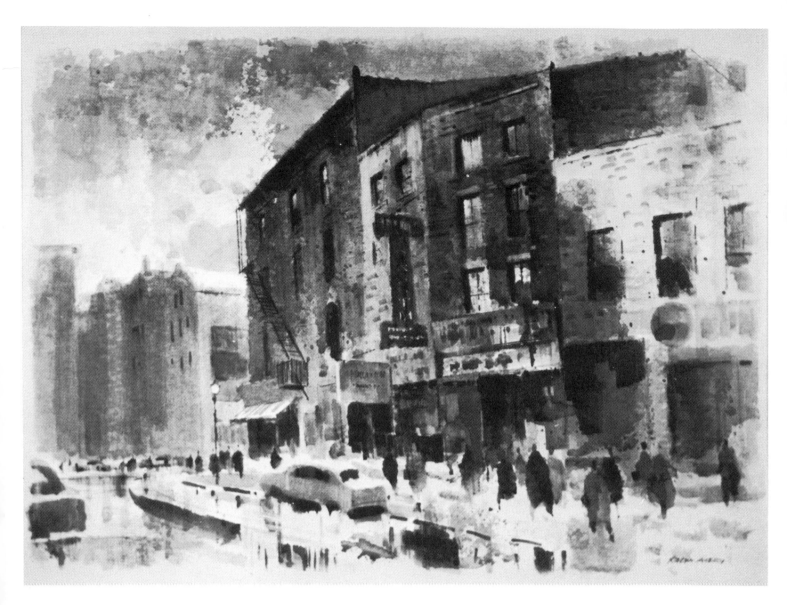

Front Street, Winter *by Ralph Avery, A.N.A., A.W.S., watercolor and acrylic on paper, 22" x 30". In view of the fact that acrylic handles so well as a watercolor medium, it may seem surprising that so many artists combine acrylic and traditional, transparent watercolor. Yet one distinct advantage of this combination is that the artist can begin by blocking in his composition with pale washes of watercolor which remain soluble indefinitely. These washes can thus be adjusted, sponged out, lightened, and generally moved around until the design is in workable form. Over these basic color areas, darker, more solid, more final passages of acrylic can be applied. The insoluble acrylic seals the watercolor washes in place and additional washes can be built up, layer after layer, for effects of unusual depth and richness.*

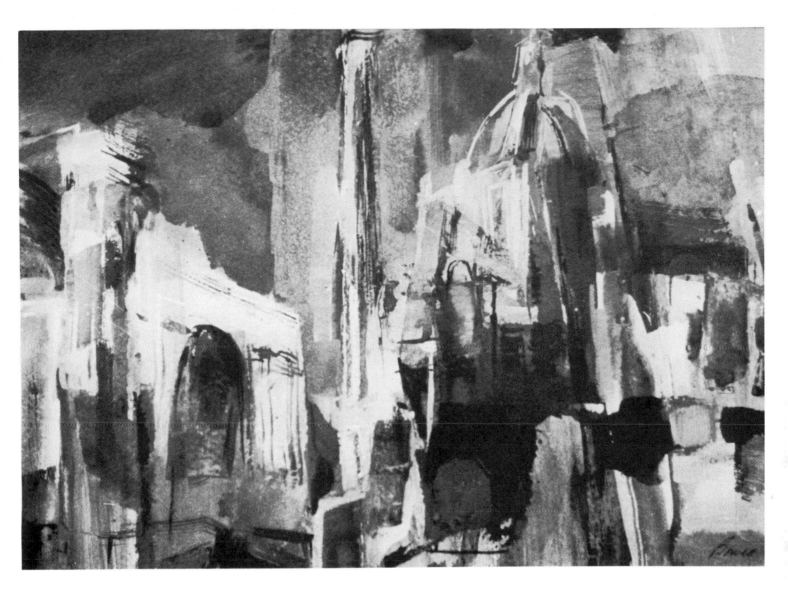

Roman Forum *by Betty M. Bowes, A.W.S., watercolor and acrylic on paper, 14" x 11". Another way to combine acrylic and traditional, transparent watercolor is to use the older medium for the more delicate, more transparent passages, while the newer medium is used for the more opaque, more solid passages. Acrylic also lends itself well to opaque linear accents like the brushwork on the dome to the left of center. The opaque acrylic tube colors always retain a certain sense of transparency and inner light. In contrast, traditional watercolor mixed with Chinese white has an unpleasant chalkiness.*

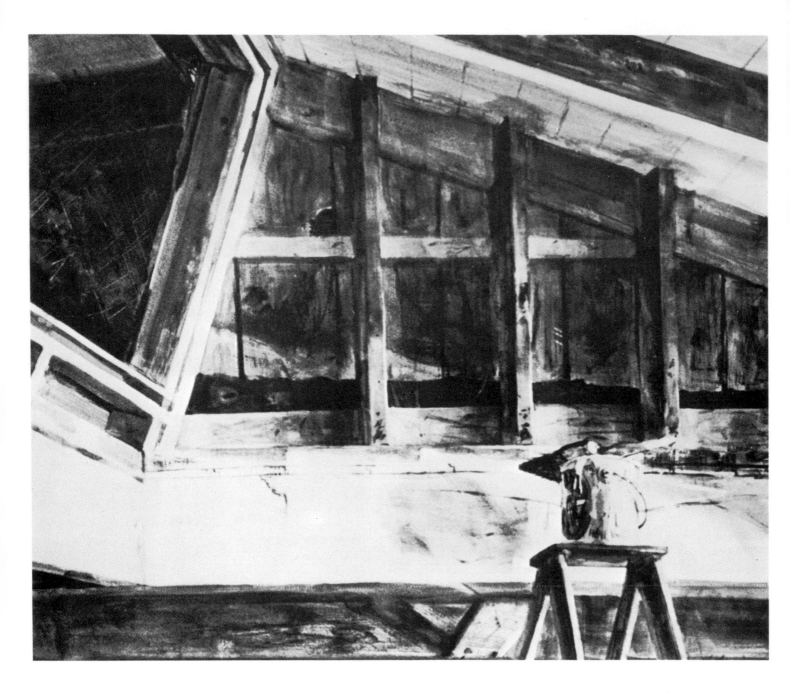

Unfinished Skylight *by Jay O'Meilia, A.W.S., acrylic and watercolor on watercolor board, 25" x 32". While washes of traditional watercolor are ideal for the delicate underlying tones of this type of painting, the complex textures of the wood are more likely to be built up successfully in acrylic. Each wash of acrylic dries insoluble and is unaffected by the next wash, so that the painter is free to indulge in free brushwork, and to apply wash upon wash. These techniques are evident in the treatment of the weathered wooden panels here. This simple, geometric composition is based entirely on horizontals, verticals, and diagonals. However, the strict architectural scheme is saved from sterility by the lively textural effects within the rectangles.*

adhesive—but thickened and made opaque by the addition of an inert, chalky material. This is sold under such names as designers' colors, gouache, or sometimes tempera (as distinct from egg tempera). Another type of opaque watercolor is casein paint, made of powdered pigment, opaque filler, and casein glue. Both types of opaque watercolor dry rapidly, remain brittle—so they can't be applied thickly—and are severely limited in their range of technical possibilities.

Adding acrylic medium will greatly enrich the pleasure of working with designers' colors or with casein. The most obvious improvement is in the brushing quality of the color, which becomes creamier, juicier, and a lot easier to push around. The paint handles just a bit more like oil—though it feels like a water based medium—and gives you much greater freedom to indulge in exciting brushwork. The paint also becomes much more flexible when it dries, less apt to crack or flake off, so you can really build up interesting textures.

Of course, adding acrylic medium to designers' colors will make the dried paint water insoluble. This *can* be a disadvantage if you're accustomed to the freedom to adjust a passage by brushing on some water, dissolving the paint, and then making a necessary change. However, you can have the best of both worlds. It's easy enough to add acrylic medium only when you want it, but leave it out when it gets in your way. For example, during the underpainting stage, you may prefer to work with water soluble paint—no acrylic medium—and then finish with glazes that contain acrylic medium.

Stained Glass, Mosaic, and Enamels

Artists and craftsmen are just beginning to discover the craft applications of acrylic paints and mediums. Here are just a few.

Acrylic tube color provides a radically new way to create stained glass. You can make stained glass segments that are actually sandwiches: two sheets of glass surrounding a layer of acrylic color. You daub one sheet of glass with a thick layer of acrylic paint, then press the second piece of glass down hard over the wet color. The tube color not only provides the hue, but also the adhesive. When the color is dry, it holds the two pieces of glass together so powerfully that you can't pull them apart without shattering the glass.

In making acrylic stained glass, transparency is the most important consideration when you choose your colors. Review the list of colors in Chapter 2 and work only with those that will really let the light through the glass. For maximum transparency, dilute your tube colors with gloss medium or gel.

Instead of working with glass, you may also want to experiment with transparent acrylic sheet, generally sold under such trade names as Plexiglas or Lucite.

You may wonder whether you can actually paint on a sheet of glass, rather than assembling your design out of small glass segments which are individually colored, laminated, and assembled with strips of lead. I've said that I'd be a bit worried about the adhesion of acrylic color to something as smooth and nonabsorbent as glass. But if you can get a sheet of glass which has been faintly roughened by sandblasting, then you've got a surface which has just enough tooth to hold a layer of paint. The sandblasting will reduce the transparency of the glass, but the sheet should remain translucent; in other words, the light will still come through, even if you can't see clearly through the glass. Working on the roughened side with transparent acrylic color, diluted with gloss or matt medium, you can create a large, transparent painting which can be set into a window or placed in some location where the light shines through the glass.

Traditionally, mosaic tesserae—the tiny segments which are assembled to make the design—are made of glass or tile. But there's no reason why you can't make your own tesserae out of more modern materials. Acrylic modeling paste has proven itself to be weatherproof when used to repair outdoor sculpture, so this new material can certainly take as much wear as glass or tile. Why not mix acrylic tube color with modeling paste and shape your own tesserae to the exact size and form you need? In this way, you can also produce the exact colors to fit your design, rather than hoping to find approximate colors among the tesserae sold by the mosaic supplier.

And don't overlook modeling paste or gel as an adhesive for your homemade tesserae. I've said that you can embed found objects in a layer of wet modeling paste. You can just as easily create a mosaic by pressing tesserae into this tenacious adhesive. And to finish things off, another layer of modeling paste can be spread over the completed mosaic, worked into the spaces between the tesserae, and then wiped away from the surface, just

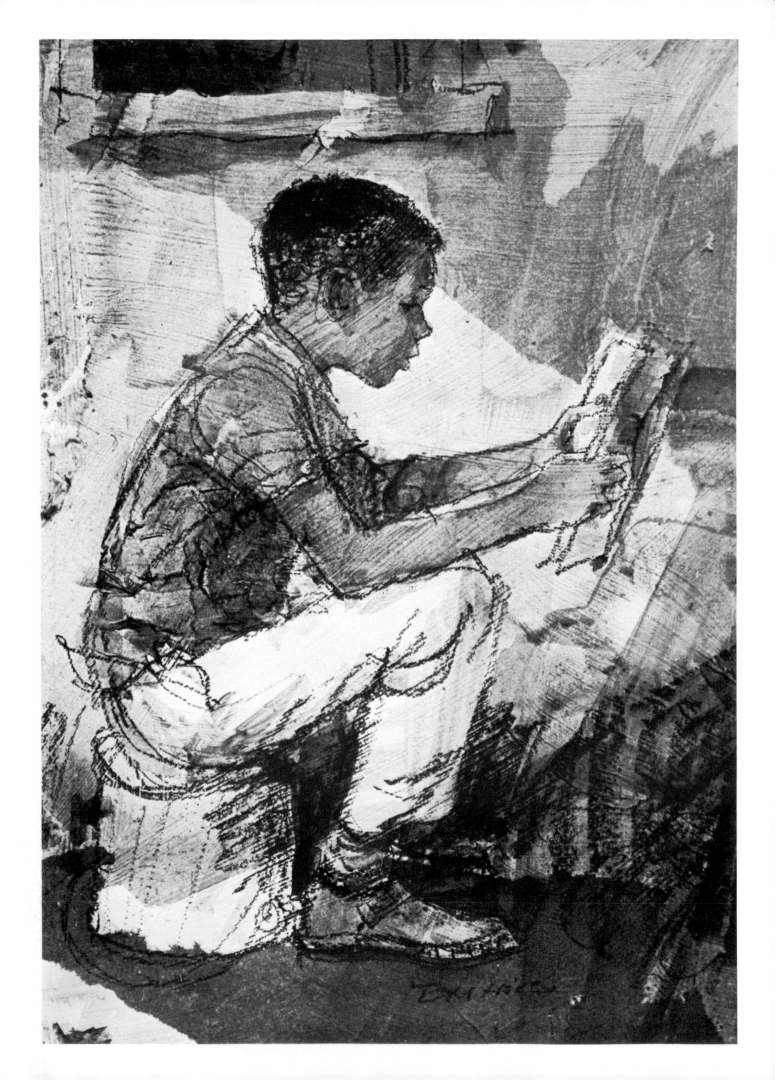

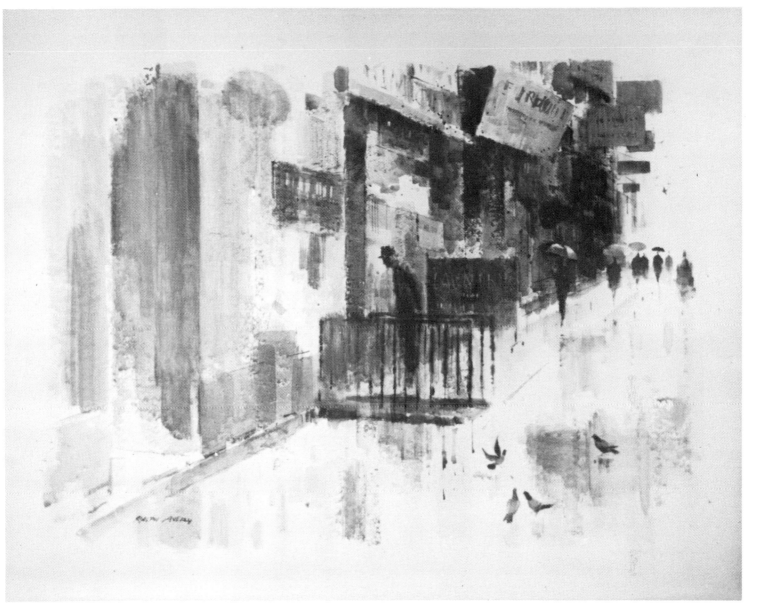

The Magazine by *Tom Hill, A.W.S., acrylic and tissue paper collage on gesso coated hardboard, 8" x 12". The simplest —and one of the most effective—mixed media combinations is an acrylic wash and a drawing medium like pencil, charcoal, Conté, or carbon pencil. The washes can go on first, and the lines can then be added when the color is dry. Or the lines can go down first, and you can quickly wash over them with color. Bear in mind, however, that charcoal and various chalks need to be sprayed with fixative unless you actually* want *them to be smudged by the wet brush. The tissue paper shapes in this painting are used with such discretion that they seem nothing more than shadows.*

Pigeons and People by *Ralph Avery, A.N.A., A.W.S., acrylic and watercolor on paper, 22" x 30". This painting has a particularly subtle vignette effect. The composition melts away at the edges so that the cityscape seems to be dissolving into misty rain. The heaviest tones and textures—the focal points of the composition in the center and upper right—are where acrylic can be most useful in this mixed media combination. Piled stroke upon stroke, acrylic retains more transparency and spontaneity than watercolor, producing deeper, more intense darks.*

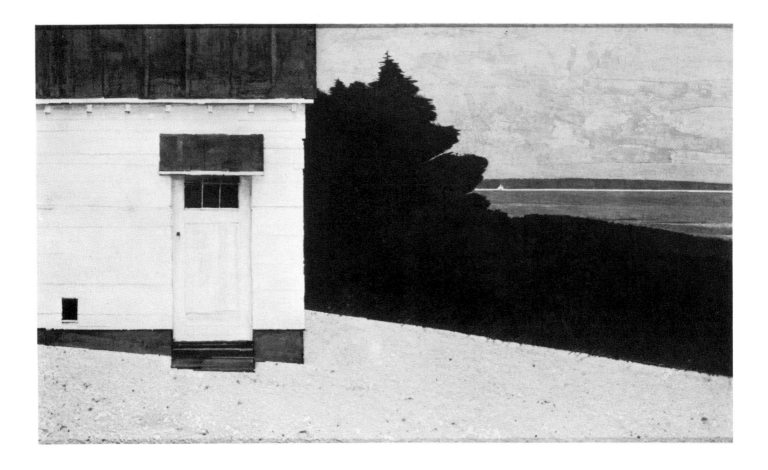

New Shoreham *by Lawrence N. Jensen, A.W.S., acrylic on paper, mounted on Masonite panel, 35" x 20½", collection Richard Selink, New Rochelle, New York. This handsome composition of geometric and free forms—a prizewinner at the American Watercolor Society—suggests a subtle combination of three different elements. The immediate foreground appears to be a granular material—perhaps fine grained sand—cemented to the painting surface with acrylic medium. The cloud-like shapes in the sky suggest irregular scraps of paper. The brushwork in the ragged shape of the trees and distant landscape, as well as the building to the left, is controlled. Everything is handled with extreme restraint and subtlety, so you're never conscious of the shift from collage to acrylic color: the sky really functions as a sky and the foreground texture is never insistent. Collage, textural painting, and mixed media effects are never ends in themselves. All elements should be integrated, as they are here. (Photograph by Peter A. Juley & Son)*

Study for Summer House *by Robert Dash, acrylic on gesso panel, 5" x 7". This enlargement of a tiny painting reveals the special character of acrylic, when used in the opaque technique. Applied wet-in-wet or even over a dry passage of another color, the fluid paint is enlivened by the color beneath. Unless it's applied very thickly, there's usually a slight hint of transparency which adds a certain vibration to a freely brushed passage. At its best, acrylic brushwork seems casual and easy-going, even though it may be controlled. Also, the brush leaves behind its mark and records the artist's personal handwriting in every stroke. (Courtesy Graham Gallery, New York)*

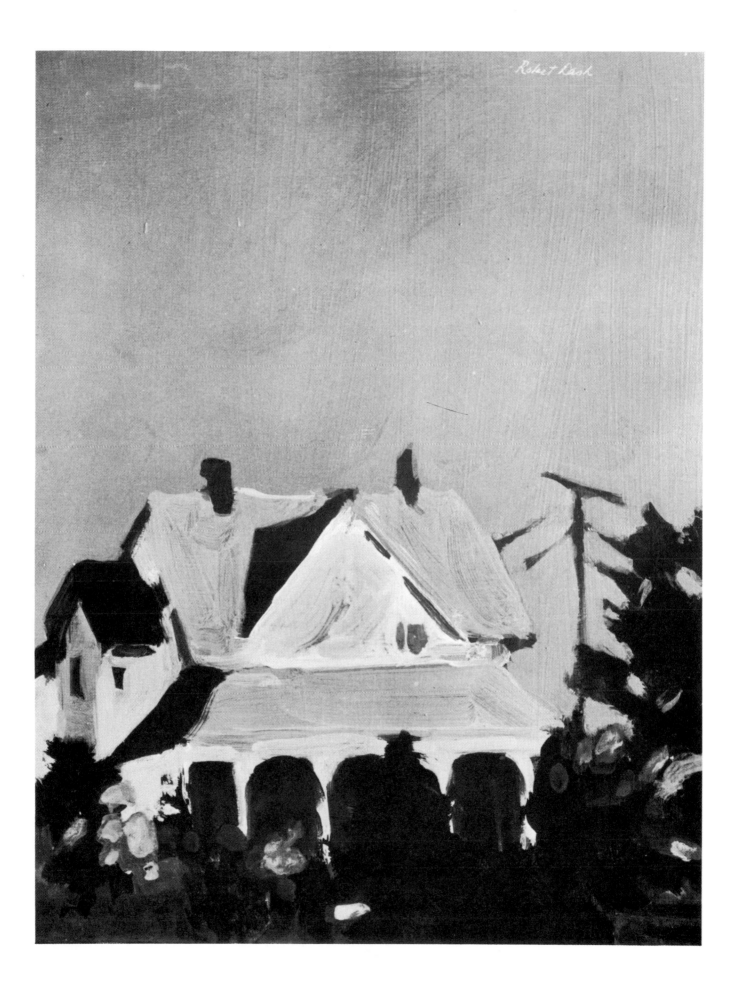

as you would with the grout that fills the spaces of a traditional mosaic.

The ancient craft of enameling is normally done by dusting powdered glass on a sheet of copper (or some other metal like aluminum) and then melting the powdered glass in a kiln. The molten glass forms a luminous film that sticks solidly to the metal. It's a slow process, requiring not only lots of patience, but a kiln and other equipment which few painters have on hand. But I've recently discovered that acrylic tube colors and mediums can produce effects that look surprisingly like enamels.

Like glass, polished metal is a bit too smooth and nonabsorbent to grip a layer of acrylic paint. So you've got to begin with a piece of copper or aluminum which has been lightly sandblasted or which you've lightly roughened with a very fine grain emery paper. Jewelers and stonemasons work with emery papers that will roughen a surface so imperceptibly that you won't see a single scratch. Yet this provides just enough tooth to hold the paint.

With the metal surface slightly roughened, you can paint on the copper or aluminum just as you would on a panel or on a sheet of illustration board. It's important to work with transparent tube colors, preferably diluted with gloss medium or gel to intensify the reflection of light from the surface. While the transparent acrylic color is still wet, you can even try tricks like sprinkling gold, silver, or bronze metallic powder onto parts of the design. The shine of the acrylic medium and the shine of the metal coming through the transparent color can produce an "acrylic enamel" which comes amazingly close to the luminosity of the real thing.

However, it's not an *imitation* of stained glass, mosaic, or enamel that you're really shooting for. What acrylic gives you is a fresh look, a modern variation of these traditional art forms. The sandwich method of making stained glass, working with acrylic modeling paste to make your own tessarae, and actually painting on metal will give you far greater freedom to experiment with color than you can possibly have in these older, slower techniques. The purist may object, but acrylic *is* a revolutionary medium which is meant to shake up our time-worn assumptions about how things are "supposed" to be done.

11
Varnishing and Framing

Because acrylic has greater resistance to physical wear and tear than any other painting medium, varnishing and framing would seem to be simple jobs. But there are lots of decisions to be made about what kind of varnish and how to apply it, how to mat and frame various types of pictures, and how to provide proper protection from people and from the elements—protection which even a tough acrylic painting needs. This final chapter offers some suggestions on this subject.

Gloss and Matt Varnish

An oil painting is fragile at best, so proper varnishing is essential to protect the picture from destructive chemicals in the air, accumulated dirt, and greasy fingertips. Furthermore, the varnish we use on an oil painting has the terribly important function of heightening the color in the picture, since oil colors have a tendency to "sink in" over the years. The usual strategy is to coat an oil painting with a layer of varnish that's easy to remove. As time passes, the varnish gathers chemical waste from the air, airborne dirt, and fingerprints. Then, when the varnish has taken all the punishment it can stand, the protective layer is cleaned away with a mild solvent. The varnish, not the picture, takes the abuse, so when the varnish is removed, the picture is theoretically as good as new. Hopefully, all that's needed is a fresh layer of varnish to protect the painting for another period of years, until the next cleaning.

But this is *not* the strategy when you varnish an acrylic painting. Many painters would argue that an acrylic doesn't need varnishing at all, since acrylic medium is so tough and the color never "sinks in." The granules of color are completely encased in a permanent, wear-resistant, completely transparent layer of plastic—the dried acrylic emulsion with which the paint is made—and many artists feel that this is all the protection that the color needs. So the first question is simply: does an acrylic painting need varnishing at all?

Frankly, if you paint with lots of medium— whether gloss, matt, or gel—I think it's perfectly possible to get along without any protective layer of varnish. The "varnish" is built into the paint. Provided that the picture is executed on a wear-resistant painting surface, like Masonite or sturdy canvas, the picture requires no further protection, except for a good framing job.

When *does* an acrylic painting need a coat of varnish? Offhand, I can think of only three reasons for varnishing an acrylic. First of all, if you've thinned your paint mainly with water and thereby diluted the protective emulsion in the paint, the dried painting surface is obviously less wear-resistant, and a protective layer of varnish may be in order. Second, if your painting surface is relatively fragile—let's say you've painted on silk or your picture contains delicate collage paper—a layer of varnish may be a good idea to toughen the surface. Third, you may actually want to change the character of the painting: if it's too glossy, you may want to turn it matt with a layer of matt varnish; if it's too matt, you may want to shine it up with a layer of gloss varnish; if it's glossy in some spots and matt in others, you may want to unify the surface with a layer of matt *or* gloss varnish, depending upon your taste.

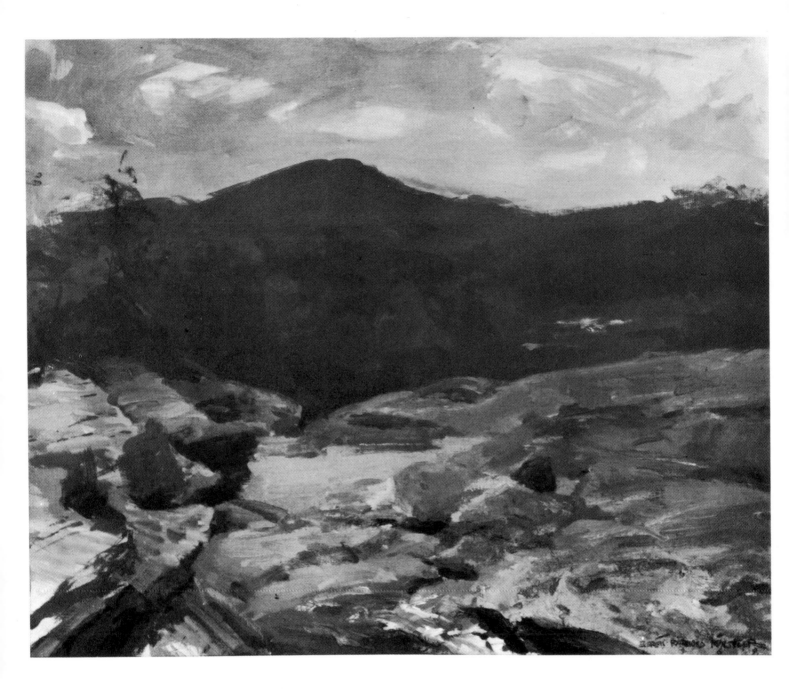

Limerock, Connecticut *by Everett Raymond Kinstler, A.W.S., acrylic on canvas board, 20" x 24". This rapid outdoor sketch stays close to essentials: a few large, simple shapes are freely brushed in—invigorated by the artist's personal "handwriting." There are no tonal gradations, but one tone is simply scrubbed into, or placed beside, the next. Where this technique is used wet-in-wet—as in the sky—there are soft transitions. Yet, the artist never strives for the subtle blending you might expect in an oil painting. The colors are simply scrubbed together in the freest possible way and roughly mixed on the surface of the canvas. A complete landscape is suggested with a minimum of strokes and detail. (Photograph by Peter A. Juley & Son)*

As the preceding paragraph suggests, there are two kinds of acrylic varnish: gloss and matt. Some manufacturers tell you to varnish your picture with *painting medium*, either gloss or matt or a combination of the two, since they don't manufacture a separate varnish formulation. Others manufacture matt and gloss varnish which are more or less like the matt and gloss painting media, but adapted slightly for varnishing purposes. Follow the manufacturer's instructions. If he tells you to varnish with painting medium, he knows from experience that this will work. But if he's taken the trouble to develop a separate formulation for varnishing, he obviously has his reasons, so don't fool around with the medium, trying to make it act like varnish.

Like matt and gloss mediums, acrylic varnishes are normally water soluble and milky looking when wet, but clear and insoluble when dry. Once the varnish dries, you can't get it off. Unlike the kind of varnish used on an oil painting (a formulation which is specially designed for easy removal), acrylic varnish forms a permanent bond with the paint beneath. So if you don't like the effect of the varnish, you can't change your mind and clean it away. It's there to stay. You don't clean an acrylic painting by dissolving the varnish—as you do an oil painting—but the surface is so tough and water resistant that you need nothing more than a damp cloth (and perhaps some mild soap) to eliminate accumulated dirt. Generations of restorers have made a living by cleaning oil paintings, but anyone can clean an acrylic painting in a matter of minutes.

However, the incredible toughness of a dried layer of acrylic varnish presents some problems. Most important of all, you can't afford to make any mistakes when you apply the varnish: any bubbles or dust will be there forever. So here are some tips for applying varnish efficiently.

(1) I always play it safe by diluting matt or gloss acrylic varnish half-and-half with water. This more fluid varnish goes on more easily. The fluidity of the solution also eliminates any danger of trapping microscopic air bubbles which sometimes show up as a faint mist in the dry varnish. Particularly on a very dark painting, I've had some bad experiences applying varnish straight from the bottle: the undiluted varnish sometimes leaves a faint haze on the darkest parts of the picture—and this threat seems to be eliminated by diluting the varnish.

(2) Brush on the varnish with a big, broad nylon utility brush, using long, slow, straight strokes. Apply the varnish with a smooth rhythmic motion, and avoid scrubbing back and forth, which can produce air bubbles that may be locked in to the dried varnish.

(3) Work on a clean, dust-free surface. Stay away from dust, lint, sawdust, bread crumbs, hair clips, or anything that might become embedded in the varnish. This all may sound farfetched, but I know one artist who found bread crumbs stuck to the surface of a dried picture—then he remembered that he was eating a sandwich while he was varnishing. I know another artist who was baffled by bits of hair stuck to the varnish until he remembered that he'd gotten himself a haircut, hadn't brushed his shirt off properly, and then went to work in the studio. The bread crumbs and the hair are part of the picture forever!

(4) Two or three coats of diluted varnish are always better than one thick coat of varnish used straight from the bottle. The varnish dries in minutes, so there's no long, time-consuming wait between coats.

Whether you choose gloss or matt varnish is purely a matter of taste. If you want your picture to look like an oil painting, gloss varnish will seem right. On the other hand, if you prefer a tempera or gouache effect, you'll like matt varnish. You can also mix gloss and matt varnish half-and-half (or in any other proportion) to get the proper compromise to suit your taste.

Framing Canvases and Panels

If your painting is on a panel or on canvas, you won't need glass, of course. All you need is a good, sturdy frame which will protect the edges of the picture and hold it rigid, without buckling. If a panel is more than 2' long or high, it needs cradling as I described in Chapter 3.

An acrylic painting on canvas will benefit from some sort of backing in addition to the frame. There's always the danger that some clumsy oaf will poke a foot or an elbow into the resilient canvas. The best protection is a sheet of stiff cardboard which you cut to the exact size of the canvas and attach to the back by driving tacks or staples into the back of the stretcher frame. This will seal the canvas from behind. But be sure to cut a small hole, about an inch in diameter, in the center of

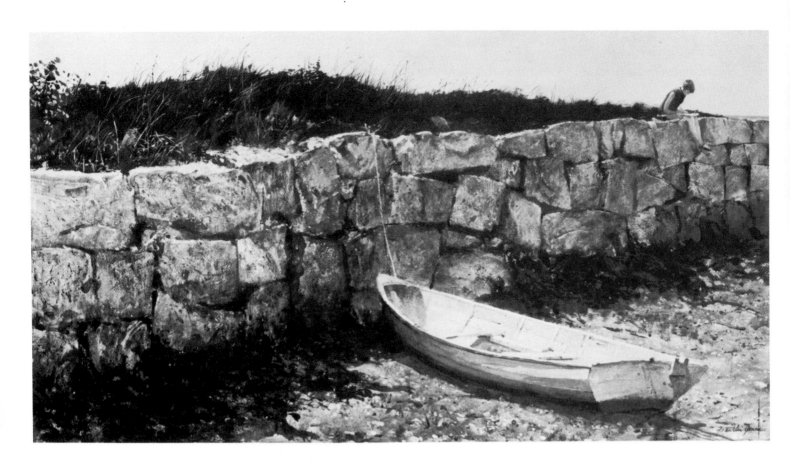

The Sea Wall by Franklin Jones, acrylic on Masonite, 20" x 36". After making a watercolor of the same size, the artist felt that acrylic allowed for greater textural qualities in a study of a granite wall, so he began a second painting—the one you see here. He began by laying in the sky, grass, and wall with opaque tones. Next, he dragged white paint over the rocks to produce a rough texture. Light and dark spatters were applied over this, followed by transparent washes. The boat was modeled carefully in opaque color and then it, too, was "aged" with transparent washes. The ground is a series of transparent washes, beginning with warm, rich tones, and ending with gray-green tones. The stones and pebbles combine light, opaque strokes and dark spatter tones. Finally, a pale, warm wash was applied over the entire painting; before this wash dried, the interior of the boat was wiped lightly with a rag.

the protective cardboard so the painting can "breathe."

A wide, rugged molding provides maximum protection, since this sort of frame grips the canvas or panel firmly and fights any tendency toward warping or buckling. Many contemporary painters like the current fashion which calls for a simple wooden strip (perhaps with a layer of gilt or some other color) which is nailed to the four edges of the panel or the canvas stretcher. This can be very attractive, but be sure that the panel is properly cradled, even if it's small, or that your canvas is mounted on really firm stretcher bars, perhaps with a crossbar for additional support. Since a strip frame doesn't provide any kind of rigidity, the cradle or the stretcher bars must do the job on their own.

Framing Paintings on Paper or Illustration Board

Acrylic watercolors and gouaches are normally painted on paper or illustration board. Although the paint dries as tough as nails, it's the painting surface that needs protection. All paper is fragile, even if it's the strong white sheet on the face of an illustration board. The usual solution is to frame an acrylic watercolor or gouache under glass, like a traditional watercolor or gouache. Since it's a "rule" that glass must never come into direct contact with the surface of a painting—to avoid trapping destructive moisture—there must be a mat between the picture and the glass. I also think it's wise to have a separate backing board behind the painting. And the entire sandwich (glass, mat, painting, backing board) is finally enclosed in a frame. As I'm sure you know, the molding for a watercolor or gouache is generally much thinner than the molding used to frame a picture on canvas or on a panel.

Speaking of mats, acrylic colors and mediums add a new dimension to the job of making mats. Acrylic gesso, toned with tube color, produces wonderful colored mats which are exceptionally resistant to wear. And acrylic mediums are excellent adhesives for making cloth covered mats, which require gluing silk or linen to cardboard.

But what if you'd like to try framing an acrylic watercolor or gouache *without* glass? Every painter agrees that glass is only a necessary evil and that we'd all enjoy a painting much more if we didn't have to look at it through a sheet of glass. If you're willing to experiment, it's possible to use acrylic varnish to provide the same kind of protection that's normally provided by glass. You can carefully sponge the back of a completed acrylic watercolor, coat the back with acrylic medium, and then smooth the paper down onto a precut sheet of Masonite—so your watercolor is now mounted on a panel. Then, several diluted coats of matt acrylic varnish will toughen the surface sufficiently so that the panel can be framed and hung without glass. If you miss the feeling of a mat, make a thick one out of wallboard and paint it with acrylic gesso (white or tinted) or cover it with fabric, then add a frame. You can thus mat and frame your watercolor-on-a-panel without glass.

If your watercolor or gouache was done on illustration board, the job is even easier. You can mount lightweight, flexible illustration board on Masonite, using acrylic medium as your adhesive, and then coat the surface with matt varnish—or gloss varnish if you prefer. Or if you think the illustration board is stiff enough by itself, coat both sides with acrylic varnish for maximum protection. The panel or board can then be framed without glass, with or without a matt.

One word of warning about varnishing acrylic watercolors and gouaches. Particularly with the delicate tones of a watercolor, you want to be absolutely sure that you have the effect of matt or gloss varnish—before you slap that non-removable coat on a precious painting. Take an old, unsuccessful painting and varnish it first, to see how it looks. Or take a scrap of watercolor paper or illustration board, paint some washes on it, preferably in colors similar to the painting, and then experiment with varnish on the scrap. If you don't like the look of a varnished watercolor or gouache, there's still time to go back to the traditional mat and glass sandwich, provided that you haven't already mounted the picture on Masonite.

Framing Collages and Textural Paintings

If you've done a collage on paper or illustration board, you can frame it like a watercolor, with a mat and glass. Be sure that the mat is thick enough to keep the glass away from any parts of the collage that may protrude. Not only the delicate surface of the paper or illustration board will need protection, but fragile collage papers themselves often need a sheet of glass between them and the outside world.

But it *is* possible to frame a collage without

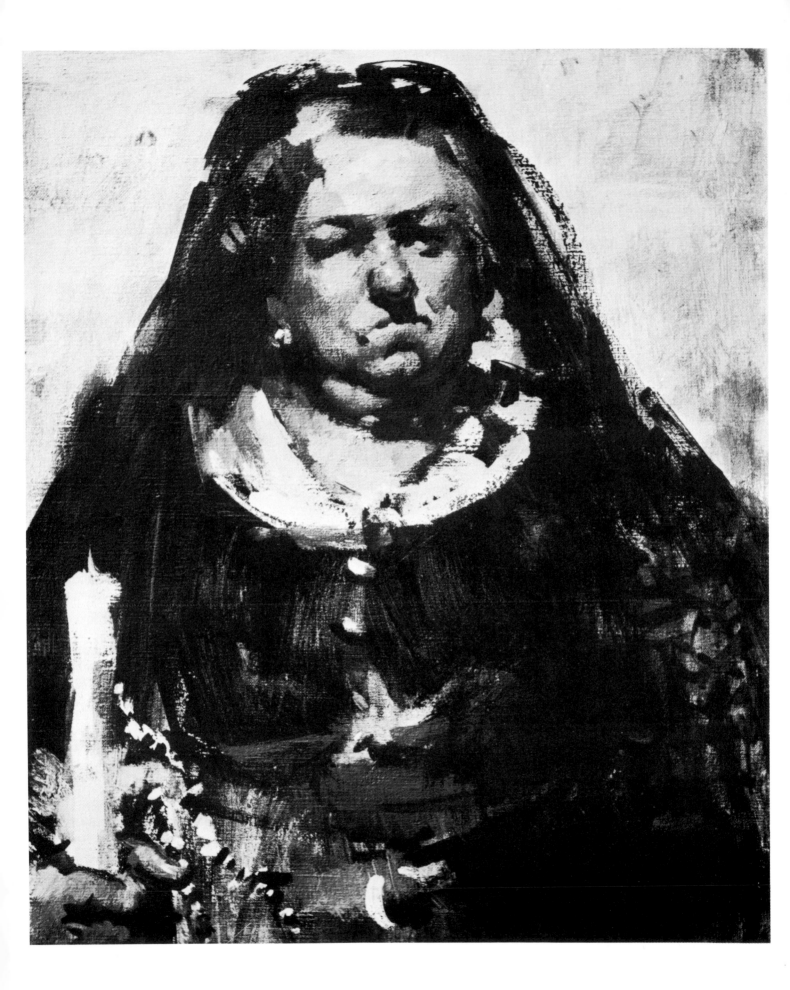

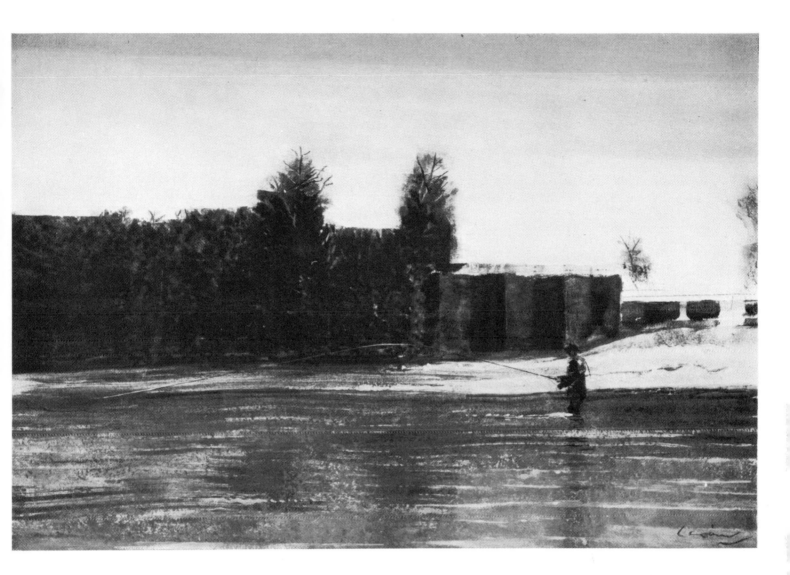

Woman from Seville by *Sergei Bongart, A.W.S., acrylic on gesso coated canvas, 24" x 30", Charles and Emma Frye Museum, Seattle, Washington. This loosely painted character study was executed in an essentially opaque technique, similar to that described in this artist's demonstration in the final section of this book. Note the difference between the thinly applied, somewhat transparent darks of the dress and the thick, crusty impasto of such light areas as her collar and the candle in her hand. There's very little blending—except in the face—but colors are painted into and over one another, often wet-in-wet.*

Weir Bridge Pool, Galway, *by Charles Coiner, acrylic on panel. The subtle textural variety of this serene landscape deserves careful study. The underlying color of the water is a middletone, over which the painter has alternated dark-on-light drybrush and light-on-dark drybrush to develop a sense of depth and surface sparkle. The dark shape on the shore—where architecture and trees seem to merge—suggests a wet-in-wet stipple, with dark paint roughly dabbed into a wet wash of lighter color. There is so much texture in the foreground and middleground that the artist has wisely left the sky almost bare. (Courtesy Midtown Galleries, New York)*

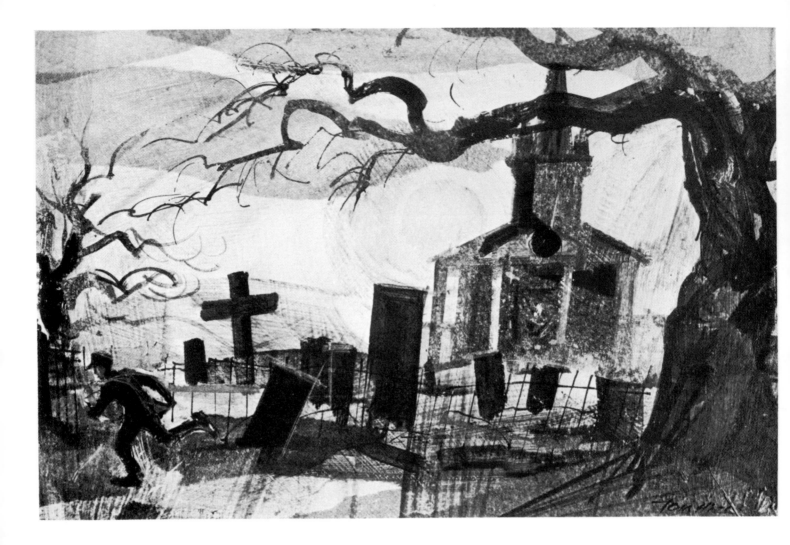

The Old Graveyard *by Tom Hill, A.W.S., acrylic and tissue paper collage on gesso coated hardboard, 8" x 12". The shadowy tissue paper shapes in the sky and on the ground function as washes of transparent color. Colored tissue is actually transparent; when one piece overlaps the other (as in the upper left) a darker tone results. The gesso has been applied to the board in rough strokes, so that the liquid color sinks into the crevices and produces a random, streaky texture. Observe how the "action" of the brush in the branches reflects the action of the running figure. When used in a watercolor technique, acrylic lends itself beautifully to this rapid calligraphy.*

glass. If the collage was done on canvas or on a panel, you've started out with a wear-resistant painting surface. But now you must be sure that the materials of the collage itself—paper, cloth, or other found materials—can take the possible punishment they face without a protective sheet of glass. A layer of acrylic varnish—or rather, several diluted layers—is absolutely essential to toughen the fragile materials that usually go into a collage. These materials must be completely sealed between a layer of acrylic adhesive on the underside and a layer of acrylic varnish on the top.

Like an acrylic watercolor or gouache, a collage on illustration board or on paper can also be framed without glass. The paper can be mounted on Masonite and the illustration board can be mounted as well, or left unmounted if you think it's stiff enough. Once again, the trick is to coat everything thoroughly with acrylic varnish so that the surface will be sufficiently toughened. But remember that the colors of found materials may react unpredictably to a layer of varnish. Before you varnish an acrylic painting on paper and frame it without glass, it may be wise to test your varnish on a few scraps to see if you like the effect. If unexpected changes occur and you're worried that a layer of varnish might throw all your color relationships out of kilter, then stick to glass.

Heavily textured painting really shouldn't need glass. In fact, I think the effect of such a picture is severely hampered by a sheet of glass; glass kills the three dimensional effect of the texture, since the irregular surface of the painting is covered with something smooth and shiny which has no business being there. Presumably, a textural painting contains lots of gel or modeling paste, both of which are extremely resistant to any kind of wear. Such pictures are normally done on tough painting surfaces like Masonite panels, so neither the paint nor the surface needs the protection of glass. So frame a textural painting just as you would any other picture done on canvas or on a panel. The surface will probably be so tough that you won't even need varnish, unless you want the varnish to provide a unifying matt or glossy film.

Labeling Acrylic Paintings

Because there are so many different ways to paint in acrylic, an acrylic painting may be hard to identify. Once you've sold a picture, it's out of your hands and the purchaser may have very little idea of how to take care of it. He may not even know what medium it's painted in. This may not present any problem until the time comes for him to have it cleaned, varnished, reframed, or perhaps repaired if the picture has been damaged in some way. But when that time comes, he may think he has an oil painting, a tempera, or a watercolor, and he may do something foolish like trying to clean it with a petroleum solvent, or perhaps slapping on a layer of retouching varnish to "bring out the color" as you might do for an oil painting.

I like the idea of a label on the back of the picture, preferably on the frame or on the backing board. A simple label with a few bits of information may save the purchaser a great deal of trouble and will give you the security of knowing that your picture will be properly cared for. What should the label say? Silly as it sounds, purchasers often forget the exact titles of their pictures and may even forget your full name if you sign your pictures with your last name only, as many painters do. So I'd recommend that your label begin with the same information that's normally found in an art book like the one you're now reading. Give the title of the picture, your name, the painting medium and painting surface, and the size: "*Winter Landscape* by John Smith, acrylic on Masonite panel, 24 x 36." If you like, you can add the date the picture was painted.

This identifying line can then be followed by a few terse instructions: "Clean only with a damp cloth. If necessary, use mild soap (like Ivory) and water, then wipe away with a damp cloth. Do not use solvents for cleaning. Do not wax or varnish. This picture has been permanently varnished."

Properly framed, varnished (if you need it), and labeled, your painting is now ready to face the world.

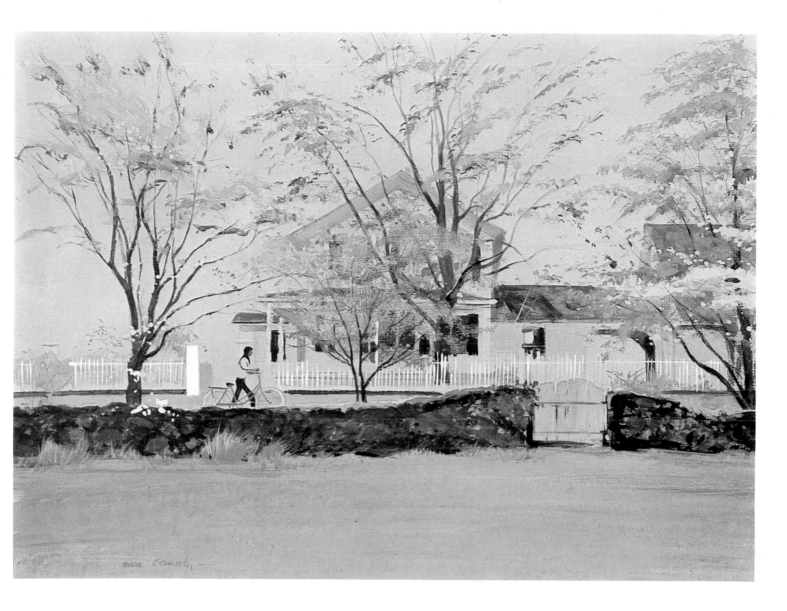

GOUACHE (OPAQUE WATERCOLOR) METHOD

Early Spring *by Hardie Gramatky, N.A., A.W.S., acrylic on gesso board, 18" x 24", collection T. J. Fontelieu, Westport, Connecticut. Painted in the opaque technique, this might be called an acrylic gouache. The variety of brushstrokes is worth studying. Compare the long, soft, lazy brushstrokes in the immediate foreground with the tiny, arc-like strokes of the leaves against the sky; the latter are like the famous "comma brushstrokes" of the impressionists. The dark wall in front of the house is rendered in a series of short, stubby strokes that beautifully express the stonework. The white picket fence is a series of slender vertical and horizontal strokes. These strokes never become monotonous because their spacing varies and they differ slightly in thickness.*

STIPPLING TECHNIQUE

Castle Rothes *by Charles Coiner, acrylic on Masonite, 16" x 22". The trees are painted with a fascinating broken color effect. They're strange combinations of stipple and drybrush, painted dark over light so that the light undertone is allowed to peek through. A similar type of brushwork appears on the wall of the distant castle, faintly suggesting the texture of the ancient masonry, but maintaining the essential flatness of the architectural pattern. Still more flat areas of broken color appear in the immediate foreground. (Courtesy Midtown Galleries, New York)*

Demonstrations

On the pages that follow, six leading American painters demonstrate six different acrylic techniques. Sergei Bongart demonstrates the basic opaque technique in a richly colored floral still life. Paul Strisik demonstrates the opaque technique in a subtle winter landscape. Claude Croney shows how to paint an acrylic watercolor in the basic transparent technique, showing the rich possibilities of acrylic as a watercolor medium. Helen Van Wyk paints a complex still life in which she re-creates the old master method of monochrome underpainting, followed by an overpainting in full color. Franklin Jones demonstrates the most demanding of all acrylic techniques in a painstakingly executed tempera. And Arthur J. Barbour provides a revealing demonstration of textural painting in acrylic, combining tube color, modeling paste, and a variety of found materials.

DEMONSTRATION 1: OPAQUE TECHNIQUE

Spencer Hollow by Paul Strisik: Step 1

*The artist prepares a good grade of linen canvas, 24" x 36",
with two coats of acrylic gesso, sanding the first coat lightly
before he applies the second. "After several pencil thumb-
nail sketches to feel out the composition," he uses charcoal
to transfer his final composition directly to the canvas.
Notice that he works almost entirely in bold lines, with an
occasional scrub of tone to indicate a shadow area, but
leaving the lights untouched, so they remain bare canvas.
He makes no attempt to define precise contours which
would restrict his free brushwork in the later stages.*

Spencer Hollow by Paul Strisik: Step 2

Strisik then lays in the general values and establishes the overall distribution of tone, working simply with thin washes of raw umber, diluted only with water—never with white. "At this stage," he explains, "the painting resembles a monochrome watercolor." Working in this way, the artist can evaluate all his decisions and make any necessary changes or corrections in composition. Translucent whites are roughly scrubbed in to make adjustments in shapes, such as the shadow pattern in the lower left hand corner; compare it with the shape indicated in the preliminary charcoal lay-in. The casual, scrubby brushwork will be refined as more opaque color is applied.

Spencer Hollow by Paul Strisik: Step 3

Now Strisik begins to apply color, which he thins with a mixture of water and medium in equal quantities. "I strive to make the values more accurate and to express the mood of a winter afternoon in color. All my attention can be devoted to color and to color values, since the canvas has already been covered and the composition established in the previous steps." Examine how the values have been adjusted on the shadow side of the house, where the windows have been lightened to melt into the general tone. The horizon line is softened and the trees are edged with light to pick out the details of trunks and branches. There's an interesting effect of atmospheric perspective in the stone wall in the foreground, which grows gradually lighter as it recedes into the distance.

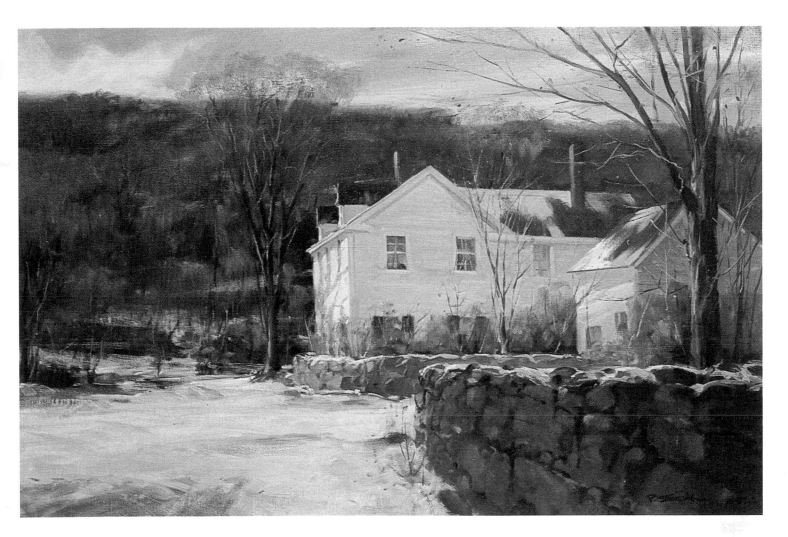

Spencer Hollow by Paul Strisik: Step 4

"In the final stage," the artist explains, "all the values are brought into proper relationship." Exactly the right contrast established between the light and shadow sides of the house, both of which contrast crisply with the darkened hills beyond. Detail is suggested, but not neatly rendered, in the foreground wall. Throughout, the brushwork is free and suggestive, rather than tight and literal. Examine the broken color effect on the distant hillside, where so much detail is implied, but where you can barely pick out a single tree. The branches of the nearby trees are painted with swift, calligraphic strokes. The foreground wall is a very rich interplay of warm and cool broken color. The overall softness of the painting is a result of the free, scumbling, scrubby strokes which give acrylic its unique character.

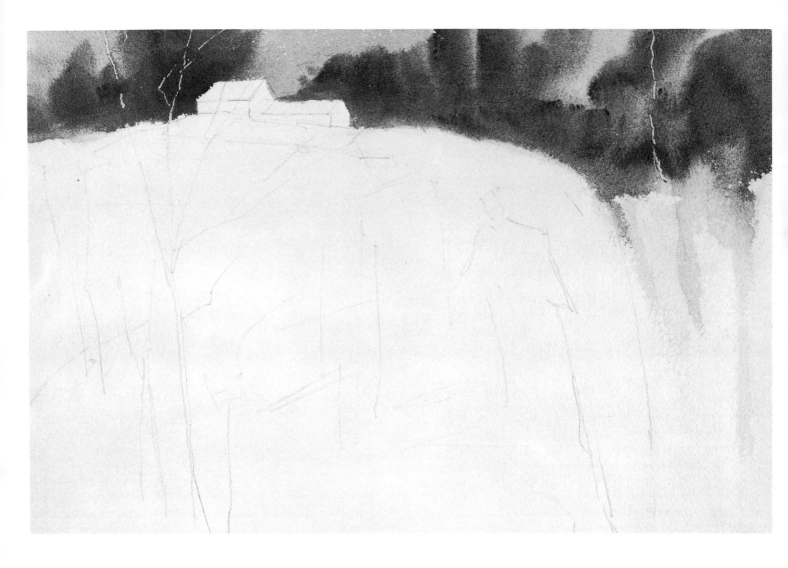

DEMONSTRATION 2: TRANSPARENT TECHNIQUE

Winter Patterns by Claude Croney: Step 1

The artist begins by stapling a half sheet (15" x 22") of 300 lb. rough Arches watercolor paper to his drawing board. With the minimum number of lines, he draws his subject on the paper with an ordinary number 2 office pencil, establishing only the major areas of the design. Onto a white porcelain butcher tray, he squeezes the colors for this particular painting: burnt sienna, naphthol crimson, Hooker's green, manganese blue, and Mars black. He wets the entire background sky area with water, then paints into this wet surface with a 1" varnishing brush, carrying a mixture of burnt sienna and Hooker's green. Then, the darker tones are added while the first are still damp. "Some soft edges are needed where the dark background meets the white paper, which will later suggest snow," the artist explains. "This is the time to soften them, while the paint is still wet. A tissue is used to wipe along the edge of the still-wet paint." The thin, light strokes that suggest branches against the dark background—to the left and to the right—are scratched in with a painting knife while the color is still damp.

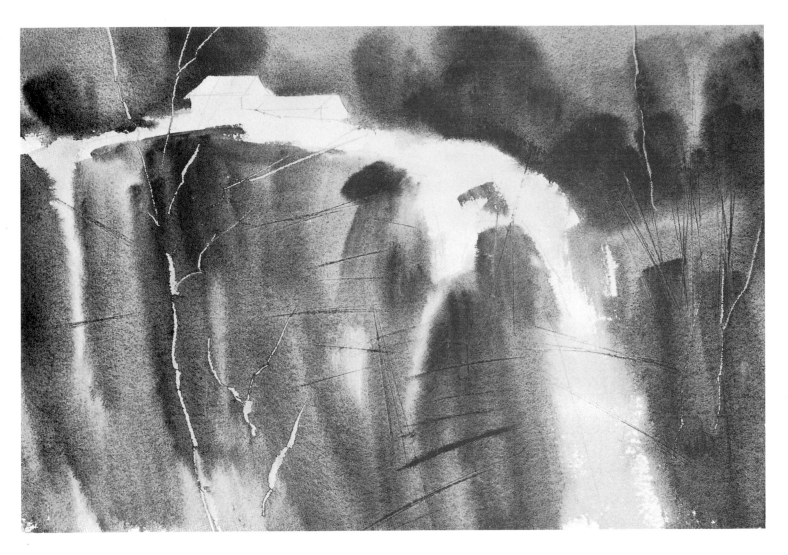

Winter Patterns by Claude Croney: Step 2

Now Croney paints the large cliff area. "It's a good idea to get as much of the paper covered as soon as possible," he emphasizes. He begins by painting in a middletone that combines burnt sienna, burnt umber, manganese blue, and Hooker's green. Still using the 1" varnishing brush, he adds some dark variations while the big, bold washes are still wet. Some sharp, dark lines are added that will later suggest tree trunks on the right and cracks in the cliff near the middle. "This is done by pressing down on the front of the painting knife blade and creasing the paper by sliding the blade back and forth," Croney explains. "The crease in the paper fills with the color, which is still wet—hence the dark lines." Just as he scraped out some light branches in step 1, he scrapes out some lights here in front of the cliff, while the paint is still wet.

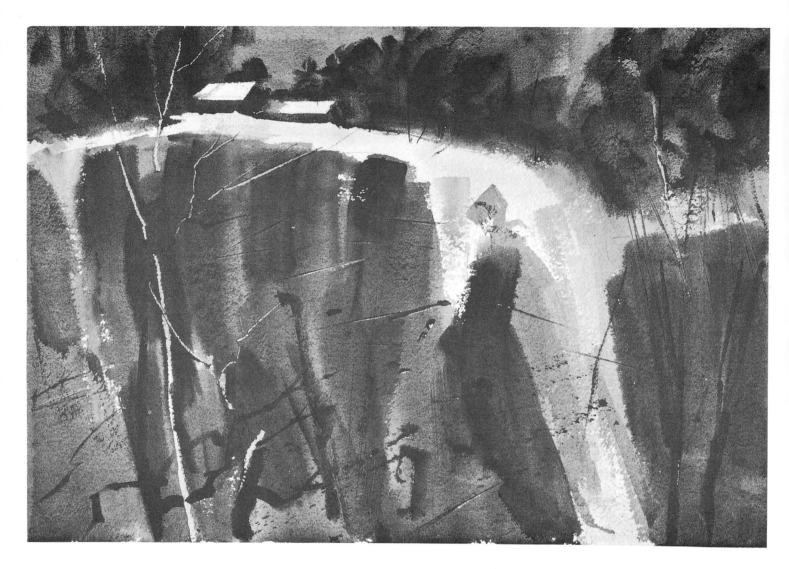

Winter Patterns by Claude Croney: Step 3

As he moves into the third stage, Croney begins working with smaller brushes: numbers 5, 8, and 12 round sables. He paints in the building with a mixture of naphthol crimson and manganese blue. The shadow on the roof is painted next, while the side of the building is still wet; this gives him a soft edge where the shadow meets the side of the building. However, he leaves the rooftop as the last area of white paper to be covered. "Now that I have the approximate value and color over the entire picture space," Croney explains, "I can complete the effect with a combination of other techniques." He uses a number 12 round sable brush
to paint in some darks that suggest lighter tree trunks in the foreground; then he adds some tree trunks in the background with a smaller brush. To suggest detail and texture, he adds drybrush to areas in the wooded background and also to the cliff area. He also adds some spatter tone for even greater variety of texture: "Load a brush with some dark paint and hold it up over the area you want the spots and flecks to go on, then tap the brush hard against your left hand." Next to the dark lines on the cliff, added in step 2, he scrapes out a thin, light line, exaggerating the lines in the cliff.

Winter Patterns by Claude Croney: Step 4

As he moves toward the finished painting, a number 5 round sable brush is used for small details. "I don't try to finish any one area, but keep working over the entire area until I feel it's completed." Croney comments: "The only difference between step 3 and the finished painting is the variety of textures I add in the form of thin lines, spatter tone, drybrush, and some scraping out with the razor blade. It's a good idea to stop once in a while and lay a white mat on the painting; this makes it easier to see the picture's progress and decide when it's finished." The artist's limited palette achieves an effect of great subtlety, yet a surprising range of warm and cool color is suggested within the almost monochromatic scheme. Acrylic is particularly suitable for a watercolor technique in which a wide variety of textural effects must be built up over one another without disturbing the underlying color. Croney also notes that "acrylic colors have a more potent intensity when they dry, and this is helpful if you like to use subdued color, as I do."

DEMONSTRATION 3: TEMPERA TECHNIQUE

On the Sound by Franklin Jones: Step 1

After sketching in the major areas of his composition with pencil—on a gesso coated 24" x 30" Masonite panel—Jones restates these shapes with washes of burnt umber. A warm mixture of burnt umber, burnt sienna, and yellow ochre is freely brushed over the area that will be grass, while the darkest notes in the picture—the distant trees and the boat interior—are established. "Such a procedure gives me the chance to see the general tonal pattern of the entire picture," Jones explains. "I leave the boat untouched, though, because I plan to develop the overall construction of the picture before working with tone." It's interesting to note that the slow, meticulous tempera technique begins with such a free, washy lay-in. The first attack is as spontaneous as watercolor.

On the Sound by Franklin Jones: Step 2

"Satisfied with the shapes within the picture," Jones goes on, *"I begin developing the texture in the grass area, working from background to foreground, still concerned mainly with values, but with more subtle values to give form to the ground as it slopes down to the shore. At this point, I put in a tone for the water, work a bit on the boat, and then very boldly try some indication of the beach surface with a large brush and very wet washes. Since I've planned this foreground area to be very light, I try not to carry my brushwork too far. I hadn't really expected to be satisfied with my first attempt at this area—usually I have to try an area like this a number of times, working into it with opaque color to get the effect I want—but this time I decide to leave it and I plan to build my textures on top of it."* The artist is still working loosely, with broad brushwork, in a spontaneous technique that will lend vitality to the more meticulous brushstrokes in the final stages.

On the Sound by Franklin Jones: Step 3

Now Jones works back into the grass area with smaller, more meticulous strokes, building up the grass texture. He begins to develop the sea and spends considerable time modeling the outer form of the boat with opaque color, working in more or less monochromatic umber tones, planning to add transparent washes of color later on. Transparent washes are also used to establish the color and tonality of the sand in the foreground. Moving back and forth over the entire picture surface, he now begins to develop the shapes and details of the distant trees and the building. He then establishes the position of the long line that ties the boat to the shore. Although the buildup of small strokes has begun, the artist withholds details, working for values, modeling, and three dimensional form.

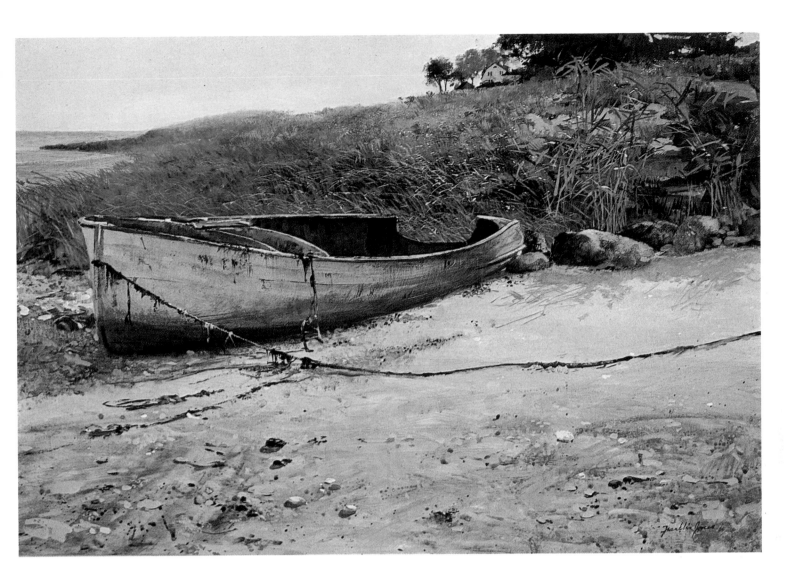

On the Sound by Franklin Jones: Step 4

In the finished painting, you can see the elaborate detail that brings the picture to completion. First, the side of the boat is "weathered" with several washes of transparent color that are allowed to settle into the minute depressions of the panel surface, which carries a faintly streaky coat of acrylic gesso. The details within the boat and the accents of sunlight along the top edges are added now. The sunlit blades of grass are next, using opaque white paint; color is applied over these strokes, which shine through the transparent washes. The final work is devoted to the texture on the beach. Bits of seaweed are added to the mooring rope and to the boat itself. The entire painting is a fascinating interplay of free, scrubby strokes in the foreground (with carefully placed touches of detail) and intricate, highly controlled brushwork on the boat and in the landscape beyond. (Collection of Mr. and Mrs. David Huenerburg)

DEMONSTRATION 4:
OPAQUE AND TRANSPARENT TECHNIQUE

Roses and Blue Pitcher by Sergei Bongart: Step 1

Working from nature in his own garden, the artist paints on a 30" x 40" linen canvas, primed with acrylic gesso. The entire preliminary drawing is done with a brush, using transparent washes of the same colors that are dominant in the final painting. The picture is blocked in with tube color thinned with gloss medium and water; no white paint is used in the mixture. The artist works entirely with large brushes to maintain a bold approach from the very beginning. At this stage, he deals with three basic problems: establishing color harmonies; design and placement of spots and shapes; and value relationships in the large areas.

Roses and Blue Pitcher by Sergei Bongart: Step 2

Still working with large brushes, the artist begins to use thicker, more opaque color, in contrast with the initial washes. However, he tries to preserve transparency in the shadow areas, while working with more opaque color in the light areas. Everything is kept in middletones, without accentuating lights and darks. Now his two main goals are to develop correct color relationships and to improve value relationships. The brushwork remains rough and vigorous, with no attempt to define edges or to focus on details.

Roses and Blue Pitcher by Sergei Bongart: Step 3

Now the artist begins to model the simple, large masses, introducing heavy impasto in the light areas, such as the surface of the table and the lighted areas of the dishes, fruits, and flowers. The shadow areas remain thin and transparent. Shapes like the pitcher and the globular fruits are more precisely defined, though still loosely painted. Throughout, the texture of the painting is constantly enlivened by big, distinct brushstrokes, which are never ironed out.

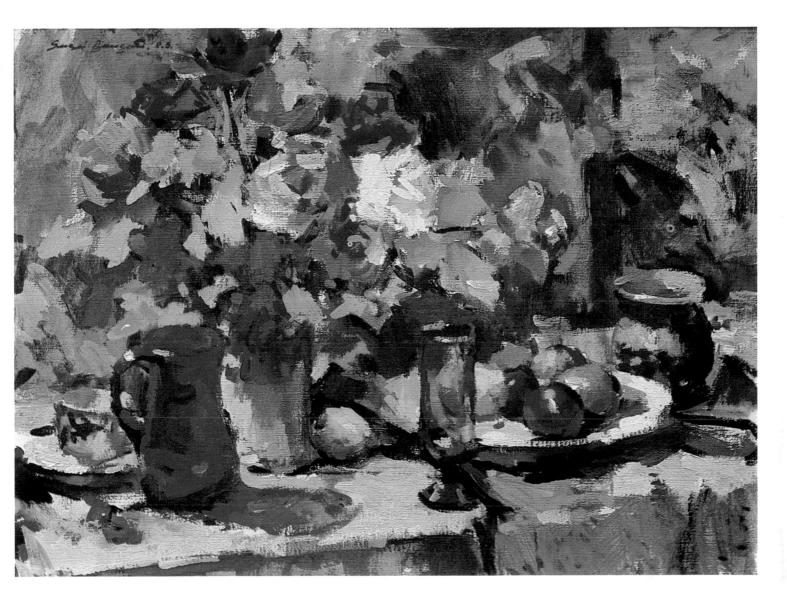

Roses and Blue Pitcher by Sergei Bongart: Step 4

In this final stage, the artist works energetically throughout the canvas, introducing the darkest and lightest accents. The lightest lights are vigorously brushed in with heavy impasto. The surface is enriched with a variety of textural effects like the drybrush strokes on the table at the foot of the blue pitcher, the broken color effect in the upper right, and the semi-opaque scumbles in the lower right hand corner. Glazes are used to darken some areas and make them cooler or warmer, as in the transparent shadow scrubbed in behind the rose in the top center. Throughout all four stages, Bongart has used water and gloss medium to thin his color, except where he's used gel for glazing. The finished painting, when dry, is protected with two coats of gloss varnish.

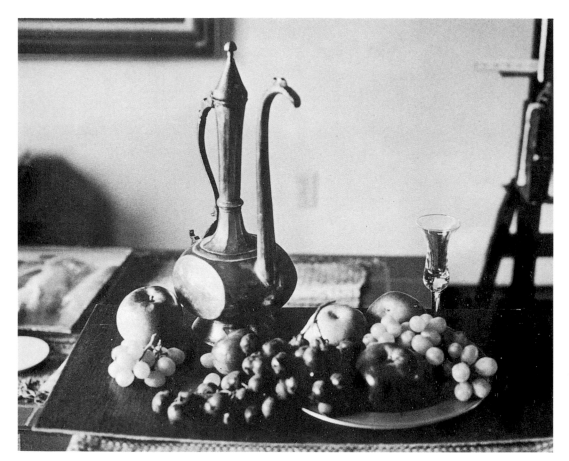

DEMONSTRATION 5:
UNDERPAINTING AND
OVERPAINTING

Still Life with Copper Pot
by Helen Van Wyk: Step 1

The painter begins by setting up the subject: "To me, it's like a juggling act; all the fragments that make up the design have to be fitted together to bring about the whole pictorial impact. For this reason, I regard still life as realistic abstraction."

Still Life with Copper Pot
by Helen Van Wyk: Step 2

When the actual still life objects have been composed, the artist gets a second chance to "play with composition," arranging the pictorial elements within the confines of the 22" x 28" canvas. "An approach that I find logical is to start making marks on the canvas to indicate the outermost areas of the arrangement. This is done with a gray mixture of thalo blue and burnt umber, greatly thinned with water."

Still Life with Copper Pot
by Helen Van Wyk: Step 3

The general compositional scheme has now been indicated so the actual forms can be delineated with a brush.

Still Life with Copper Pot
by Helen Van Wyk: Step 4

The artist begins to develop her monochromatic under- painting, working with this basic gray mixture and adding varying amounts of white to produce a variety of values. Initially, the canvas will be covered entirely with values of gray, rather than with colors—which will come later on. "This step shows further development of the composi- tion," she explains. "What we have here is merely a scaf- folding for the drawing that will be developed as the painting progresses."

Still Life with Copper Pot
by Helen Van Wyk: Step 5

Here, the painting of the background area has covered up many of the preliminary delineations. Throughout this demonstration, the artist thins her acrylic paints only with water when necessary.

Still Life with Copper Pot
by Helen Van Wyk: Step 6

At this point, the shapes of the objects have been lost in the pattern of the darks. But this is only a momentary stage in the development of the overall pattern.

Still Life with Copper Pot
by Helen Van Wyk: Step 7

Now the forms of the objects have come back as the pattern of the light values is reestablished and strengthened. To mix the basic gray for a monochromatic underpainting, the artist points out that any combination of two complements will do, although a mixture of blue and brown is traditional in so-called gri-saille underpainting.

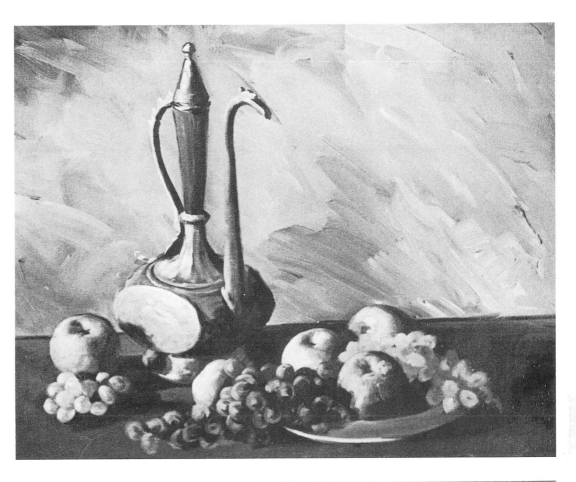

Still Life with Copper Pot
by Helen Van Wyk: Step 8

The light areas are developed still further as the artist adds lighter and lighter values. Then the dark pattern is accented with still darker values. At this point, the monochromatic underpainting is finished.

Still Life with Copper Pot by Helen Van Wyk: Step 9

Color is added in this final stage. "In order to take advantage of the underpainting," Miss Van Wyk emphasizes, "it must be colored, not covered. This is done with glazes. In most cases, this means color that's thinned; in all cases, this means color that's not mixed with white. Even somewhat opaque colors, like the cadmiums, can be applied thinly enough to perform as a glaze. The background is first glazed with thalo green mixed with burnt sienna. This mixture is thinned with water and a retarder to slow drying. The light values of the copper pot are glazed with cadmium orange

and cadmium red light; the mass color of the pot is glazed with burnt sienna; the darkest areas are glazed with burnt sienna, modified with a touch of blue. After the fruits are glazed with their respective colors, the table is done with burnt umber. This completes the picture, except for the highlights and light gray areas which are so hard to effect with a glaze, but need an addition of white."

Helen Van Wyk is author of Acrylic Portrait Painting, *Watson-Guptill Publications, 1970.*

DEMONSTRATION 6: TEXTURAL PAINTING

The Wall by Arthur J. Barbour: Step 1

Barbour begins by submerging a full sheet (22" x 30") of rough Arches watercolor paper in water for fifteen minutes; he then uses gummed paper to glue all four edges of the sheet to a plywood board. The board and paper are set aside to dry overnight. The following day, he surrounds his drawing board with brushes, acrylic paints, a container of water, a bottle of India ink, a can of acrylic modeling paste, and a container of sand and pebbles taken from his driveway. His palette is a large enamel butcher tray. He attacks the area of the wall in a carefree manner, spreading on the modeling paste in thick, juicy gobs, taken straight from the can. The wall is covered in broken areas, letting patches of bare paper show through. He works in some tints of burnt sienna and cobalt blue—"Not too much, and not all over," he notes. At this point, the wall is no more than a rough abstract pattern, significant mainly for its rich texture.

The Wall by Arthur J. Barbour: Step 2

Sand and pebbles are thrown on in small handfuls and squashed into the paste with the palm of the artist's hand. He then shakes off the excess. Warm siennas and cool blues are mixed into the paste, letting some of the gray stone and sand lend their own color. As the modeling paste begins to harden, he suggests details of concrete, such as stains, old rusty metal straps from which timbers had once hung, holes, and other irregularities in the wall. For the wall on the right, modeling paste, sand, and pebbles are mixed together on the brush and applied directly to the paper. Details and stains are mixed in while the paste is still wet. Again, burnt sienna, raw sienna, and cobalt blue are used.

The Wall by Arthur J. Barbour: Step 3

Barbour then attacks the sky. "A mixture of cobalt blue and ultramarine blue, grayed slightly with burnt sienna, is applied in a heavy wash. As this is just starting to dry, the bushes on top of the wall, along with the hill and the trees in back, are put into the damp sky area, using a mixture of India ink and thick color. Pieces of sponge are dabbed into the modeling paste and pushed into the bushes. Sand and small stones are spread over the hill area and allowed to dry in with the heavy, paste-like washes. The excess is dumped off later." The faintly soft-edged quality of the foliage is the result of this wet-in-wet technique.

The Wall by Arthur J. Barbour: Step 4

The foreground is now painted in strong washes of transparent color. Before this dries, heavy impasto mixtures of burnt sienna, cobalt blue, and raw sienna are boldly stroked into the washes. More sand, pebbles, and still more sand are dropped on and pressed into the thick mixture. In selected places, color is added over the textured sand, but most of the foreground is simply sand and gravel—in its original color. Small stones are pasted on for added texture and decorative quality, as well as realism.

The Wall by Arthur J. Barbour: Step 5

In the final stage, you can clearly see the techniques used to complete various details. The smaller bushes are stippled in with sponges and drybrush. The large bushes are begun by wetting the wall area with clean water; black India ink and Hooker's green are painted into this wet area, over the modeling paste and stones, giving a soft, diffused feeling. When this dries, it's sharpened up by adding branches (black India ink and burnt sienna) here and there. Bits of sponge are pasted on for additional texture. Cobalt blue and cadmium red are used transparently to produce the cast shadow on the wall. When this is dry, the large trees are painted into the shadow with burnt sienna and black India ink. Some of the branches are highlighted with tints of pale color. The boy is loosely drawn in with pencil and stained in place with ink and color to lend a contrasting note.

Index